photographing wildbirds

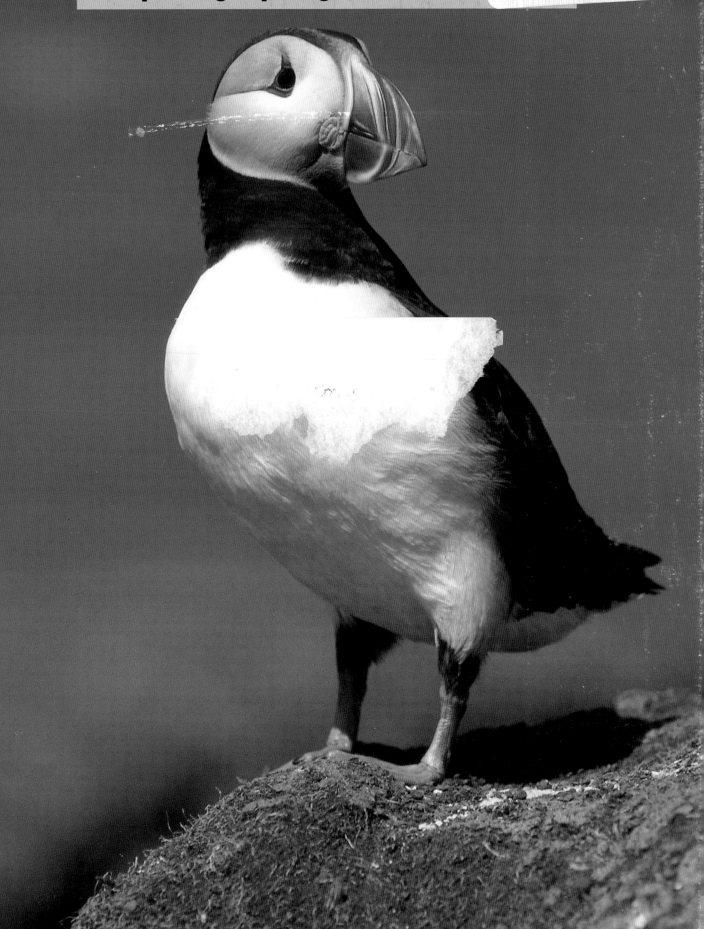

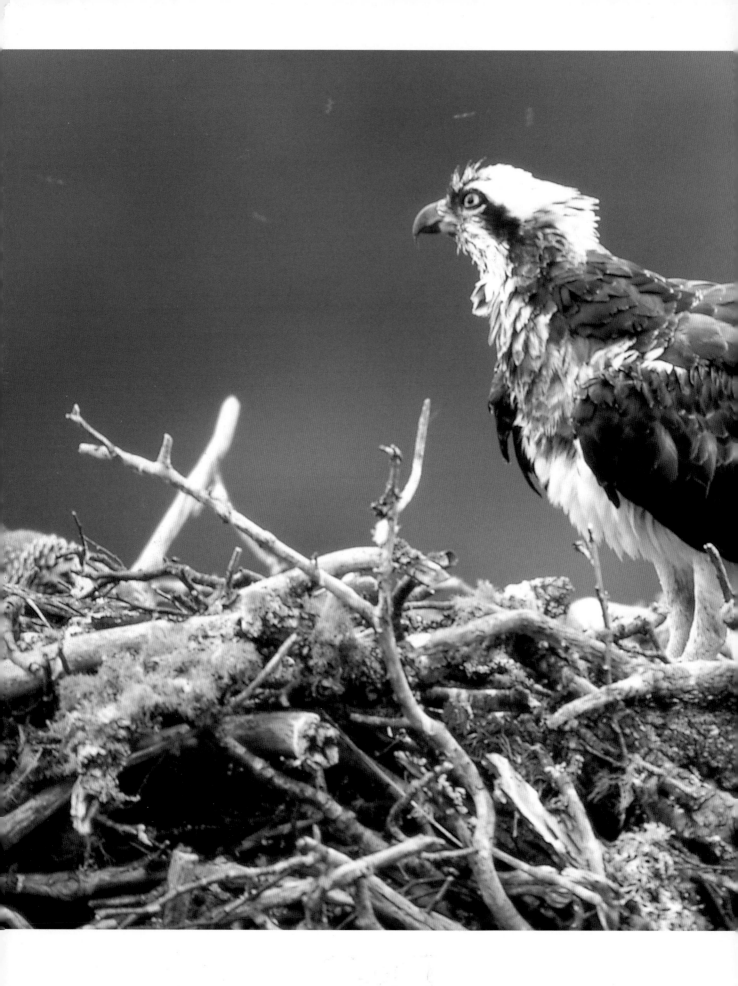

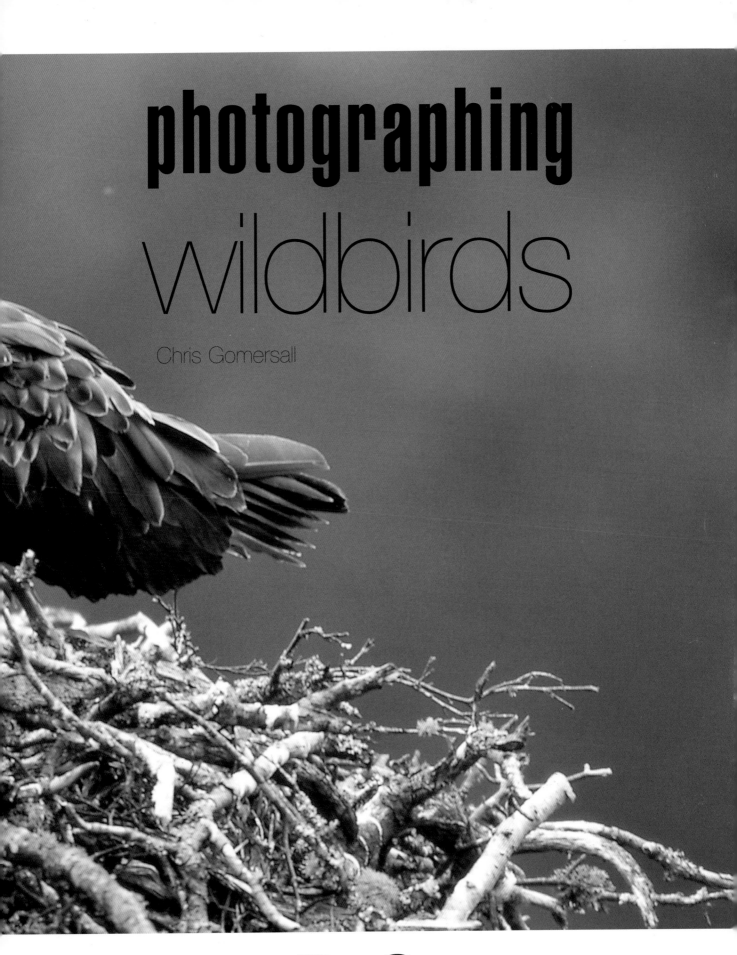

photographing
wildbirds

Chris Gomersall

D&C
David and Charles

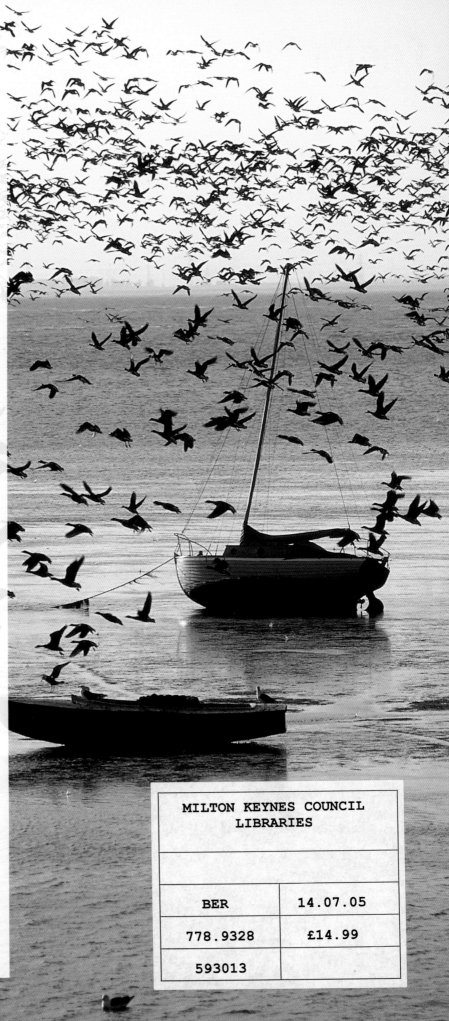

Dedicated to the memory of my
mother Jane (1930–1996)

I sing but as the bird does sing
That in the silence dwelleth
Goethe

A DAVID & CHARLES BOOK

David & Charles is a subsidiary of F+W (UK)
Ltd., an F+W Publications Inc. company

First published in the UK in 2001
First UK paperback edition 2005

A catalogue record for this book is available
from the British Library.

ISBN 0 7153 1113 1 hardback
ISBN 0 7153 2144 7 paperback

Printed in China by RRD Shenzhen
for David & Charles
Brunel House Newton Abbot Devon

All photographs are by the author, except where
otherwise identified.

Copyright in the following photographs belongs
to the Royal Society for the Protection of Birds,
reproduced here courtesy of RSPB Images:
pages 17, 49 (bottom), 93, 97, 116–117,
129, 130 (bottom), 131 (both), 134 (top),
137 (top), 138, 156–157.

Contents

(half-title page) **Atlantic puffin in breeding plumage**

(title page) **A female osprey at her Scottish eyrie**

(opposite) **Brent geese wintering on the Thames estuary**

INTRODUCTION

The most frequently asked question of all wildlife photographers must be, 'How long did it take you to get that photograph?' When it comes my way in casual conversation, I often dismiss it with a peremptory 'one thousandth of a second' – not because I mean to be rude or evasive, but because it would take too long to answer comprehensively.

Take the example of the backlit shot of a white-tailed eagle in flight that appears on page 135. If I were to consider only the day of photography, the reply might be 'a few hours', but that would still be misleading, as that particular field trip had already taken more than a week, waiting for a suitable weather window and getting into position to take the photograph. Then there were several previous visits to the same area over three or four years, and the many less successful attempts at other locations dating back some 15 years. What about my years of learning photography and ornithology, and acquiring the field skills and practical experience to be able to capitalize on the opportunity when it eventually occurred?

Should I go back to when I first began to look at and take an interest in birds, or when I took my first holiday snap? The only conclusion is that the most honest and accurate answer must be 'all of my life'.

Similarly, when people remark that 'you must have been very lucky', it's tempting to nod in agreement. Nobody really wants to hear about your enormous time commitment, but it's undoubtedly true that the harder you work, the luckier you get. The one thing that is sure is if you never go out with your camera, you'll have no luck of any kind.

Another comment that I hear with surprising frequency is 'you must have some really good equipment'. And I tend to agree that yes, I have equipment that is good enough to do the job I need it to do. But cameras alone don't create great photographic images. Why is it that photography is generally held in such low esteem by so many people, even though I am quite sure they don't mean to insult its practitioners? Would the same people suggest that Gabriel Garcia Marquez must have a fantastic word processor with the

Hoopoe with crest raised
You have to be alert to capture the brief moment the hoopoe's crest is displayed, just after it lands.

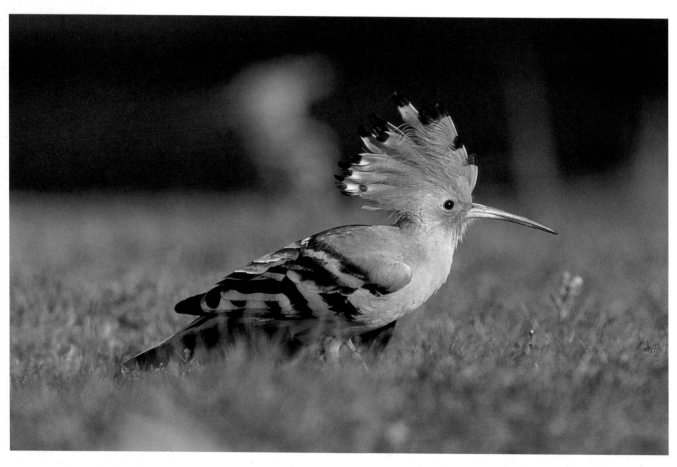

very latest spellchecker to be able to write such wonderful books? Or that a good carpenter must have a brilliant set of chisels? It is plainly ludicrous to suggest that good equipment is the only explanation for their accomplishments, and yet it seems to be an all-too-common attitude with regard to photography. Perhaps it is because we see so many examples of good photography in our daily lives, and assimilate their messages so readily without the need to think too hard about how they were made. With particular reference to bird photography, the commentator has probably recognized the fact that you can't just walk up to a wild bird and expect it to pose for the camera. And I do acknowledge that technological developments are very much influencing the way all of us work, allowing us to shoot from a greater distance, and enabling more candid representations of natural behavioural activities

– this has got to be a good thing, for us and the birds. Still, the specialist hardware is only a small part of the whole deal.

So, when it comes to writing a 'how to do it' book on photographing wild birds, I wouldn't wish to deceive you that there are any set menus of convenient short cuts, quick fixes, and tricks of the trade. It just isn't possible to provide a recipe book detailing precisely where to go and when, with foolproof formulas for obtaining perfect photographs every time. I'd be doing you a disservice if I were to pretend otherwise. What I can do is to pass on some of the benefits of my experience, relate a few techniques that have worked for my colleagues and I, and generally give encouragement. This will, I hope, make your understanding greater and your photography easier, but in the end it is your own experience, and learning from your mistakes that will count for most.

Short-billed dowitcher
Many migrant shorebirds such as this feeding dowitcher can be photographed on Florida's coast by careful stalking, in this instance using a 300mm lens with a 2x teleconverter.

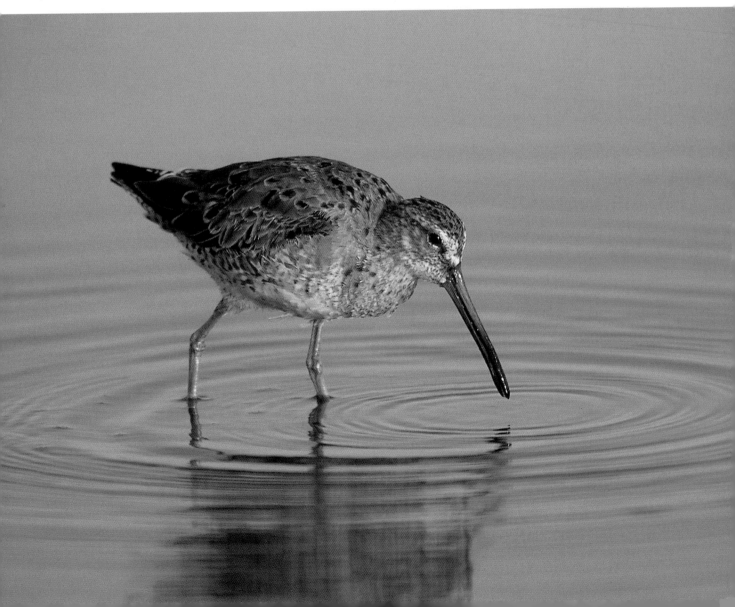

The main ingredient for success must surely be a passion for birds and nature – without that you're unlikely to have the necessary patience and commitment to get very far. For this reason, I believe that an enthusiastic birdwatcher is more likely to become a successful bird photographer than an already competent photographer who just wishes to diversify. Imagine if I tried to switch to sports photography, for example. Even though many of the camera techniques are similar, it would be a hopeless quest if I didn't understand the rules of the particular game I was trying to cover. It might take some years of sitting on the touch line of a football pitch before I could hope to anticipate where the ball would be at a given time well enough to capture it on film with any degree of reliability. I would go so far as to say that you should go birdwatching for a while and hone your observational powers before taking up a camera in earnest.

Having learned my craft and done most of my work in the British Isles, I have grown up with the idea that wild birds are rather shy creatures and not at all easy to approach. It is also a given fact that British light and weather are very variable, if not to say downright unhelpful in the way they seem to conspire

Great bustard male in spring plumage

It took many weeks of hide work to obtain a few satisfactory photographs of this shy and difficult subject.

against all outdoor photography. I would like to think that this background has provided me with a sound foundation of the necessary field and camera skills, and shaped a responsible, well-rounded approach to photographing wild birds. It is certainly the main reason I have concentrated so much on the fieldwork aspects of bird photography, which sometimes seem to be taken for granted in other books on the subject. At the same time, I have also tried to reflect the more international nature of modern bird photography, and to allow for the fact that people are increasingly likely to travel outside their country of residence in order to pursue their interest. I hope there is sufficient cosmopolitan flavour here to interest readers on any continent.

It is my great privilege and your good fortune that we have been able to include the work of a number of guest photographers, all of whom are acknowledged leaders in their respective fields and styles. In fact, when my publishers suggested the idea to me, I confess to an initial reluctance. After all, it was asking for unfavourable comparisons to be made. The guests would be able to show one favourite image from their lifetime portfolio, while I could use examples of my own work to illustrate such unfortunate phenomena as 'red eye'! But I was soon won over to the idea, especially as it meant that I wouldn't have to bluff that I had been everywhere, and done everything. I mean, why try to pretend that I'm an expert in high-speed flash photography when everybody knows that title rightly belongs to Stephen Dalton? To my amazement and immense gratification, everybody I invited to contribute said 'yes'. Of course, I could have included many more beautiful photographs to illustrate the same points, and let me apologize straight away to the many excellent bird photographers I have excluded – honestly, no slight intended! It's a matter of regret, though, that there weren't more female role models from whom to choose.

There are a few ethical matters that need to be raised, relating to the way nature photographers conduct themselves. First and foremost, it has always been my belief that the welfare of the bird is more important than the

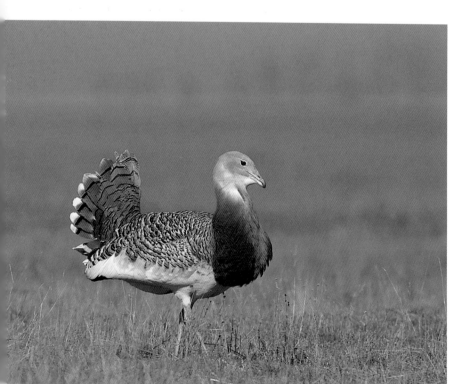

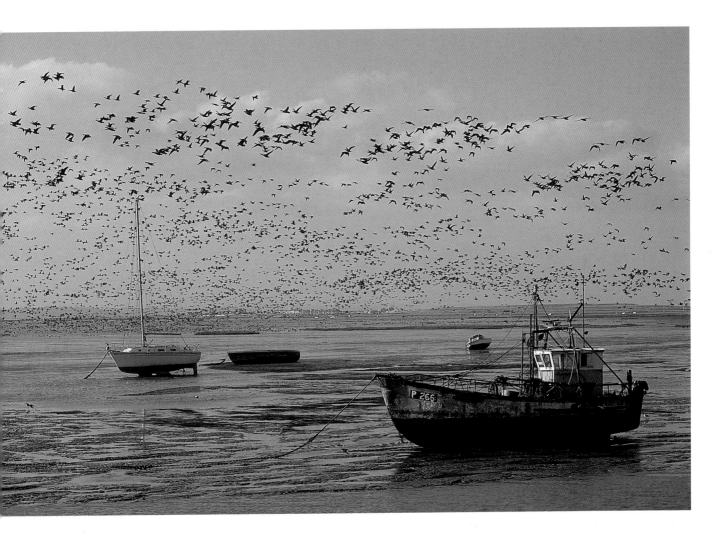

photograph, and that is an underlying premise of this book. As in all matters of conduct, the actions of an irresponsible few can seriously undermine the public perception of all wildlife photographers. To behave with due consideration to wild birds and other people should be the natural way of things, but unfortunately it is not always so – sometimes through malice, more often ignorance. Of course, you should behave impeccably at all times because it is the ethical thing to do, but even to take a purely cynical view, it makes sense to guard your reputation from the very outset of your photographic career. Mud sticks, and it is exceptionally difficult to shake off suspicions of bad practice. You might spend your whole life building the trust and confidence of others, whether landowners, licensing agencies, or fellow photographers, but you can blow it all with one stupid act. And then you find out just how much you depend on the co-operation of all these people and institutions. So for selfish as well as

altruistic reasons, it makes sense to behave responsibly and sensitively.

Bird conservation and biodiversity has always been the primary motivation for my photography, so the realization that not all bird photographers think the same sometimes comes as a surprise. Few things depress me more than hearing nature photographers complain about conservation organizations and their representatives, usually over some trivial matter of access or facility. This seems to me extraordinarily selfish and short-sighted. To those who believe their civil liberty has been in some way curtailed because a nature reserve has been established where they once roamed without restriction: wake up and consider for a moment what might be there now, or in ten years' time, if not for this or that environmental group. A shaky boardwalk, or restricted hide window view is really quite insignificant compared to the need for habitat conservation and management, isn't it? If the water level at a wetland reserve seems to be

Brent geese flock
These birds were photographed from the promenade at Southend on the Thames estuary with an 80–200mm zoom lens.

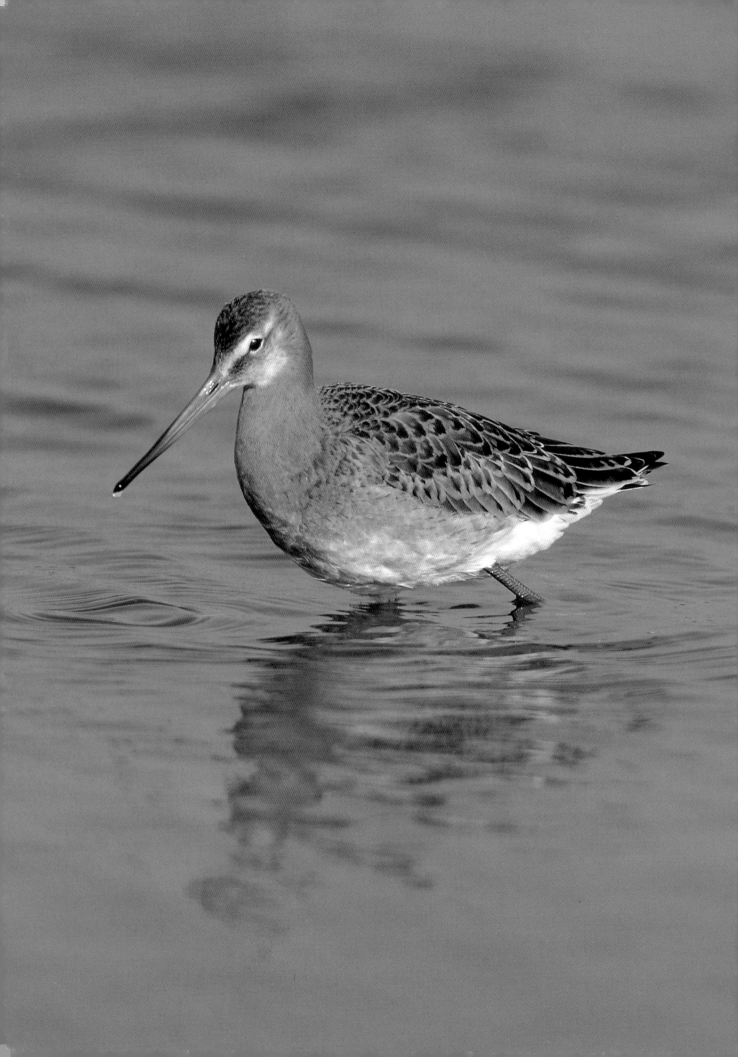

inconveniently high for your photography on a particular day, it might well be because flooding is an important management tool in vegetation control, to create the best possible nesting conditions for certain species. Remember that, in the eyes of the warden or estate manager, you are part of just another special interest group, no more deserving than dog-walkers, rock-climbers or horse-riders, for example. It's up to you to convince them otherwise. Yes, of course photography can be a potent communication tool, and they will probably appreciate that too if you take the trouble to understand what they are trying to achieve – what we should all be trying to achieve. And do you know what? If successful, there might just be more birds for you to photograph at the end of the day. Again, only through our continued good conduct can we expect to be allowed any right of access at all.

The truth of the final image is an important consideration for all photographers, not just those working with wildlife. In our case, controversy and debate has long centred around whether the subject is genuinely wild, or 'controlled' in some way by the photographer. The accepted code of good practice is that the photographer should declare prominently in the caption if the subject is captive. This generally satisfies everybody, even though the captive status is rarely referred to when the same image appears in print. That would be an editorial decision, and we might sometimes take issue with it, but on the whole it's a workable solution. But woe betide the photographer who tries to pass off a captive subject as wild and free – it might not seem like a crime of the highest order, but the perpetrator is usually viciously denounced if the transgression is discovered. Really, it's easiest to own up from the outset. There may be very good reasons for using a captive subject anyway. Perhaps it's a globally endangered bird that would be almost impossible to photograph in the wild, and to try to do so would further jeopardize its chances of survival. Perhaps you need a close-up of the hooked bill of a bird of prey to illustrate its feeding adaptation, and it's just not practical to attempt this with a wild

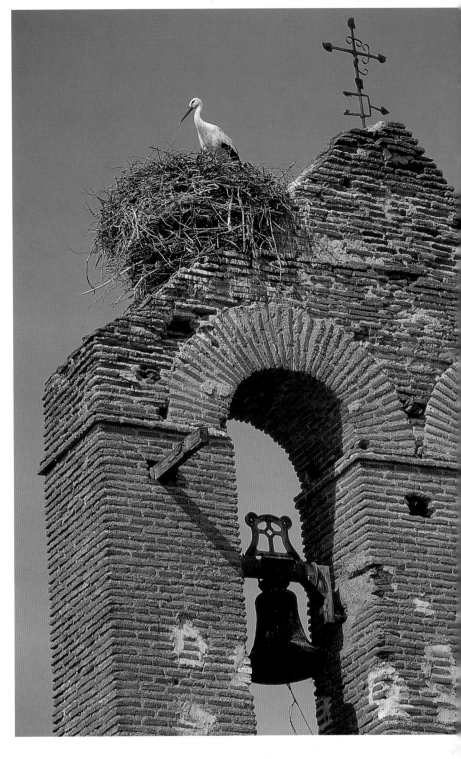

bird. Either way, it's a simple matter to declare the subject's captive status in the caption, even though you might think it would be obvious to most viewers anyway. For my part, I am happy to confirm that all of the images in this book are of wild birds, as the title implies. The single exception is the photograph of a pinioned duck on page 76, included specifically to show how to spot a fraud!

More recently these ethical concerns have

White stork in bell tower
Since the stork is traditionally associated with habitation, it seemed appropriate to show a little of its preferred nesting site.

(opposite) **Black-tailed godwit juvenile in late summer**
A 500mm telephoto lens and a hide were necessary for this close-up.

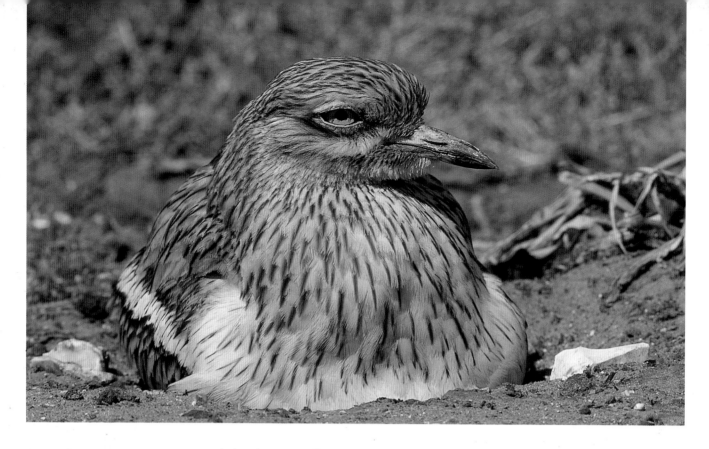

Stone-curlew incubating

Photography of this British rarity at the nest required a Schedule 1 licence from English Nature.

(opposite) Distant gulls over intertidal mudflats

Not all bird photographs have to be frame-fillers to be effective; by exploiting unusual light conditions and paying attention to composition, you can create evocative images of nature. This was taken at the Wash estuary in eastern England.

extended to the potential for deception through the use of digital enhancement and manipulation. Indeed, it is possible to make totally convincing but wholly fabricated images of 'nature' through the computer. This concerns me much less than it used to, as the technology and its application comes of age. The important thing is that there should be no intention to deceive. Quite honestly, I can't feel offended or deceived if an advertiser uses a digital composite to impart some witty message. We all understand the terms of engagement here. So context is everything. In editorial, we expect to be told the truth, and quite rightly so. On the few occasions where news and magazine editors have overstepped the mark in publishing misleading, digitally altered photographic images they have quickly been exposed, and often by the very photographers concerned. The usual response is a hastily amended editorial policy with regard to altered images; after all, the worst thing for them would be to lose credibility with their readers. All in all, I'd rather make my images in camera than in computer, and expect the editors to police their own houses.

I will undertake to declare any digital manipulation on my part, whether in the name of art or otherwise. As far as this book is concerned, none of the images have been in any way modified or enhanced, other than the normal requirements of colour management and print production. Indeed, the great majority are shown full frame without any subsequent cropping, except where this would have seriously compromised the design of the page. But of course, you have no idea what I left out of my composition at the moment the exposure was made – this is potentially the greatest misrepresentation of all! However, most people would see that as an important part of the creative process. Ethics aside, the techniques of manipulating images in computer are not dealt with here. It would take a book on its own, and others are better qualified than I am to write it, so we'll stick to generating bird images from first principles.

Presumably you don't need any persuading as to the beauty and attractiveness of wild birds, or else you wouldn't have got this far. Like me, you would probably rather be outside communing with birds and nature. So now if you don't mind, after several months of being confined to my office writing this book, I need to get out into the field again. You will too, I hope, shortly after you have finished reading. Enjoy. I would wish you 'good luck', but as you know, luck doesn't come into it.

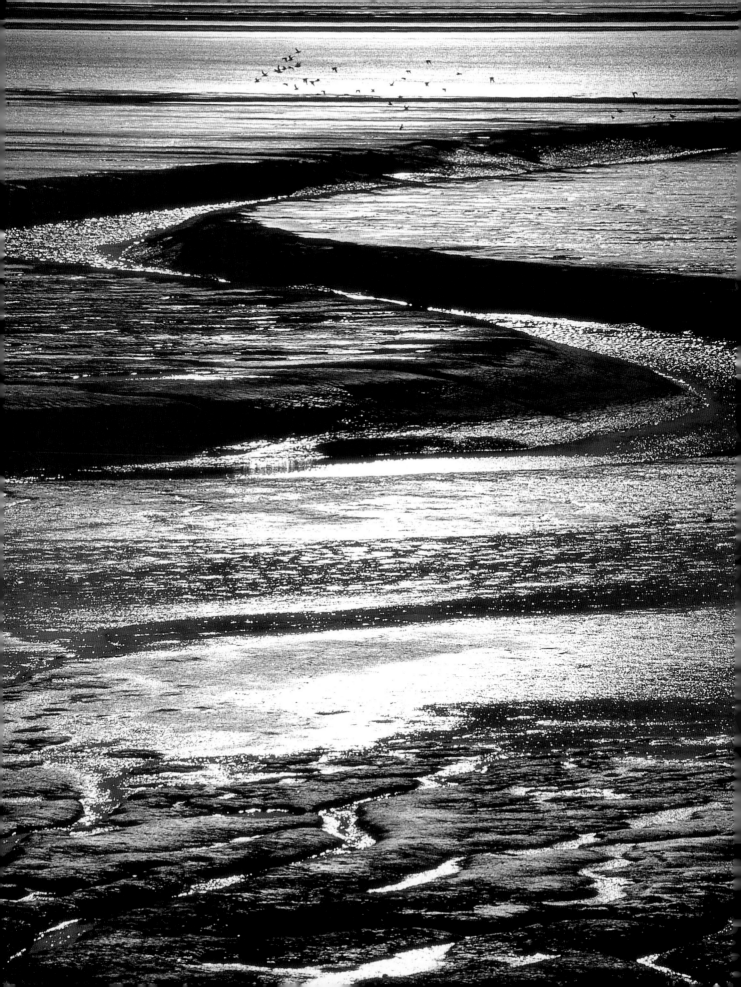

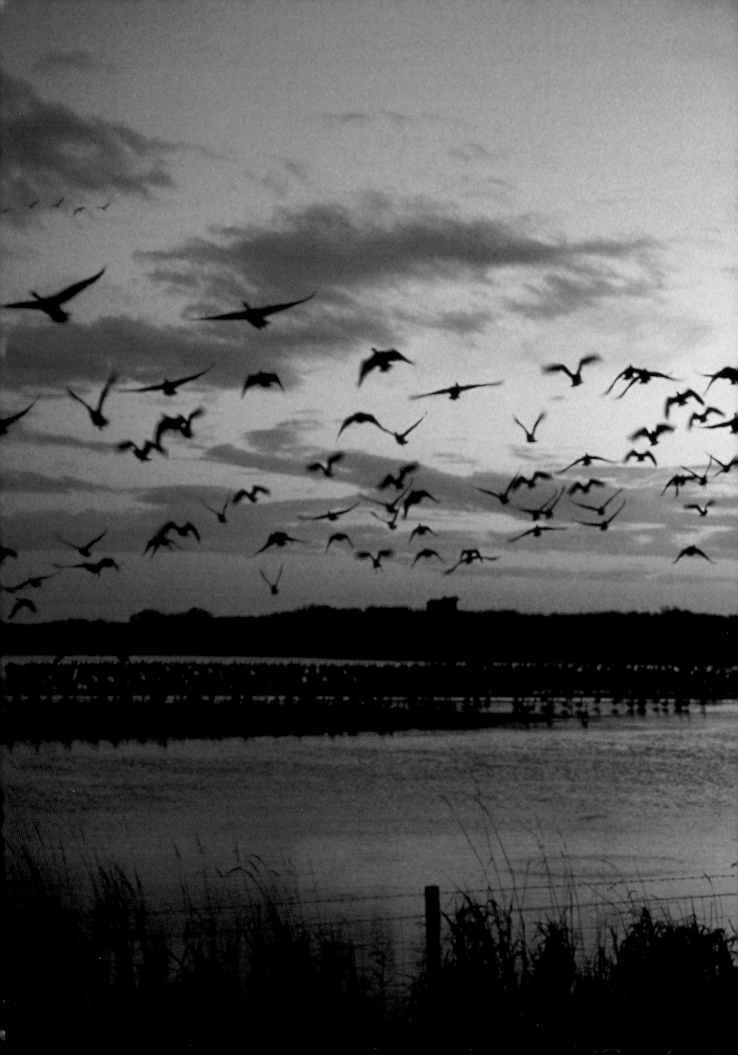

Chapter 1
EQUIPMENT

The image-making process must begin with the
acquisition and understanding of our basic
tools. Here we explore the various types of
cameras, lenses, films and photographic
accessories, their functions, and their specific
relevance to bird photography.

WHERE TO START

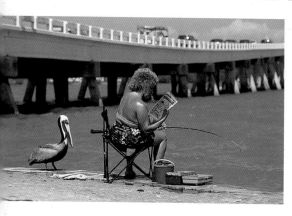

Brown pelican and angler

Do you suppose it needed a special rod to catch this fish? The pelican, photographed at Sanibel Island in Florida, doesn't agree.

Camera: *Nikon F5*

Lens: *50mm f1.4*

Film: *Fujichrome Velvia*

(previous pages) **Dawn flight of pink-footed geese**

Photographed from a hide with a 50mm f1.4 lens, these birds were just leaving their night-time roost.

(opposite) **Avocet and recently hatched chick**

Avocet chicks move away from the nest within a couple of hours of hatching, so I had to plan for this event by estimating the hatch date and carefully maneuvering my floating hide into position over several days. My final camera position was only about 3.5m (11ft) from the birds, but the adult is clearly relaxed about it. Note the egg-tooth still visible on the chick's bill.

Camera: *Nikon F3*

Lens: *300mm f2.8 plus 2x teleconverter*

Film: *Kodachrome 64*

Exposure: *$^1/_{125}$ sec. at f8–11*

Obviously there is a minimum level of equipment required for serious bird photography, and we must all cross that threshold to pursue our interest practically. As a child wanting to take close-up photographs of wild birds and animals, I quickly became aware of the limitations of my Kodak Instamatic 126 camera. I remember being bitterly disappointed on being advised that it couldn't accept a telephoto or zoom lens, and all the more so when I discovered how much it would cost to replace with the recommended 35mm SLR camera system. Happily, what would have cost a lifetime of pocket money in the 1960s is now much more affordable, though it is still a significant investment to most people.

So where should you start? Firstly, how serious is your interest in photography? If you are basically a birdwatcher who wants to keep a pictorial record of birds you have seen, most likely as prints, then possibly a camera adapter for your telescope will best suit your needs. The advantage is that you save on weight, bulk, expense, and many hours of frustration. The disadvantage is that the quality of the photographs is nowhere near as good as with a purpose-built camera lens. A modern variation is the technique of 'digiscoping', whereby a compact digital camera is attached to a large eyepiece telescope. This method delivers huge magnifications and surprisingly clear images when viewed at low resolutions, but it is not suited to action or creative photography.

The next question is, which camera format to choose? Don't professionals usually use medium-format (120) and large-format (4 x 5in or 8 x 10in) cameras? Well, if their interest is mainly in landscape, studio, or portrait photography, then this is certainly true. But film emulsions are so good now, and the portability of equipment so fundamentally important, that 35mm is really the only sensible choice for bird photography. The single-lens reflex (SLR) camera is the basic unit of a modular camera system that allows for interchangeable lenses, including powerful telephotos, and a whole range of other accessories. An SLR is relatively light, versatile and inexpensive, and most importantly for wild bird subjects, quick to use. The 35mm format shall be assumed from here on.

The main manufacturers of 35mm SLR camera systems are Canon, Nikon, Minolta, Pentax, Contax, Leica and Olympus, with the first two being the market leaders for wildlife photographers. Certainly there are great photographers creating beautiful photographs with all of these makes, but it is Nikon and Canon that you see most often in the field. I happen to use Nikon, and wouldn't easily be tempted to switch brands, because it does the job well and I am familiar with the layout and handling. However, I am pretty sure that if I'd got used to the Canon system I'd probably feel the same about that. Most objective critics reckon that Nikon have the superior camera bodies and light metering, while Canon have the more advanced lenses. But don't get too hung up about owning the "right" gear, just make sure you know how to get the best out of whatever you have.

If you can rent or borrow equipment for a proper trial before you buy, so much the better. You will want to be assured that the camera feels right, that the key controls are accessible and intuitive to use, and that it is well-built and reliable. Lenses need to be similarly well-constructed, easy to focus, and in balance with the camera. More than anything, you will want to see some results and check out how the equipment performs for you.

Contemporary cameras can be pretty intimidating at first, but as with a computer there is nearly always more than one method of achieving what you want – you just need to get familiar with the layout and functions, choose which suit you best, and gain confidence in using them. Using your camera system must become a more or less automatic response, and this can only be achieved through practice.

As well as camera and lenses, your basic kit will need to include a tripod, accessories like flash and cable release, and a backpack or

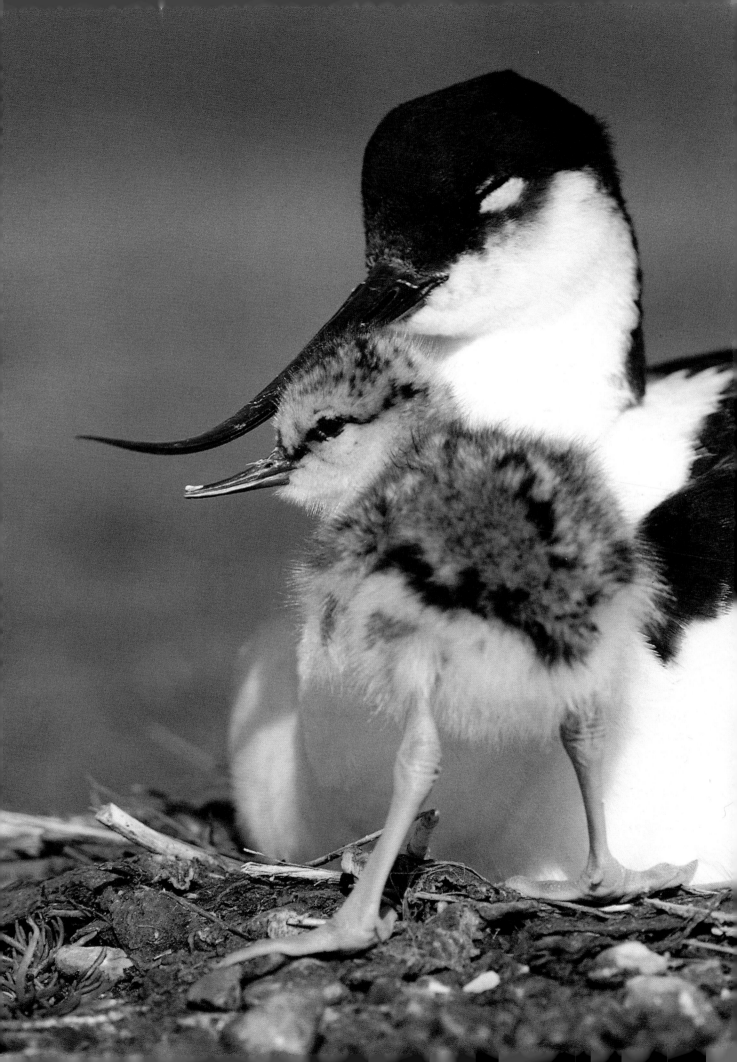

holdall for carrying it all about in. If all this is beginning to sound like a bulky and heavy load, well, you are right – and it's a burden you'd better prepare for, or else reconsider your interests. Round shoulders and an aching back seem to go with the territory. Just as new weight-saving innovations come along and cameras and lenses should become lighter and more compact, there always seems to be some new, vital facility that adds to the overall mass again.

CAMERAS

Before you get into all of the gadgets, and electronic and technical considerations of a camera, first try to weigh it up in terms of its general design and ergonomics. Does it feel comfortable in your hands, both horizontally and vertically? Can you reach and operate all the key controls without taking your eye from the viewfinder? Does your nose get in the way when you try to look through it? Such basic things as whether you are a right- or left-eye viewer, or whether you wear spectacles suddenly become highly significant. What about the lens mount – which bayonet system is employed, and is it back-compatible with any lenses you may already have? How heavy is the camera, and is there a central tripod mount? And crucially, can your fingers negotiate the buttons and dials? Remember that you will sometimes need to be able to work all of this with cold hands, through gloves.

Construction

Generally speaking, the more you pay, the more likely it is that a camera body will be strong and durable, resistant to dust and moisture, and fundamentally suited to the rigours of outdoor work. You will want to be confident that it can withstand the occasional knock, and you can't afford to worry about the odd shower of rain, although hazards like salt spray, blowing sand and prolonged periods of high humidity will always demand extra precautions. The point is, you mustn't be so concerned about cossetting your equipment that you never take it out and use it.

Noise is an important consideration. Motordrive, mirror and shutter noise can be disturbing to bird subjects up close, but most birds habituate to moderate sound pretty quickly. Nevertheless, you may as well try to get something as smooth and quiet as possible: a soft, purring camera is so much more reassuring.

Examining the camera a little more closely, look for the essential details such as a depth-of-field preview button. Amazingly, there are still cameras being made that don't offer this basic facility, but it is an essential requirement. There should be a flash hot-shoe, and maybe even a PC (power cord) socket for using independent or older types of flash gun. What about a film cassette window? This simple provision is so useful, letting you check at a glance whether you have film loaded, what type it is and its nominal speed.

Buy the best you can afford, with a good guarantee. I wouldn't advise buying a second-hand camera body other than through an authorized dealer, as they are much too complex to assess at a glance. And remember that manufacturers' guarantees will be invalid if you purchase equipment through unauthorized 'grey' importers.

Power supply

Just about every function on a modern SLR camera is electrically powered, with film advance, autofocus and image stabilization being particularly power hungry. All of these energy demands become greater at low temperatures; batteries need to be changed more frequently, and some camera functions may cease altogether in particularly severe cold.

The main choice to be made is between disposable and rechargeable batteries. Disposables are the most convenient. You don't have to have access to a mains supply for recharging, and if you can utilize standard sizes, such as AA, you should be able to find these for sale pretty well anywhere in the world. Alkaline AA batteries are the cheapest and most widely available, while lithium cells are 30 per cent lighter and last about three times as long, as well as being more reliable in cold weather.

Rechargeable batteries are clearly the greener option. Nickel-cadmium (Ni-Cd) have

David Tipling

Emperor penguins, Weddell Sea, Antarctica

The Antarctic is becoming increasingly accessible to photographers, with a wealth of organized tours to choose from. But to catch the end of the emperor penguin breeding season, David Tipling had to join a special expedition a month or so earlier than usual, before the sea ice broke up. David gives us some tips based on his experience there:

‘ During a month-long camping expedition to the Antarctic, I worked in temperatures that varied from just above freezing down to an incredible –55 °C (–67 °F); combined with a strong wind, this made for a formidable wind-chill effect. I was relieved that my Nikon F5 performed admirably throughout, particularly when used with the Ni-MH rechargeable power packs, which I found lasted much longer than lithium batteries. Spare power packs were stored inside my jacket to keep them warm. Other necessary precautions included refraining from breathing over lenses or viewfinders, and not bringing camera equipment into warm tents and vehicles, to prevent

condensation becoming a problem. And of course, it was important not to use liquid solutions for cleaning lenses as they would have frozen immediately.

I also had a Fuji 6 x 17cm panoramic camera with me – a format that seemed to suit the wide-open spaces of this pristine wilderness – and I used this for the photograph you see here. As I was walking across the ice to keep up with the line of penguins, a tripod wouldn't have been practical, so I hand-held the camera with its 90mm lens at $1/60$ sec. With only four frames per roll of 120 film (I used Fujichrome Velvia exclusively), I had to compose and shoot discerningly as frostbite was a real danger when reloading; you could take your gloves off for a maximum of only 30 seconds at a time, and the brittle film had to be wound on very slowly and carefully. There were no electrical problems with the panoramic camera either, though it has no built-in lightmeter or motordrive and requires only a small alkaline battery to operate the electro-magnetic shutter, and this has a manual back-up facility. This photograph was taken at about 11 o'clock at 'night'. During the day at the penguin rookery I spot-metered off the grey chicks with my Nikon F5, but for this shot the exposure would have been estimated, based on readings from previous evenings. ’

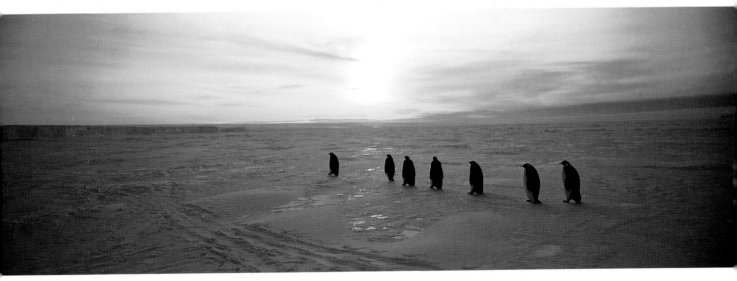

been the commonest type until recently, but the AAs hold less than half the charge of their alkaline equivalent. They should be discharged fully before recharging, otherwise they will not 'top up' properly and you'll notice fewer and fewer films going through the camera between battery changes. Nickel metal hydride (Ni-MH) rechargeables are much the better option, as they can pack up to 100 per cent more charge than Ni-Cds, perform better in

the cold, and can be fully recharged every time without discharging first.

Battery failure is the most common cause of camera malfunction. If you are experiencing a problem with your camera, always try replacing batteries before looking elsewhere. You may need to do this more than once to be sure, as your new set could have one or more duds. The moral is: always carry plenty of spare batteries in your field kit.

Film transport

The long-serving manual lever wind has now pretty well disappeared and been replaced with the power winder or motordrive. So every time you press the shutter, an exposure is made and the film is automatically advanced to the next frame, with the mirror reset and shutter cocked ready for your next exposure. You will probably have a choice of single-frame or continuous-frame film advance, and maybe some variation in speed. In continuous mode, the maximum speed could be as fast as eight or ten frames per second on a standard camera body. Keep the shutter depressed, and a whole 36-exposure film can be gobbled up inside 4 seconds. This might be more useful than you would first imagine. You can wait all day for some interesting bird behaviour to occur, only for it to be all over in a couple of seconds. At other times, you can shoot roll after roll of action on the continuous high-speed setting, to discover afterwards that only one or two frames have the bird in just the position you want. Even with static subjects, the continuous high-speed drive is very useful for making 'in-camera duplicates', which will be of higher quality and cheaper than second-generation copies derived at a later date. So

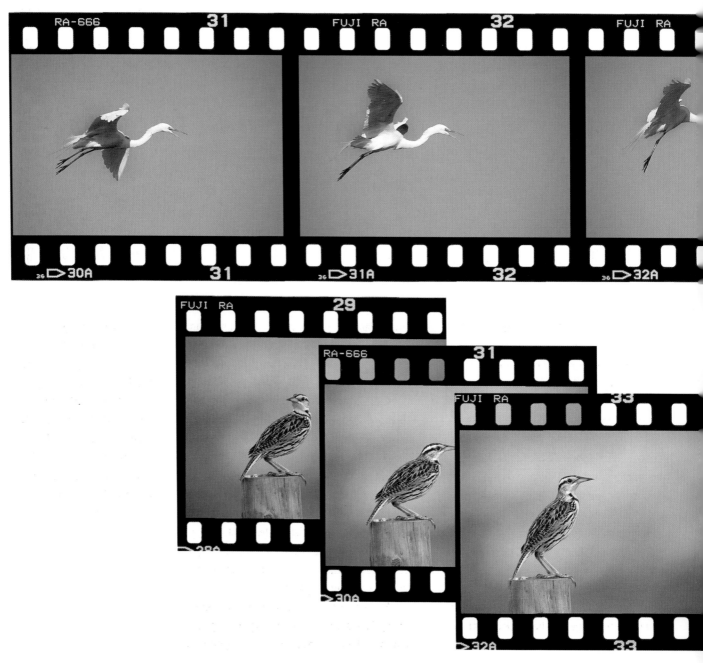

take advantage of the faster drives, and regard your film consumption as an investment.

Automatic film-loading is quite a bonus – you just need to lay the film leader over the take-up spool, close the back, and the film advances to the first frame. Motorized film rewind will also rewind film into its cassette, sometimes automatically after you expose the last frame, and this can gain precious time when reloading. How fast is it, and how quiet? Can you still rewind manually if you want to, to save on battery power or keep noise to a minimum with a sensitive subject? Can you rewind from any point in the film? There may

rarely have time to think about such a subtle difference with moving birds.

Viewfinder information displays tell you about your camera settings via a series of LEDs or LCDs. Are you able to read these easily, and is there any information you would like to have that isn't there? For instance, you don't always get a check of the frame number in the viewfinder, or you might not be able to see the exposure compensation selected, both of which I would say are essential requirements. There should also be some method of viewfinder illumination, and you need only to try to use your camera in a dark hide to

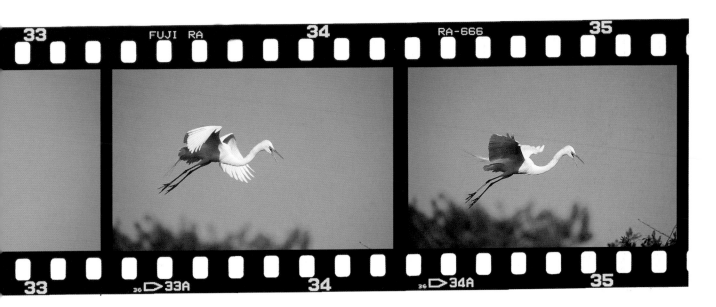

be a custom function that lets you leave the film leader out of the cassette (useful for partially exposed film you may want to finish another time), but be careful as there is a danger here that you could confuse exposed and unexposed films.

Viewfinder and pentaprism
The pentaprism is the optical array inside the viewfinder, which makes it work, in combination with the reflex mirror, and lets you see just what the lens sees. Or a good proportion of it. Some viewfinders give close to a 100 per cent representation of the final exposed frame, some a little less, and both types have their advantages. You will need to know what coverage you have for critical framing of your portraits, though you will

appreciate the importance of this. Is the light easily switched on when you need it?

Image brightness is crucial for fast and accurate framing and focusing. For this reason, it used to be important to be able to change the ground-glass focusing screen to give a crisper image when working with long-focus lenses, but most modern cameras now come equipped with clear, bright screens. If you're using an older model that has a split-image or microprism-type focusing screen, it will black out with longer focal length lenses, so do try to exchange it for a plain matte version, ensuring that the replacement will preserve correct metering displays.

Some cameras have an eyepiece shutter (or blind). This is used for eliminating stray light that would otherwise affect exposure when your

Continuous shooting
Use your motordrive in continuous high-speed mode not only for action sequences (great egret, above) but also to make in-camera duplicates of static but co-operative subjects while you can (eastern meadowlark, left). I was shooting at eight frames per second in both cases.
Camera: *Nikon F5*

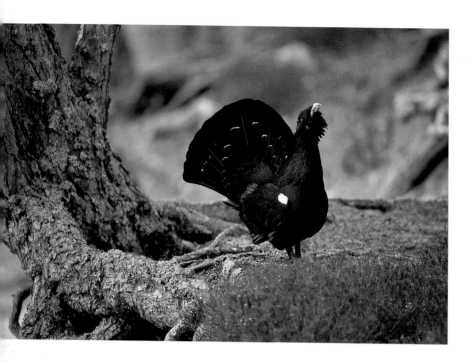

Male capercaillie at lek
Exposure time for this early-morning shot in the forest was $1/8$ sec., even with my 500mm lens wide open at f4, and uprating Fujichrome Sensia 100 film by 1 stop. To overcome camera shake, which would otherwise have resulted at this slow speed, it was necessary to use a cable release and lock up the reflex mirror.
Camera: *Nikon F5*

eye is away from the viewfinder, for example when using a cable release or remote-control apparatus, but it is easy enough to shield it in other ways. Spectacle wearers will appreciate a viewfinder with built-in dioptre correction, and an accessory soft rubber eyepiece.

Reflex mirror

The mirror reflects light from the lens up through the pentaprism, and is flipped out of the way immediately prior to exposure to allow light through the shutter to the film. It has to be reset at the end of the exposure to let you resume viewing. So you can imagine that this has to work pretty fast with motordrives working at up to eight or ten frames per second. Impressive as this is, there is an important down side to mirror vibration (also called 'mirror slap'), as it is a major cause of camera shake and consequent non-sharp pictures, particularly at shutter speeds around $1/8$ sec. and $1/15$ sec. Mirror vibration can be overcome through the provision of a mirror lock-up facility, although as a result you lose the ability to see through the viewfinder, so it is only really viable with stationary subjects. You also lose autometering and autofocus functions with the mirror out of commission, so it is a slow and cumbersome operation – but effective. Not many cameras have mirror lock-up. Those that do are sometimes complicated to set, and may not allow multiple exposures with the

mirror locked up. Mirror damping is improving all the time, but image-stabilization technology may well be the long-term answer to this age-old problem, precluding the need for mirror lock-up altogether.

Shutter

The shutter opens to allow light from the lens to expose the film, so that the longer the shutter is open, the more light enters the camera. Doubling or halving the shutter speed is said to increase or decrease the exposure by 1 'stop'. Faster shutter speeds 'freeze' motion, while slower shutter speeds tend to blur it. These are absolutely fundamental concepts to be grasped, regardless of whether you choose to use automatic or manual exposure modes.

To overcome blur caused by camera shake, most people will need to use a shutter speed of $1/60$ sec. or faster when hand-holding a camera fitted with a standard (50mm) lens. Longer focal length lenses will magnify camera shake as well as image size, so your shutter speed needs to be faster. The rule of thumb for hand-holding is that your shutter speed should not fall below the reciprocal of the lens focal length in millimetres ($1/200$ sec. with a 200mm lens, $1/500$ sec. with a 500mm lens and so on). You can get better at hand-holding with practice. If you are using a tripod, you can afford to shoot slower with the same lens, and slower still with a cable release – $1/125$ sec. for a 500mm lens ought to be sufficient, but again you can improve this with care and practice. Much depends on the sturdiness of your tripod.

Overcoming blur caused by subject movement depends on how fast the subject is moving. A preening bird might well be arrested on film at $1/125$ sec., but to render the wing tips sharp and all the feathers well defined on a fast-flying songbird might easily need $1/2,000$ sec. Usually I would try for a shutter speed of at least $1/250$ sec. to feel confident if there is the slightest subject movement, and for larger birds in flight I would hope for about $1/1,000$ sec. Of course, blurs in the right places can be a good thing, adding to the impression of movement in a photograph. In practice, there often isn't sufficient light to allow shutter

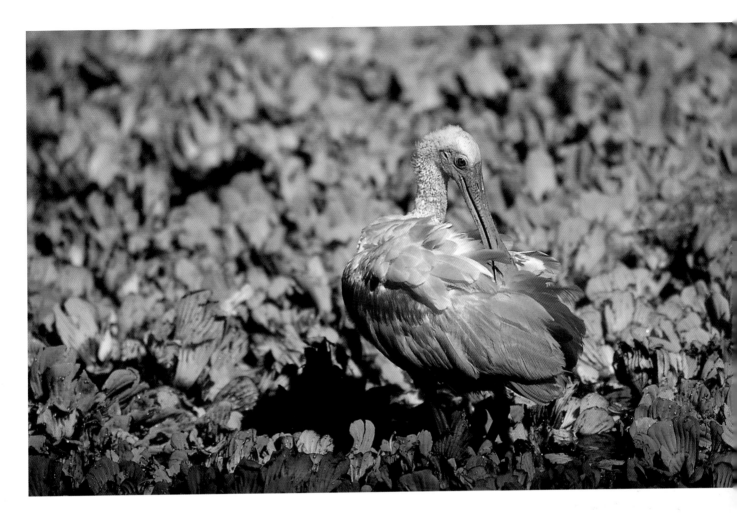

speeds faster than $^1/_{2,000}$ sec. and flash is employed instead, and in this circumstance the flash duration is the determining factor rather than the shutter speed.

The most useful range of shutter speeds to a bird photographer is something like $^1/_8$ sec. to $^1/_{2,000}$ sec. Most cameras now offer at least this range, with a B setting as well (when the shutter stays open for as long as the button remains depressed).

Potentially more important is the fine control you are able to exercise over shutter speeds within the range. Until quite recently, the shutter speed series used to go up in whole stops: $^1/_{60}$ sec., $^1/_{125}$ sec., $^1/_{250}$ sec. and so on. Now many cameras allow $^1/_2$ or $^1/_3$ of a stop increments. This is of great significance when you are shooting 'wide open' (with the aperture as open as possible) and trying to get the fastest possible shutter speed; changing from $^1/_{1,000}$ sec. at f4 to $^1/_{800}$ sec. at f4 is so much more useful than having to suddenly switch to $^1/_{500}$ sec. Find out whether you have the option of selecting shutter speeds by a $^1/_2$

or $^1/_3$ of a stop. It is easier to think in $^1/_3$-stop steps, since film speeds are also described in a $^1/_3$-stop series (25, 32, 40, 50, 64, 80, 100, 125, 160, 200, 250, 320, 400, 500, 640, 800, 1000 and so on).

The shutter-release button itself is usually thoughtfully located right where your index finger wants to go (if you are right-handed). Sometimes you get an extra button on the side to facilitate shooting in the upright position – this should have a lock to prevent accidental firing. In addition to the shutter-release buttons, it is vital that you are able to trigger the camera shutter via a cable release to reduce camera shake. Almost certainly the cable release will be an electrical device, but some cameras also have a socket for the older mechanical type. Frankly, although they're more expensive, the electrical ones are more reliable as well as being more versatile in that they lend themselves better to remote triggering devices.

Advances in shutter design have also allowed the normal flash synchronization

Roseate spoonbill preening
The most usual cause of blurred photographs is camera shake. With a telephoto fitted, you should be looking for shutter speeds of at least $^1/_{250}$ sec. to avoid this hazard and allow for moderate subject movement (such as a bird preening or walking slowly). As light was not a limiting factor here, I opted for $^1/_{500}$ sec. to be sure. Naturally the lens was mounted on a tripod.
Camera: *Nikon F5*
Lens: *300mm f2.8 plus 2x teleconverter*
Film: *Fujichrome Sensia 100*
Exposure: *$^1/_{500}$ sec. at f8*

speed to increase from $^1/_{60}$ sec. to $^1/_{250}$ sec. This is welcome because it gives more flexibility when photographing with daylight-balanced fill flash, and minimizes ghosting effects (where two images are recorded on the film from the respective, simultaneous daylight and flash exposures).

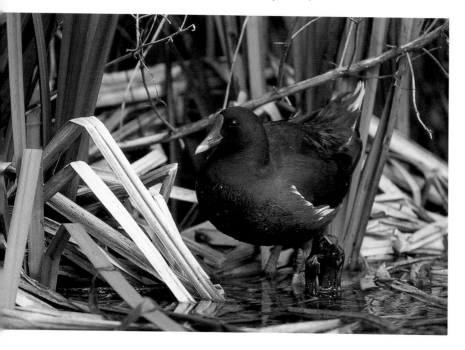

Moorhen amongst reedmace

Multi-segment 'matrix' metering has successfully calculated this exposure, because there is an even balance of light and dark tones throughout the scene. Selecting a centre-weighted pattern might well have resulted in over-exposure because it would have been biased to the central, dark subject.

Camera: *Nikon F5*

Lens: *500mm f4*

Film: *Fujichrome Sensia 100*

Metering system

The range of through-the-lens (TTL) light-metering modes on a modern camera is perhaps the most bewildering aspect to a novice. Firstly, there is usually a choice of metering pattern: where on the film format you want the meter actually to measure the light. Then you will have a choice of various automatic and programme modes to set exposure, with a given metering pattern, in any permutation. Somewhere among all this there needs to be a good, old-fashioned manual setting – you may not think so at first, but this will be vital to your success in accurately and consistently determining exposure.

To deal with metering pattern first: the time-honoured method of measuring light in the camera is the **centre-weighted pattern**, which as the name implies gives most emphasis to the area in the centre of your view, predicting that this is where your subject is likely to be. Typically, about 75 per cent of the meter's sensitivity is assigned to a 12mm ($^1/_2$in) diameter centre circle, with about 25

per cent outside the circle. Some centre-weighted systems are further biased to the lower part of the frame, in an effort to exclude the influence of bright sky. This is a useful and reliable work-a-day system, but will be fooled by non 'standard' lighting situations such as strong backlight, for example.

A more sophisticated version of this is the **multi-segmented metering pattern** (Canon's 'evaluative' metering, Nikon's 'matrix' metering), where a large number of light sensors simultaneously measure light across the whole scene and interpret the results through a set of pre-programmed algorithms, to deliver a 'smart' exposure value prediction. Multi-segmented metering will try to take account of more complex lighting situations, and what it is you're trying to do, with varying success. These multi-segmented patterns are probably accurate more often than the centre-weighted system, but they are certainly not infallible. And they will work only with the designated lenses, which possess a built-in electronic chip to process the information and set the correct lens aperture.

Often, you will see the same light reading with both centre-weighted and multi-segment metering, but there can be significant variations – try metering a scene with a bright sky filling exactly half of the picture to see an immediate difference between the two. Good advice would be to get used to using one or other of the centre-weighted or matrix metering patterns, and keep it as your default; constantly switching between the two is bound to confuse matters.

Spot metering is a very precise method of light measurement, particularly when used in conjunction with telephoto lenses. The sensitive cone is especially narrow, so the active spot might be as little as 1.5 per cent to 2.5 per cent of the frame area. You can see the light reading fluctuate dramatically as you track the lens across a scene in this setting. Spot metering can be very useful in bird photography, but meter readings must be interpreted and applied intelligently. It is therefore a bit slower to use in practice, requiring more thought as well as co-operative subjects. The better spot-metering systems

sensibly allow the metering spot to coincide with the active autofocus area.

Partial metering is a system exclusive to Canon, and is an expanded version of spot metering with a sensitive central spot of about 8.5 per cent of the frame area.

Program-metering modes (usually designated P, sometimes mysteriously 'green rectangle') are superficially attractive, inviting you to abdicate all responsibility for metering decisions. Both shutter speed and lens aperture are selected on your behalf. Variations within the program mode can tip the emphasis in favour of a faster shutter speed or a smaller aperture; but none of these program settings give you anywhere near enough control. Spurn them – not that you'll be able to buy a new camera without them fitted.

Automatic metering is commonly separated into aperture priority and shutter-speed priority modes. The former allows you to select your preferred lens aperture and automatically sets the shutter speed according to the current meter reading. The latter lets you choose your preferred shutter speed and automatically sets the appropriate aperture. Aperture priority automatic is the most useful in bird photography, as you so often want to select the widest aperture to obtain the fastest available shutter speed. An automatic exposure lock (AE lock) is normally provided so that you can maintain an exposure setting when recomposing. For instance, you can lock in a light reading off the ground to then photograph a bird in flight overhead, in order to prevent the meter being fooled by a bright sky background.

Finally, the **manual-metering** mode, while being the simplest and most straightforward, is absolutely indispensable. Make sure you have it. In manual, you set both lens aperture and shutter speed by reference to the lightmeter reading. It is best to have a clear analogue scale to read from, so you can instantly see both the lightmeter reading and your selected setting, and how they relate to one another. The lightmetering scale is deficient, in my opinion, if you can't see at least 2 full stops either side of the median. As with shutter-speed settings, it is distinctly advantageous to

be able to read and set $^1/_2$ a stop, or better still $^1/_3$ of a stop, aperture values.

An **exposure-compensation dial** is a vital facility; it is used in conjunction with the automatic metering mode to make subtle but important adjustments to the automatically selected exposure. You should be able to add

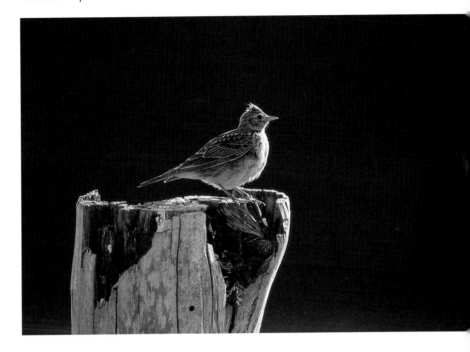

or subtract light relative to the automatic exposure setting, using your experience and judgement, up to about 2 stops either side of the median. Again, this should be broken down in $^1/_2$-stop or $^1/_3$-stop increments.

Film speed setting has an important bearing on metering methods. The DX facility automatically selects the film speed on the camera by reading a pattern on the film cassette. It is best if you have a full manual override to the DX setting, so that you have more flexibility when 'pushing' films, for example; setting the film speed manually leaves your exposure compensation dial free for its more usual purpose. In any case, I have known the DX facility to be unreliable and occasionally register spurious film speeds with consequent bad exposures.

Automatic daylight-balanced fill flash is one of the great brain-saving features of modern metering systems, in combination with intelligent, electronic flash. Camera, lens and flash communicate with each other, and the camera's CPU (central processing unit, or

Skylark in evening light
No automatic metering system would be able to interpret this scene and expose correctly as shown, without some intervention by the photographer. The dark background would be too strong an influence. For this reason, you need to have an exposure-compensation dial to override the automatic exposure or, better still, a manual-metering mode with spot-metering capability.
Camera: Nikon F5
Lens: 500mm f4 plus 1.4x teleconverter
Film: Fujichrome Sensia 100 uprated to EI200

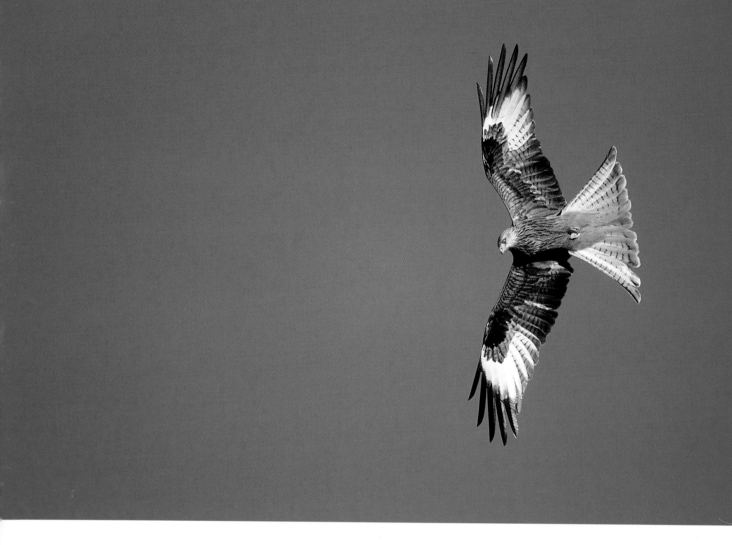

Adult red kite

Autofocus is of great benefit in action and flight photography, and the better modern cameras allow for off-centre subject placement. The Nikon F5 used here has five active AF brackets arranged in a diagonal cross, while the Canon EOS3 and EOS1V have up to 45 selectable AF points.

Lens: *AF-S Nikkor 500mm f4*
Film: *Fujichrome Sensia 100 uprated to EI200*
Exposure: *¹/₁,₂₅₀ sec. at f4*

computer chip) balances measured ambient light with an automatically selected flash setting to deliver perfect fill flash exposures. Photographs have a natural light appearance with the flash barely noticeable, but all the shadow detail is now miraculously illuminated while preserving its tonal value.

Another modern refinement is **autoexposure bracketing**, whereby 'bracketed' exposure values above and below the average meter reading are automatically selected, allowing you to hedge your bets. Custom functions normally let you select the number, order and size of bracketed exposures. This is probably of limited value in bird photography, but if you think you might take advantage of it, investigate whether AEB is available with all film advance settings.

Autofocus systems

To take advantage of autofocus (AF) lenses, you must have an autofocus-capable camera. That will include almost all cameras on the

market today, although autofocus systems vary in speed and sophistication. Look for a system that offers predictive AF or focus tracking, designed to keep pace with a moving subject and predict precisely where it will be when the exposure is made. This is a tremendous asset for photographing birds in flight, especially in combination with a fast motordrive, although it has to be said that such systems are fallible, and all will struggle with a fast-flying bird moving directly towards the camera. So far.

Canon have certainly been the pace-setters in autofocus technology, having developed the first really fast and reliable system, although the other makes now seem to have caught up. Before the Nikon AF-S (or 'silent wave') lenses were available, I had never been persuaded of the advantages of AF. It simply wasn't good enough to be worth the extra expense. But I was appreciative of the AF functions of the Nikon F4, and subsequent models, which gave me a focus confirmation light in the viewfinder even with

my manual focus lenses. This is very useful when your eyes are tired during a long hide session, or when using extremely long focal lengths with the depth of field so narrow and critical. So it's still very useful when using newer AF lenses in manual mode. It even tells you in which direction to focus – good news for all the over-40s.

There are generally single servo (one-shot) and continuous servo (AI servo) AF modes, so you can elect for the shutter to fire only when there is a positive focus check (single servo), or to allow continuous firing even if the AF is still hunting (continuous servo). Both of these will be valuable at different times and with different kinds of subject.

Earlier autofocus cameras had only a single, central, active area for autofocusing. This hardly lent itself to creative composition. Then came selectable AF areas, permitting off-centre subject placement. The Canon EOS3 and EOS1V now offer a staggering 45 AF areas grouped in an ellipse, although you can opt for fewer to improve selection speed. With systems that offer multiple AF areas, you may have the option of dynamic AF, and this is well worth having. Dynamic AF detects a moving subject and automatically selects the appropriate AF bracket or cross-hair, so this does expand your possibilities considerably. Use dynamic AF in combination with focus tracking in continuous servo mode, and you really do have a powerful system. Sometimes, selecting a slightly slower motordrive speed (say, six frames per second instead of eight frames per second) helps to keep it keen and effective.

The Canon EOS3 and EOS5 cameras even incorporate advanced eye-controlled autofocus where the camera can detect what you are looking at and focus on it automatically; an awesome prospect, but not always fully effective in field situations. It does give us some indication of where things are going, however, and how further exciting advances can be expected within the realm of autofocus; see also p.31.

LENSES

Having selected a camera body, you will need to think about a lens or two to go with it. Ultimately, you will probably want a range of lenses to do different jobs, but don't be disheartened if you can't afford a full set of glassware in the beginning. It is the lens more than anything that will determine the final quality of the photograph, so have fewer better quality lenses rather than many cheap ones, and plan to build your system over time.

How lenses work

Lenses focus reflected light from an object on to the film plane in the camera. In simple terms, the distance between the lens and the focused image (on the film) is called the focal length of the lens. In practice, camera lenses are made up of several lens elements so they don't have to be physically as long as their nominal focal length. Lenses of longer focal lengths (telephoto) magnify the image, while lenses of shorter focal lengths (wide-angle) make things appear further away. It follows that the angle of view of a lens decreases as focal length increases, and this has an impact on perspective. So with telephotos you have a foreshortening effect and a flatter, more two-dimensional looking subject, while wide-angle lenses tend to extend perspective and distort the shape of objects close to. These characteristics influence our choice of lens, and how we use them.

Approximate picture-taking angle of different lenses:

Lens focal length	Angle
20mm	94 degrees
28mm	74 degrees
50mm	45 degrees
135mm	18 degrees
300mm	8 degrees
500mm	5 degrees

The iris diaphragm in a camera lens controls its aperture or opening, and thereby the amount of light reaching the film (in combination with the camera shutter). These apertures are described by a number called an f-stop or

f-value, with the larger apertures having a smaller f-value. The f-stop progression on lenses follows a conventional sequence: 1.4, 2, 2.8, 4, 5.6, 8, 11, 16, 22, 32. Moving up or down between adjacent f-stops in this series either halves or doubles the amount of light entering the camera. Hence we refer to a decrease or increase of 1 stop, 2 stops, and so forth. You will remember that the shutter-speed scale on the camera also follows this doubling and halving formula, so that an exposure of $^1/_{125}$ sec. at f8 allows exactly the same amount of light to the film as an exposure of $^1/_{250}$ sec. at f5.6, $^1/_{500}$ sec. at f4, $^1/_{60}$ sec. at f11, or $^1/_{30}$ sec. at f16.

Changing aperture also has an effect on the depth of field (the amount of the final image that is in focus). Photographs taken at smaller apertures (higher f-values) exhibit a greater depth of field, and vice versa. This means that with the same lens and subject distance, more of the scene will be in focus from front to back with an aperture of f16 than at f11 or f8. This effect can be viewed by pressing the depth-of-field preview button on the camera (or lens), which operates the diaphragm, at various apertures, but of course the image will also be dimmer at smaller apertures so the effect can be hard to see. Many lenses have f-values inscribed on the barrel next to the focusing scale, and reference to these lets you work out depth of field more accurately. Note that depth of field extends further beyond the point of focus than in front of it, and this has relevance for critical focusing, not least when using long telephotos at wider apertures. A 50mm lens focused to 3m (10ft) shows that at f11 the depth of field extends from just over 2m (7ft) to 5m (16ft), not 2m (7ft) to 4m (13ft) as you might have expected. Actually, it is the reproduction ratio of the image that determines depth of field rather than lens focal length, so a bird imaged at 1:10 on the film ($^1/_{10}$ life size) at an aperture of f8, say, will have the same depth of field whether photographed with a distant 500mm or a closer 50mm lens. It is the angle of view and the distance between lens and subject that change. But in practice we think of longer focal length lenses as having a smaller depth of field because of the way we use them.

Lenses are normally defined by their focal length followed by their maximum aperture, thus 50mm f1.8, 400mm f5.6, and so on.

Types of lenses

With a 35mm format camera, the 'standard' lens is considered to be a lens of approximately 50mm focal length. This is roughly similar to the diagonal measurement of the 24 x 36mm film frame, and gives a more or less normal angle of view and perspective, most similar to our everyday perception of the world. However, you would have to be standing very close to a bird to obtain a reasonable image size on the film. Standard lenses are not terribly useful in bird photography therefore, but they are relatively easy to manufacture and produce in bulk, so they are cheap and you may as well have one. They have the highest maximum aperture of all lenses, typically f1.8 or f1.4.

Wide-angle lenses are of shorter focal length than standard lenses (anything less than about 35mm is usually termed wide-angle), have a wider field of view, and record smaller image sizes than a standard lens with the same camera-to-subject distance. They can be used to exaggerate perspective and maximize depth of field in a scene, making them particularly effective for landscape and habitat photography. So although they may not often be suitable for taking bird portraits, they do have particular characteristics that can be exploited from time to time, for example with remote-control bird photography. Since they are quite small and compact, and not too expensive, you would be well advised to have one in your kit. Probably a 24mm or 28mm would be the optimum if you were to buy only one wide-angle.

Now to the main tool. Telephoto lenses have a much longer effective focal length than standard lenses and record a larger image size on the film at the same camera-to-subject distance. In other words, they appear to magnify the scene by a factor equal to the multiple in focal length of the standard 50mm; so that a 300mm lens magnifies about six times, a 400mm about eight times, and so forth. This is beginning to sound more useful, isn't it?

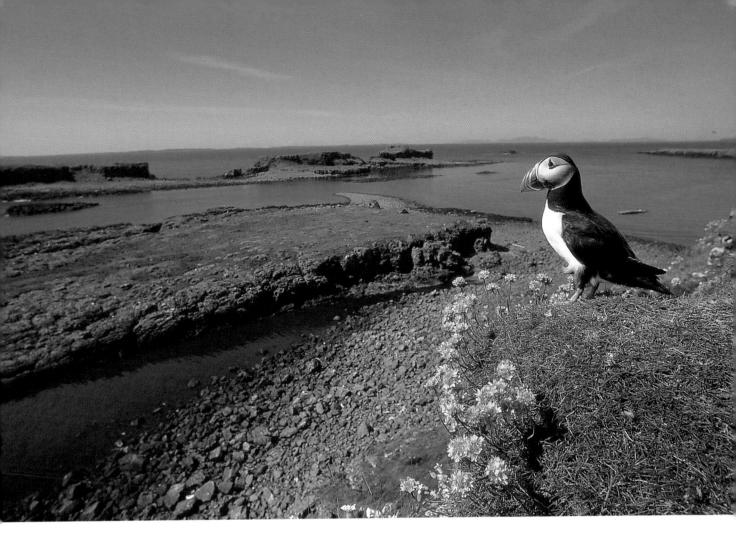

You will certainly need a lens in the telephoto range to be able to undertake any kind of serious bird photography. However, there seems to be a common misconception that all you need is a long telephoto lens, and suddenly you will be able to photograph a wren at the bottom of the garden or a golden eagle on a distant mountain perch. Unfortunately, the reality is somewhat different. You will probably be surprised at just how much work you still have to put in to get close enough to your subject. As the focal length increases, the weight and cost of lenses go up exponentially, and all sorts of other technical difficulties come into play. More light is required to work with the smaller maximum apertures, camera shake becomes a bigger problem than ever, and the depth of field is restrictively narrow. Telephotos of 600mm or longer really do take a bit of experience to be able to use successfully. My own favourite lens is a 500mm f4, which is still quite a weight (3.8kg/8lb) but it fits comfortably in my

backpack and is nothing like so monstrous as the 600mm f4 (5.9kg/13lb), so I'm not too discouraged from lugging it around and using it. Sacrificing 1 stop on the maximum aperture would save you a few thousand pounds and a couple of kilos! I would recommend starting with a telephoto of 400mm f5.6 or perhaps a 500mm as a practical compromise. If you can afford it, by all means go for one of the super telephotos of the type you see at sports events the world over, and you won't be disappointed.

Size, weight and cost are obviously key concerns when purchasing a telephoto. Other considerations will be: closest focusing distance, maximum aperture (or 'speed'), and not least, the type of glass used in construction. This may sound unnecessarily technical, but there are great advantages to be gained in picture definition by going for better quality glass. This is because different wavelengths of light refract by different amounts as they pass each glass/air interface in the lens, so they come to focus at slightly

Atlantic puffin at breeding island

Not too many bird subjects allow such a close approach, but the use of a wide-angle lens in these situations can have quite an impact, allowing you to show both the bird and its habitat in focus.
Camera: Nikon F5
Lens: 20mm f2.8
Film: Fujichrome Sensia 100
Exposure: $^1\!/_{60}$ *sec. at f16*

different positions at the film plane with a resulting loss of sharpness. Such refraction is more pronounced with lenses of greater focal length, but the effect can be minimized by using low-dispersion glass. Such lenses are said to be apochromatic and are variously described as APO, LD, L, ED, fluorite – all meaning basically the same thing. They are of course more expensive than lenses with 'ordinary' glass, but well worth buying if your budget allows.

Telephotos are optimized in their design to work well at wider apertures. This is just as well, because you probably won't often use one at anything other than its widest setting, or perhaps 1 or 2 stops down. The virtue of this is in enabling you to work at the fastest possible shutter speed, minimizing camera shake and subject motion blur. So there is a lot to be gained from having a 'faster' lens with a wider maximum aperture. You will also get a brighter, clearer image in the viewfinder, and faster, more positive focus acquisition (whether manual or autofocus). Another feature of working with wide apertures at long focal lengths is the narrow depth of field, and this can be used to your advantage to make clean, unfussy, out-of-focus backgrounds complement sharply focused subjects. There's no special trick to this, other than being alert to the distance between subject and background, and being prepared to move your camera position a little. But remember, to obtain an extra stop on the maximum aperture of a telephoto means a lot of extra glass and consequently a proportionally heavier, more expensive lens.

Minimum focusing distance varies quite a lot between different makes of lens. Typically, a 300mm lens will focus down to about 2.5m (8ft), and a 500mm down to about 5m (16ft), but you can find better and worse. You're probably thinking that you'd never need to be closer than that to any bird, and chance would be a fine thing. However, a tiny bird like a goldcrest (or kinglet) still only occupies about a quarter of the frame width viewed side on with a 500mm lens at 5m (16ft), so there are times you might wish to be closer. And you might be interested in photographing butterflies as well as birds. So pay close

attention to minimum focusing distance before purchasing, and I would say it should be no more than ten times the focal length of the lens (5m with a 500mm, 6m with a 600mm, and so on). Closer focusing can be achieved by other methods, however (see Teleconverters p.33, and Extension tubes, p.34).

As well as the weight, also check the balance of a telephoto lens when mounted on your camera body, and whether you can easily hand-hold it for flight shots. Make sure that there is a tripod mount on the lens itself, which should be solid, substantial and attached to a rotating collar. How does the lens fit on your tripod head, and is there room for it in your backpack or holdall? Faster lenses should have a drop-in filter drawer to save you buying enormous, impractical and expensive screw-in filters for the front element, and it's even better if these are a standard size, allowing you to redeploy screw-in filters from your shorter lenses. Lens hoods are necessary for preventing flare on your photographs, especially when shooting into the light. Some seem to be unnecessarily long and cumbersome, but may be retractable or removable.

Zoom lenses are those that have a variable focal length, say from 28–80mm or 70–210mm. The change in focal length is achieved either with a push-pull operation of the lens barrel, or a twisting action. With push-pull types, ensure that the zoom mechanism is tight enough to prevent accidental zooming when pointing the lens up or down. With rotating zoom mechanisms, check whether you can cover the whole range of focal lengths without changing hand position.

There are clear attractions to having zoom lenses, not least the convenience of being able to use the zoom facility to quickly frame your subject without having to change camera position. You can also cut down on the number of lenses you need in your outfit and there are obvious benefits for travelling, reducing overall bulk and weight. A mid-range zoom, such as a 28–80mm or thereabouts is a popular alternative to a standard lens, though you'd expect to pay a bit more. Telephoto zooms are particularly advantageous to bird photographers, as you are more flexible when

Hannu Hautala
Whooper swans in flight, Kuusamo, Finland

Hannu Hautala is a master of the slow shutter speed action shot, which characterizes much of his work. He explains how he achieves this special mood in his flight study of two whooper swans:

❛ *This photograph was taken from a hide situated on top of a birdwatching tower. The hide is built specially for photographing birds in flight, and the upper part of the hide,* where the camera is fixed, turns around 360 degrees quite freely with the help of a ball bearing, so it is easier to follow flying birds with a long lens.

In the picture two whooper swans are fighting over nesting territory. The stronger bird drives away the other. I was using a Canon EOS 3 camera and a very long focal length of 1,200mm, by attaching a 2x teleconverter to my 600mm f4L IS-USM lens. The photograph was taken in evening light with the lens at its widest aperture (now f8), using a shutter speed between $^1/_{10}$ sec. and $^1/_{20}$ sec. on automatic exposure. Autofocus and the image stabilizer were very important in trying to get a good shot. ❜

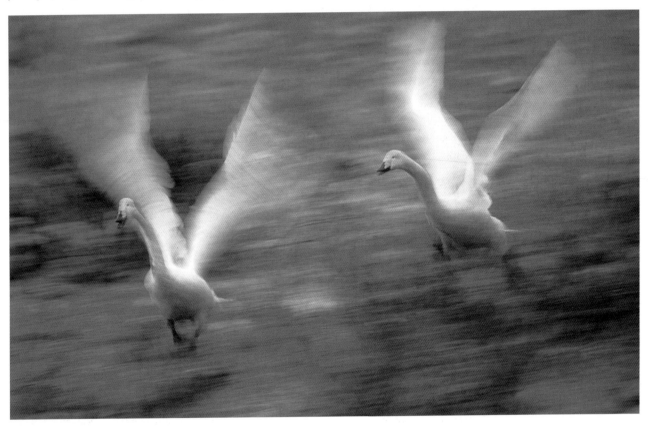

encountering different-sized subjects at different distances than with a prime (fixed-focal length) lens. They can really come into their own when working at close quarters from a hide, as to change a prime lens would almost certainly disturb the bird. Again, check for the presence of a tripod mount on the lens.

This convenience and versatility does carry penalties, however. The construction of zoom lenses calls for the use of more glass elements, and more elements mean that definition is compromised and there is a greater risk of lens flare. Zooms are also prone to optical aberrations at their extreme focal lengths: 'barrel distortion' at the short end (straight lines become convex), and 'pincushion distortion' at the long end (straight lines become concave). But the quality of zoom lenses is improving all the time – a good zoom with low-dispersion glass can have better definition than a prime lens without it. Edge-to-edge sharpness can be a problem with cheaper zooms, and any deficiencies will be most noticeable at the widest apertures. Similarly, 'vignetting' can occur at the wider apertures, giving darker corners to your pictures.

The main disadvantage to bird photographers is that the maximum aperture of a zoom will almost certainly be smaller than that of a prime lens in the range. In addition, it will probably vary according to focal length (known as 'floating' aperture) so you might find it is described as f4.5–5.6 or similar, where the wider aperture will only be available at the shorter focal lengths. You pay more to get a fixed aperture across the whole zoom range, and this generally means sacrificing something on the zoom ratio too, for example with an 80–200mm f2.8.

Good signs in zoom lenses are a fixed maximum aperture and a low-dispersion glass designation. Pound for pound, the equivalent prime lens will still give you better quality pictures at a given focal length.

Macro lenses focus closer than other lenses, and are designed to work best at higher reproduction ratios – usually up to a ratio of 1:2 (subject imaged at $1/2$ life size on the film), sometimes 1:1 (life size) or greater, though this may require the addition of an extension tube. Typical focal lengths for macros are 50mm, 100mm and 200mm, where the longer the focal length the greater the working distance for a given image size. Macro lenses are by no means essential for bird photography, but are useful for close-ups.

Autofocus lenses

Autofocus is now pretty well universal. With shorter lenses, the autofocus function can be driven by a motor in the camera, but with telephotos it is better to have a coreless motor built into the lens, which will give much faster and quieter operation, with less of that tiresome hunting as the lens tries to find and lock on to a subject. Look for 'ultrasonic motor' (USM), 'hypersonic motor' (HSM) or 'silent wave' (AFS) in the lens specification, to stand any real chance of being able to autofocus on a fast-moving bird.

Focus range limiters can assist the speed of autofocus, by setting near and far points for the lens to search. If you are working with a large subject like a heron or bird of prey, you can probably safely restrict the lens to a '10m to infinity' AF range setting. If on the other hand you are focused on a drinking pond close to a hide, you would be better off selecting '5m to 12m' or similar.

AF works on image contrast. It is therefore still difficult to get snappy autofocus (or any autofocus at all) with low contrast scenes. A gull against a featureless, white cloudy sky, for instance, will cause any system to struggle. This is just one of several reasons why you might find it preferable to switch to manual focus. You might just want complete freedom to frame your subject without being confined to designated AF areas. So be sure that you have a complete manual override with easy switching between the two. Operate the lens in its manual mode and see how smoothly and positively it will focus – but don't ever do this while the lens is still in its autofocus setting as you could damage the AF motor. Some lenses have a dual M/A setting, which will allow for both, and the moment you press the shutter-release button, autofocus is reasserted.

With an AF telephoto it is useful if there are focus lock buttons towards the front of the lens – the natural left-hand position for many people when using long lenses – as well as on the camera. Usually there will be four positioned around the lens barrel so you don't have to search too hard for one.

It's worth pointing out that the clamour for these super new autofocus telephotos has led to some great second-hand bargains among the manual and older AF telephotos. Optically these are every bit as good as their modern counterparts, and are well worth considering, especially if you're just wanting to dip your toe in the water.

Image-stabilized lenses

Essentially, image stabilization detects and reduces pitching and yawing movements in a lens, enabling you to obtain sharp pictures at slower shutter speeds than normal, perhaps by as much as 2 or 3 stops. It might mean you can do without a tripod altogether for certain shots, or make do with a smaller maximum aperture lens, or use a slower film. The attractions are obvious, and not surprisingly

such lenses have been greeted with much enthusiasm. The Canon 100–400mm f4.5–5.6 IS zoom is particularly popular, with a Nikon 80–400mm VR (vibration reduction) hot on its heels. For many people this might be the only big lens they ever need – great for trips overseas, great for hand-held flight shots.

IS technology is now being incorporated in a wider range of lenses, particularly the telephotos as you would expect, and looks like an exciting step forward for both bird and wildlife photography. But do remember that IS and VR lenses won't have any effect at all on blurring caused by subject movement!

Teleconverters

A teleconverter (or tele-extender) is a small, accessory lens that fits at the back of the main lens (usually a telephoto), increasing its effective focal length typically by a factor of 1.4x or 2x.

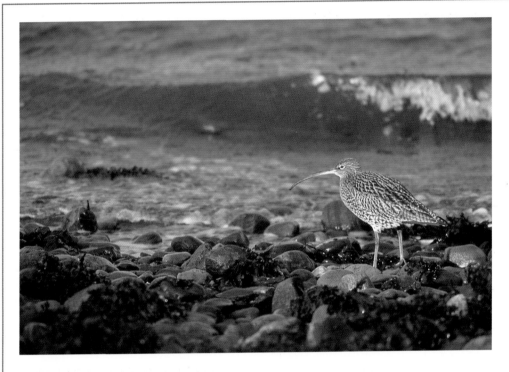

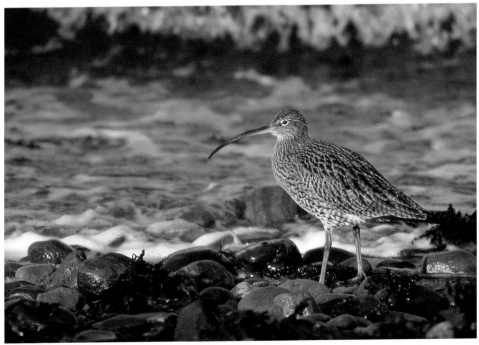

The relative effects of teleconverters
This curlew was photographed at long range from a car window, first with a 1.4x teleconverter (top), then a 2x teleconverter (bottom) fitted to my 500mm lens. The step from 700mm to 1,000mm effective focal length shows a significant improvement in bird image size. I used a beanbag to support the lens and the fastest shutter speed available.
Camera: Nikon F5
Lens: AF-S Nikkor 500mm f4 with TC14-E and TC20-E teleconverters
Film: Fujichrome Sensia 100 uprated to EI200.
Exposure: $^{1}/_{400}$ sec. at f8

There is a corresponding loss of light of 1 stop and 2 stops, respectively. So fitting a 1.4x teleconverter to a 300mm f2.8 lens would give you a 420mm f4 lens, in effect, while a 2x converter would make it a 600mm f5.6.

Teleconverters are a very neat and effective way of extending the capabilities of your main lens. They are certainly a cheaper solution than buying a whole suite of telephotos, and of course you save on weight and bulk. If you are working from a hide, teleconverters give you the ability to add to your focal length without removing your main lens from the tripod, although this is clearly a bit slower than using a zoom in the first place. There is some loss of definition, but this is barely noticeable with matched converters for a defined range of lenses. In this respect, a 1.4x would be a better bet than a 2x. Using a 2x teleconverter on a zoom would perhaps be asking for trouble, but even this is becoming more accepted practice.

It's worth remembering that a teleconverter does not affect the minimum focusing distance of the prime lens to which it is applied, so this brings an additional benefit. Your 300mm f2.8 can be a 600mm f5.6 which focuses down to 2.5m (8ft), with the addition of a 2x converter, instead of the usual 6m (26ft). Indeed, judicious use of teleconverters might influence your choice of telephotos, particularly if you aim to have more than one. A pairing of 300mm and 500mm telephotos for example, with the two teleconverters, can give you a range of 300, 420, 500, 600, 700 and 1,000mm focal lengths, and some useful close-focusing options. This is clearly more versatile than a 300mm and 600mm telephoto pairing.

Ideally, the corrected aperture reading should be displayed in your viewfinder when a teleconverter is fitted. A 300mm lens with a 2x teleconverter set at f4 on the lens will actually have an effective aperture of f8 so it is best to be reminded of this, but TTL metering will expose correctly in any case.

Ensure that your autofocus (and image-stabilization) functions are preserved when adding a teleconverter to a particular lens. Of course, you must use an appropriate AF converter, but even then AF functions can be lost at apertures smaller than f5.6 with some systems. And even if it works, autofocus will slow down as focal length increases and maximum aperture decreases. At focal lengths of 1,000mm or 1,200mm, you shouldn't expect too much of your AF.

Some adventurous photographers even stack their teleconverters on occasions to deliver monster focal lengths in excess of 1,200mm. It has to be said that this is hardly recommended as normal practice, but I have seen some astonishingly good results right up to 2,400mm, and they stand testimony to the tremendous advances in lens design. Nevertheless, expect to waste a few frames trying to get a sharp shot. When stacking converters, attach the 1.4x converter to the camera body first. Canon users must insert a 12mm extension tube between their teleconverters, while Nikon users have to have a slight alteration made to the teleconverter mounts, by filing off a small metal lug – not a service offered or officially approved by Nikon, but you can find reputable service centres who will do the job. This amendment also permits you to use AF teleconverters with your older Nikon lenses, albeit in manual focus.

Extension tubes

An extension tube (or extension ring) fits between camera and lens, but unlike a teleconverter does not have any lens elements of its own. Its effect is to reduce the minimum focusing distance of the lens, but you lose the ability to focus at infinity. Most camera systems have several sizes of extension tube, with a progressive effect on focusing range. As the tube gets longer you can focus closer, but you also lose more light. TTL metering will allow for this small amount of light loss, and an 'automatic' extension tube lets the camera continue to operate the lens diaphragm through exposure. However, not all extension tubes preserve autofocus and full lens communication.

Ensure that extension tubes are compatible with the lenses you are using – some older models can damage the CPU contacts of newer AF lenses. Independent makes of tubes may be cheaper, but are more likely to cause vignetting.

FILTERS

There are not many filters that are practical for use in bird photography. Generally speaking you don't have time to fit one, or at least it's not top of your priorities. You would be well advised to fit a skylight or UV filter to the front of all your lenses, however, if only for protecting the front element; these cut out some of the blue end of the spectrum, with a skylight being ever so slightly 'warmer' than a UV. Neither affects exposure. A 'warming' or straw-coloured filter, such as an 81A or stronger 81B, can be useful for photographing in shade or counteracting the blue light of dusk, and you lose only $1/3$ of a stop with these. This is the only extra filter I would normally carry. At a push, a polarizing filter might come in handy for cutting out glare, but the loss of up to 2 stops is usually too much of a disadvantage. Anyway, as object

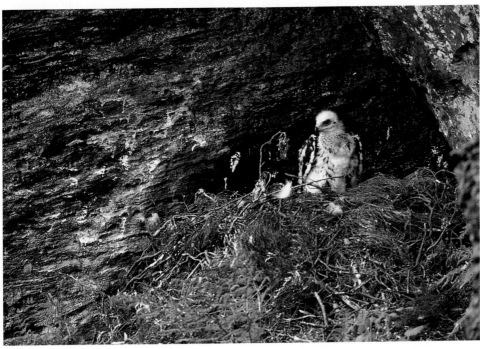

The effect of a warming filter
This golden eagle eyrie was in shade for much of the day, so I decided to use an 81A warming filter to counteract some of the blueness that I knew would result on film, at the expense of $1/3$ of a stop. The top picture shows the scene with a standard skylight filter, while the bottom picture benefits from the 81A warming filter.
Camera: Nikon F5
Lens: 500mm plus 1.4x teleconverter
Film: Fujichrome Sensia 100

lenses and filter thread gauges get larger, polarizing filters become prohibitively expensive, especially if you're going to use them only very occasionally.

With the faster telephotos, a drop-in filter drawer in the narrower part of the lens allows you to use smaller, cheaper and more manageable filters. Your UV or skylight filter would normally be fitted at this position as standard, with a protective clear glass at the big end of the lens.

TRIPODS AND SUPPORTS

A sturdy tripod is an absolutely essential accessory (image stabilization notwithstanding), and generally speaking the heavier the better. You need the inertia of a solid mass to keep everything still and stable to combat camera shake. Most tripods are metal alloy, but carbon fibre is becoming increasingly popular. This does seem to afford strength and stability at relatively low weight, for a price, but there is a great temptation to go too light – I often see photographers with enormous heavy lenses on the flimsiest looking carbon-fibre tripods, which does seem a waste of time and money. If you can't afford the heavier, higher gauge carbon-fibre models, persist with a metal one.

The conventional tripod design is the equilateral triangle type, and this is quite sensible for everyday use and the least likely to blow or topple over. The Benbo or Unilock type is rather more versatile. A single locking bolt allows you to set up in some awkward

spots, low down if you wish, in shallow sea water if necessary, and can be arranged in a way that leaves room for your own legs when used in a hide. So there is much to commend this design, but the smaller sizes are really too light and flimsy for use with large telephotos, especially when the column is extended; its off-centre positioning gives an unbalanced feel to the system.

Centre columns are a bit of a liability altogether, usually preventing you from getting down low to the ground, and introducing unwelcome wobble when extended. You ideally want a tripod that will let you use your camera comfortably in the standing position, without the need for a centre column. If your tripod does have a centre column, adjusting camera position is a lot quicker and easier, but try to leave it down when working with your longer lenses.

Maximum working height and size when folded are important things to look at when selecting a tripod. With more leg sections, there is a greater risk of vibration creeping in, but it will be more compact when folded. Twist grips and locking screws on the legs are slower than latches, but more dependable.

Tripod heads

A tripod on its own is useless without a head. There are several basic designs of tripod head,

Using a tripod

Ideally, you should be able to use a tripod comfortably in both the standing and prone positions. The Gitzo G1548 carbon-fibre tripod is shown in use at near maximum working height (right) and at minimum working height (below).

and all come with their various advantages and disadvantages – you can't seem to get one type that suits every eventuality. Those that give great manoeuvrability don't support larger, heavier lenses so well, and those that have a generous platform and handle for your big telephoto just can't achieve all the positions you need with a shorter lens. It is very much a matter of personal preference.

Three-way pan-and-tilt heads are the most widely available kind of tripod head, and suitable for most types of work. Three locking screws or handles enable head movement in each of the three axes, and there is usually a larger panning handle at the back, which helps you to counterbalance the weight of a long lens. Actually, this handle might just as likely lock and unlock the tilt action, but it also helps to pan the lens from side to side – very useful and reliable for longer lenses. I have a trusted old Gitzo Rationelle #5 low-profile head of this type, and like it for its solidity and its large, secure base with the possibility of two lens fixing points. But the large base and handle are a curse as well as a blessing; they restrict the upwards elevation, and when using a shorter lens without a tripod mount (and the camera body attached to the tripod head), it is difficult to use in the upright shooting position. Gitzo and Manfrotto (Bogen) make a wide selection of pan-and-tilt heads.

Fluid heads are a refinement of the pan-and-tilt type, principally designed for use with film cameras and video camcorders. True fluid heads use a hydraulic oil to dampen movements, so they are especially suitable for the smooth pans required when filming, and you can 'dial in' the amount of resistance you want. This is also appreciated by many stills photographers, not least because it prevents sudden and dangerous movements with valuable long telephotos. Fluid effect tripod heads mimic this kind of action through clever use of springs, making them lighter as well as cheaper. Both types will be 'two-way' heads, meaning you have to level your horizon or change to vertical format by use of the tripod collar on the lens. For this reason, this type of head is appropriate only for longer focal length lenses. Miller and Sachtler are well-known manufacturers of fluid heads, while Manfrotto (Bogen) and Gitzo offer good fluid-effect alternatives. Fluid heads tend to be heavy and expensive.

Ball-and-socket heads have become very popular in recent years. The large monoballs can cover more angles than any other type of head, offer more camera positions, and lock down with a single action, making them quick and positive to use. They are very versatile indeed. Arca Swiss and Foba are the most widely used among wildlife photographers. Arca B1 heads have adjustable tension settings on the ball, and lock with a knurled wheel. Foba opt for an angled lever. Both makes employ quick-release attachments, with various designs of quick-release plate to suit different lenses and camera bodies. You can also obtain a good range of quick-release plates from Kirk Enterprises and Really Right Stuff, for all the main combinations of camera, lens and ball head.

Personally, I find these quick-release plates on all my lenses and camera bodies a real nuisance, as they tend to snag on everything. And while I like to use ball-and-socket heads with shorter lenses, I have serious reservations about using them with long telephotos. When carrying the combined camera and tripod rig over the shoulder, the torque exerted by such a heavy lens tends to unscrew it from the head. Also, the locking wheel or lever easily rubs or catches and unlocks, letting everything swing loose. Most disconcerting! More seriously, the Arca quick-release locking screw only needs a

Different tripod heads
Popular tripod heads for supporting larger telephotos include the Arca Swiss B1 ball-and-socket head (top) and the Gitzo G1570 low-profile three-way pan-and-tilt head (bottom).

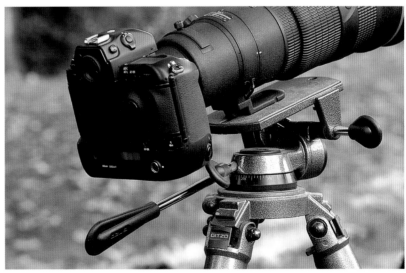

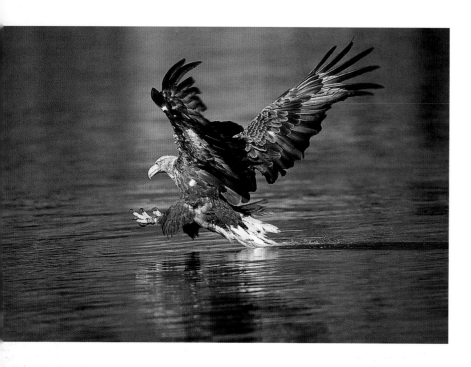

White-tailed eagle stooping
A monopod is useful where a tripod would be too much of an encumbrance, helping to support the weight of a heavy lens while allowing rapid reaction. It is the obvious choice when working from a boat, as on this occasion (see also pp.134–5).
Camera: *Nikon F5*
Lens: *AF-S Nikkor 500mm f4*
Film: *Fujichrome Sensia 100 uprated to EI200*
Exposure: *$^1/_{1,000}$ sec. at f4*

glancing contact to dump your camera and lens on the ground – I've had this happen (but only once!) causing extensive and costly damage. Manfrotto and Gitzo make quick-release systems with a double-action failsafe locking device, which look more trustworthy. Another disadvantage with ball-and-socket heads is that dirt tends to build up inside the mechanism, causing them to become stiff and eventually seize up. They will probably need servicing more often than other types.

Gimbal heads like the Wimberley work very well with longer, heavier lenses such as a 600mm f4. Their unique design makes a big lens feel almost weightless, and enables you to follow a moving subject very easily, even at height. So they are becoming increasingly popular for action and flight photography with the bigger AF lenses. There are two locking positions, for pan-and-tilt actions, with any levelling or change to vertical format realized by rotating the lens in its collar. A 'sidekick' variation in the basic design coupled with an Arca B1 head is a bit lighter and more compact, and quite suitable for lenses up to about 500mm f4 dimensions.

Monopods and other supports

As the name implies, a monopod is a single-leg support. Obviously, it gives less support than a tripod, and can't stand on its own, but a monopod can be very useful when stalking

birds, being quicker to operate than a tripod and giving you a bit more freedom to move about. I find a monopod particularly useful when photographing from boats, if only to take the weight off my arms and wrists. Monopods also double up as walking sticks, if you are treading some distance over rough ground.

Some monopods have an additional shoulder or chest brace to give extra stability. You can fix a small ball-and-socket head if you want more movements, but this can become pretty sloppy and unmanageable, and really you can do quite well by twisting and rocking with the monopod screwed straight on to the tripod mount of the lens.

If you are using a very long focal length lens on a tripod, you might seek additional support for your camera body to prevent too much flexing of the whole system, and a monopod is quite good for this job, too. Of course your subject needs to be fairly static, as it's slow to recompose with everything locked down. You can also get a support brace for this purpose, which attaches between camera body and tripod leg, and gives you a bit more mobility. Manfrotto (Bogen) make one.

There are window clamps and other purpose-built camera supports on the market, and they seem to be the type of gadget that lots of photographers like to design and build for themselves. It always seems over-elaborate to me, but the Groofwin pod from LL Rue is highly rated by others.

Beanbags

Beanbags are really quite the most practical, inexpensive and simple camera supports. No moving parts, nothing to go wrong! Sling them on to a rock, branch, hide window, car window, car roof, or anywhere solid and you get rock-steady performance, instantly. I like the double pocket type that flops nicely either side of a window ledge, with a tab for carrying it around. Choose a zippable one so you can empty it for travelling light. Fill it on arrival at your destination with the cheapest pulses or dried beans available, and cook and eat them or give them away just before you leave. Some photographers I know fill them with bird seed, so they always have an emergency supply for

baiting subjects in. But whatever you use, it should be a reasonable mass – don't be tempted by lightweight polystyrene balls, which are quite useless. You need to fill the bag fairly full so it moulds well to the shape of the lens and doesn't slip around. Keep spare beanbags around the house and in the car – wherever you are likely to need one suddenly.

CAMERA ACCESSORIES

There are a few accessories that you are likely to need pretty well straight away. A cable release is the first, electronic flash second. Most other things can wait. I would add a pair of binoculars to that list, too – not really a camera accessory as such, but if you want to photograph birds you'd better be able to find them. A light, compact pair of 8 x 30 or thereabouts would be ideal.

Sometime later you might want to add more sophisticated gizmos like an infrared remote release, beam trigger, flash extender, external power pack, bulk film back, and so on. By all means check out the availability of such accessories when you first investigate a suitable system, but don't think that you have to get them all at once.

Carrying the load

One thing you will definitely need at the outset is a decent carrying case to protect and transport all your gear. It can be hard to find one ideal case or holdall to suit every situation. Sometimes you want the protection of a hard-sided case, or water-tight seals for an amphibious landing. At other times you just want to be able to dip in and grab a different lens. But on the whole, the best compromise for a wildlife photographer is a backpack. This is the most comfortable and healthiest means of carrying a heavy load of camera gear, and leaves you with both hands free. On the down side, you have to take it off to access your equipment, and this can mean laying it down in the wet and mud at times, worse still on sand. Whatever you choose, make sure it has a good built-in frame and a comfortable harness. Waist straps are also good for helping to spread the load. Allow for your main telephoto and a couple of camera bodies at least, with

pockets for film, spare batteries, waterproof and sandwiches. Try not to be tempted into buying something too large, because you'll always find more stuff to put in it. It might be optimistic to expect to attach a tripod as well, depending on your age and fitness. A good guide would be to limit yourself to what will fit in an aircraft overhead luggage locker. Tamrac, Camera Care Systems, Domke and Lowepro all make good camera backpacks, or you can adapt a walker's rucksack by inserting your own foam protection.

You might later want to add to this basic pack supplementary carrying systems like a belt pouch or a photographer's vest with loads of pockets. These can be particularly helpful when travelling, or when working light on a particular project.

FILMS AND PHOTOGRAPHIC MEDIA

It is more or less standard practice for nature photographers to use transparency (also known as 'slide' or 'reversal') film. Other professional photographers are very happy to use negative, which is easier to expose correctly and makes better prints – so why do we bother with transparency? Well, it's not just because we like to inflict our slide shows on reluctant audiences. Transparency film emulsions are inherently of higher contrast than negative film emulsions, and make colours look rich and vibrant, or 'well saturated'. They also tend to be finer grained, and appear sharper when reproduced in print. Since it is also easier for printers to see what they are aiming at and balance colours by reference to a positive image, transparency film has become the publishing standard. And many of us are aiming to get our work published, so we are happy to comply.

If your main aim is to produce prints, then there really is no reason why you shouldn't just go ahead and use colour negative film. It is cheaper and easier to process, has wider exposure latitude, records a fuller tonal range, and makes beautiful photographic prints. It also scans very well.

Working with transparency film does call for careful and accurate exposure. Because of

Transporting camera gear
Use a sturdy and dependable backpack for carrying your camera gear in the field, such as the Lowepro Photo Trekker AW seen here.

Mark Hamblin
Jay in falling snow, Yorkshire, England

A regularly supplied and intelligently placed feeding station can create good photographic opportunities for a steady flow of different bird subjects. Mark Hamblin relates how he enticed a normally shy jay within range of his camera:

❝ Within walking distance of my home on the edge of Sheffield there is an old cemetery surrounded by mature oak woodland. In some years the bumper acorn crop attracts large numbers of jays, which often remain in the area throughout the winter, retrieving acorns that they have stashed in the autumn. However, with snow on the ground, feeding is difficult for the jays and so I set up a feeding station and began to put out peanuts. Jays and magpies, as well as the tits, soon found them

and made regular visits to feed. For this particular picture I had previously drilled small holes into a dead branch and set it up in front of my portable canvas hide. Following a couple of days of snow I pushed peanuts into the holes of the branch out of sight of the camera, and settled into the hide. My hope was that I would be able to photograph jays and other birds, not only in the snow, but also with snowflakes falling around them.

I worked with a Canon EOS 1-N camera and 500mm f4.5 lens. The light was poor and so I pushed the Fuji Sensia 100 film one stop to EI200 in order to achieve a reasonable shutter speed of $^1/_{125}$ sec. Bird activity was very slow during my session in the hide, but I was lucky enough to obtain a sequence of three or four shots of this individual. After landing, it quickly took several peanuts into its crop but then posed briefly looking back over its shoulder. This was my favourite image from a cold afternoon spent in the hide. ❞

its reduced contrast range it is easy to burn out highlights and block in shadow detail. Take greatest care not to over-expose highlights, and let the shadow detail go if necessary (the opposite advice to working with negative). Slightly under-exposed transparencies still record good tonal detail and can be salvaged in printing, scanning or duplicating. Slightly over-exposed transparencies are invariably useless.

Film speed and sensitivity
Film sensitivity (also referred to as film 'speed') is described by the internationally recognized ISO (International Standards Organization) rating. Daylight-balanced transparency films are commercially available at nominal speeds ranging from ISO25 to ISO1600. Doubling the ISO number represents an increase in sensitivity of 1 stop, so an ISO200 film is twice as sensitive as an ISO100 film. Therefore

and have higher ISO numbers, allowing you to shoot at faster shutter speeds or smaller apertures, while "slower" films are less sensitive and have lower ISO numbers. Slow films are finer grained and have better resolving power; fast films are coarser grained. The term "exposure index" (EI) describes a film speed different from the manufacturer's nominal speed, so an ISO100 film might be "pushed" or "uprated" 1 stop to EI200, calling for a corresponding increase in development time. You must therefore notify your processing lab of any change in exposure index. Pushing films tends to increase graininess and contrast and causes color shifts.

There is always much discussion among photographers about which films have the most lifelike color, and the conclusion is generally the same: it's all down to personal taste. When you think about the enormous range of colors throughout nature and all their nuances, the fact that chemical dye-coupling can come anywhere near to matching them has to be a source of some amazement and admiration. But most films have one or two subtle hues that they are unable to reproduce entirely faithfully, and you have to work out which you can most easily live with. Photographing with available light means that color temperature (the color of light, measured in degrees Kelvin) can fluctuate enormously, even minute by minute, and this has a much larger bearing on color rendition in final images, so take a pragmatic view.

Transparency films of low to medium speed (ISO64 to ISO100) are probably the most useful for bird photography, offering the best compromise between speed and grain. The best advice would be to find one film that you like and stick with it for a while. Settle on a professional lab for processing, and stick with that too. This way you will become familiar with a film's characteristics, how best to expose it in different conditions, and whether to make fine adjustments to the recommended speed. Report any gripes to the lab and work through any problems (as long as they're only occasional), and build up a good working relationship with them. Store unexposed films in a fridge, and have exposed films processed quickly.

THE DIGITAL ALTERNATIVE

Digital image capture has made quite an impact across many photographic disciplines and looks certain to replace traditional photochemistry in due course. Although nature photographers are among the last to fully embrace this technology, there are some significant benefits; among them, savings on film and processing costs, ability to perform well in low light, and immediate feedback in the field allowing informed adjustments to exposure etc. You also have unlimited, lossless copies of your 'originals'. On the down side, there is a trade-off between image quality, image capture rate and buffer capacity, so a high megapixel count will come at the expense of speed – a serious consideration for the action photographer. Do not underestimate the effect on your 'workflow' as you will now have to process and edit images as you accumulate them, and devote a considerable amount of time to post-production in computer. And whatever you save on films and processing will almost certainly be accounted for by media storage, software, and depreciation.

Whatever your equipment, and whatever medium you use to record your bird images, the essential techniques will remain the same. There will be many times when your equipment still seems inadequate, and even the most sophisticated camera cannot predict what you want to express in a photograph. That is part of the beauty, and the skill, of photographing wild birds, and where we must now turn our attention.

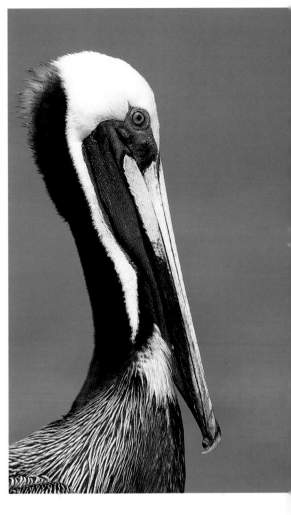

Brown pelican
Fujichrome Velvia is very fine-grained, high-resolution transparency film but, at ISO50, a little slow for much bird photography. With an obliging subject and Florida sunshine, it was the natural choice for me. Some photographers believe the colors to be too vivid, and swear by Kodachrome 64 for its more neutral color and proven archival stability. Velvia pushes well to EI100, but is prone to color shift.
Camera: *Nikon F5*
Lens: *80–200mm f2.8*
Film: *Fujichrome Velvia at ISO50*

Chapter 2
CONTROLLING THE IMAGE

Having established what we need in the hardware department, it is time to attend to the more creative side of our photography. This chapter looks at the theoretical aspects of composition and light, and how we can combine these ingredients effectively to produce a synchronous whole. We also learn about the quantifiable nature of light, how to work with it, and how to create our own.

*(previous pages) **Brown pelicans
diving for fish***
*Sunset shots are easy to meter.
A straight autoexposure looks a
little too intense, so I usually
compensate with plus ¹/₃ or
plus ²/₃ of a stop in aperture
priority auto.*

*(right) **Fairy terns courtship
feeding***
*Behavioural activity, and
interaction between birds, their
neighbours, and their
environment gives rise to
interesting compositions that
almost design themselves. But
keep the basics of framing in
mind at all times.*
***Camera:** Nikon F5*
***Lens:** 80–200mm f2.8*
***Film:** Fujichrome Sensia 100*
***Lighting:** SB-26 Speedlight on
daylight-balanced fill flash*

COMPOSITION

The subject of photographic composition is often spoken about in terms of rules and mathematical theory. This is not particularly helpful or appropriate when dealing with an unco-operative, wild creature. Most of your effort and concentration will have already gone into getting close to the subject, selecting the correct exposure and keeping focus. It is easy to neglect composition in the midst of all this. However, it is really worth pausing to consider the ultimate outcome and trying to visualize it in two dimensions. It is the difference between a haphazard palette of random colours and a work of art. In the end though, it won't be down to some academic exercise in aesthetics, but something quite personal, which you feel and express through the camera. Your awareness for composition will grow naturally as your technical skills become more proficient and intuitive, and will manifest itself in your own unique style.

Frame discipline

I use this term to describe the basic mechanics of framing a photograph. Frame discipline is the housekeeping side of composition, and is about avoiding sloppy oversights. Do you have the most appropriate lens fitted? Is the camera best in the horizontal or vertical orientation? Is the horizon parallel to the frame edge? Are there any awkward intrusions (such as out-of-focus twigs), distracting highlights (like surface reflections on water), or conflicting backgrounds (such as electricity pylons that appear to be growing out of birds' heads)? These questions should be going through your mind all the time as you look through the viewfinder. To rectify things might be a simple matter of moving a step to one side, turning the camera round, or zooming in or out. A continual state of alertness is required. Pay attention to the edges of the frame, and how your subject relates to them. Is there anything you can afford to leave out, that adds nothing to the picture? Reduce these unwanted elements as far as possible, and start thinking 'less is more'. On the other hand, perhaps you have been so preoccupied with trying to make a large image of the bird that

you have failed to see the better photograph? Consider your image size, and don't necessarily go for the biggest that you can get. And remember that with a 100 per cent viewfinder the final image will be cropped slightly when the film edge is lost under the slide mount.

Designing bird photographs

Composition means going a step further than taking just a well-executed record shot. At its best, it should encapsulate a special moment, challenge the viewer's preconceptions, raise questions and impart meaning. This might

sound fanciful, but bird photography has a bit of a reputation for being rather staid and conventional, so let's aim high! At the very least, we can try to tell something about the life of the bird, its behaviour, how it relates to its habitat, what might happen next. And we can also set about trying to design our photographs to best effect within the given circumstances. There should be no golden rules, but I can point to some devices that I think have worked for others and myself.

Arranging the elements of a photograph in a way that arrests the eye of the viewer is the simplest starting point. The result might be pleasing or it might be unsettling, but it must have the power to make people look. To do this effectively means being able to visualize how the scene will record in two dimensions, so try to assess your viewfinder image as though it were printed on paper. Look for strong lines, shapes, and patterns, real and implied, that will have an impact in the finished photograph, and think about how you can use them. Are there toning or contrasting colours and textures that could add to or detract from the subject? Are there

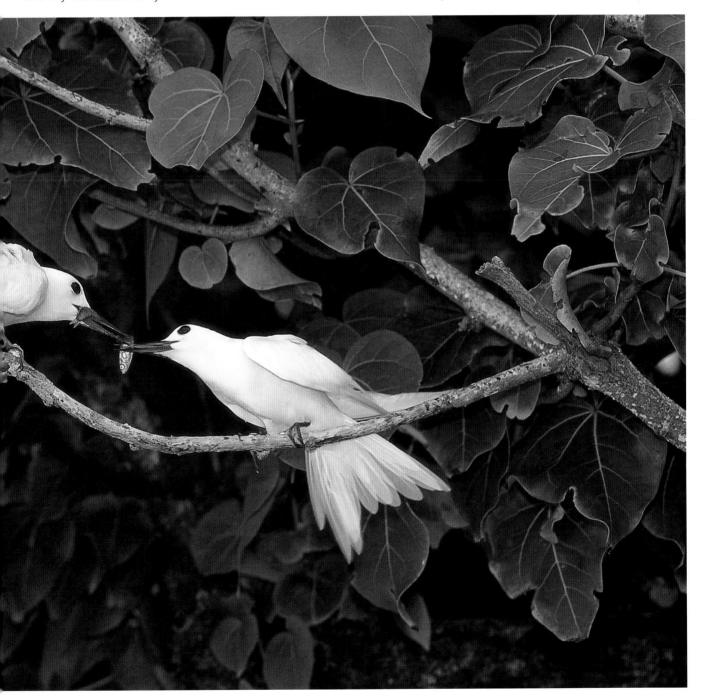

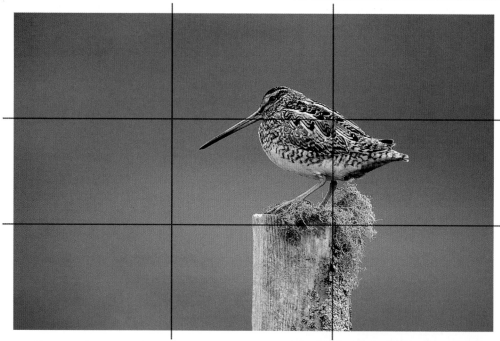

Frame orientation and subject placement
All of these views of a common snipe are conventionally 'good' compositions, complemented by the attractive perch and clean background. In the horizontal or 'landscape' format (top), the bird is positioned more or less at the 'intersection of thirds', and has space on the left to look into. This was a fortunate occasion where the bird posed long enough to allow further shots in the vertical or 'portrait' format. With the bird low in the frame (bottom left), the rusty barbed-wire fence is excluded, but there is a lot of 'dead' space above. With the bird higher in the frame, it appears better supported, and I quite like the way the rust colour is echoed in the bird's plumage.
Camera: Nikon F3
Lens: 300mm f2.8 plus 1.4x teleconverter
Film: Kodachrome 64

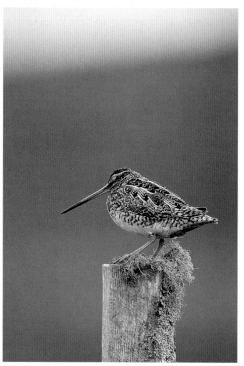

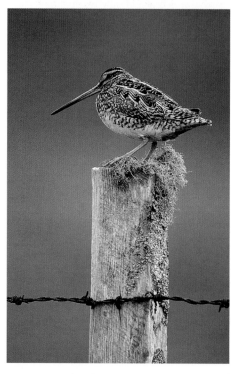

any interactions with other birds or the immediate environment? Make your mind up about what needs to be included and what might be excluded, and remember that the simpler compositions are often the most successful. Granted, you might only have this luxury with an obliging, perched bird, but often you can be thinking about it before the bird is even in the frame, and plan your approach accordingly.

Subject placement

One of the first decisions you must make is where to place your subject. The textbook formula is to locate your centre of interest at one of the 'intersections of thirds' – the four compositional strongpoints that fall within a rectangular frame. With a bird small in the frame, the centre of the bird might be thought ideally placed at an intersection of thirds; with a bird large in the frame, make it the bird's eye.

The shape of the bird or group of birds will dictate the possibilities to a large extent, but anything off dead centre generally looks good. In practice, look at the image in the viewfinder and try to achieve a sense of balance.

Usually it looks better if you leave space for the implied movement of the subject. So if the bird is looking or moving towards the left, you leave a bigger space on that side for it to move into – somehow it just seems the natural thing to do. However, you should always question whether it could be done better or differently. For instance, when a moving bird is leaving a trail or wake, it seems preferable to show where the bird has been rather than where it is going. Practicalities always intercede – the space you'd prefer to leave has a telegraph pole in it, or perhaps half of another out-of-focus bird, which would only result in a poorer photograph – so you need to adapt to the situation. With flocks of birds in flight, if there is a recognizable outline shape to the flock you will probably find yourself leaving room in front of the leading bird. It seems to matter much less if the tail-end birds are chopped in half. When the flock more than fills the frame, there's really no decision left to make.

In the upright format, compositions tend to work better with the subject placed in the upper third of the frame, so that it has some 'support' space underneath. But beware too much out-of-focus foreground, particularly if it is cluttered and only just out of focus. With birds on or near water, pay particular attention to reflections and whether their inclusion might improve your shot.

Other considerations apply if you are shooting for stock libraries or aiming to supply your work to publishers. Then it is less important to have the perfectly composed photograph in camera, and much more important to leave options open to the graphic designer. So a smaller, centrally placed subject might be quite acceptable, allowing the picture to be cropped to fit the space available on the page. Think about leaving copy space (plain background that will take type) around your subject. Take lots of uprights – most books and magazines are printed this way up, and publishers are always on the lookout for good candidates for full-page

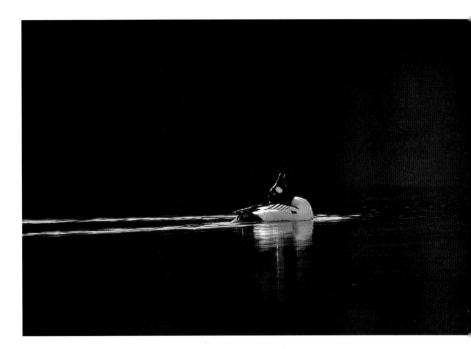

photographs. If you want a coveted front-cover shot you could improve your chances by leaving a space at the top for a title.

Camera viewpoint and perspective

Foreground and background will be affected by relative distances, focal length of lens and camera viewpoint. With telephoto lenses, because of the small angle of view, a very small shift in camera position can make a big difference to the foreground and background. Explore the possibilities of more pleasing, less fussy backgrounds by moving the camera up or down, and from side to side rather than just settling for the comfortable, eye-level view.

Foreground elements such as foliage or grasses might be seen as a nuisance, but look to see whether they can be used to make an interesting, natural frame and lend depth to the photograph, particularly if they are a contrasting colour to the subject. Foreground framing generally needs to be either in the same plane of focus as the subject, or well blurred, not somewhere in between. This also helps the subject to appear more natural, at home in its habitat, undisturbed. Low camera viewpoints lend themselves to fuzzy foregrounds, and give a more intimate perspective for birds on the ground or water. Set the tripod at its lowest position, or rest your lens on a rock, camera bag or directly on

Goldeneye drake displaying
The silver wake of the goldeneye against the inky loch really begged to be included in my composition, and provided a good enough reason to break the 'rules'.
Camera: Nikon F5
Lens: AF-S 500mm f4 plus 2x teleconverter
Film: Fujichrome Sensia 100 uprated to EI200

The effect of changing camera position

Moving a couple of steps to one side can have a profound effect on background with long telephotos, because of their narrow field of view. These two shots of a red-shouldered hawk were taken moments apart, with only a metre or so difference in camera position.
Camera: Nikon F5
Lens: AF-S 300mm f2.8 plus 2x teleconverter
Film: Fujichrome Sensia 100

the ground to achieve that intimate feeling. It might mean getting yourself wet or muddy, but the end result justifies the pain. In contrast, looking down from high viewpoints with shorter lenses often looks awkward, suggesting tame or captive birds in a confined setting. Camera viewpoint is something you can change quite quickly and easily, so make it work for you. Get down, get dirty!

Remember that the focal length of your lens will also affect perspective. Assuming that you are using a telephoto, bird images will

tend to appear flattened and two-dimensional. The longer the lens, the more pronounced the effect. It would be a shame always to portray birds as flat and shapeless, so don't use huge focal lengths indiscriminately. Other objects in view will also be foreshortened and compressed, making relative size and distance difficult to judge. This effect can be used to makes things appear closer together than they really are, stacking up a succession of tree trunks, waves, mountains, or whatever, in a way that enhances the overall composition.

Turnstone foraging on sea shore
I lay on the ground with my lens
supported on a beanbag to
achieve this low camera angle.
This position presents less of a
threat to the bird, and also seems
to lend a certain intimacy to the
photograph.
Camera: *Nikon F5*
Lens: *AF-S 500mm f4 plus 1.4x*
teleconverter
Film: *Fujichrome Sensia 100*
uprated to EI 200

Shorter focal length lenses will incorporate more background, because of their angle of view, so don't forget the wide-angle option with larger, tamer birds (or with a remote-controlled camera). The use of a small aperture on a wide-angle lens can permit both bird and habitat to be shown in focus, but subject placement is critical so that the bird doesn't get lost against a cluttered background.

Depth of field

Depth of field plays a big part in composition, too. Use wide apertures to obtain soft, blurred backgrounds with telephotos. For a small to moderate-sized bird shown large in the frame you will need to stop down a bit to achieve sufficient depth of field, particularly if it is a front-on view. Employ your camera's depth-of-field preview to check. Focus on the bird's eye and let the tail go out of focus, if needs be. Where there is more than one bird in view, they seldom come together in exactly the same plane of focus, even though they often look as though they are in the viewfinder. Try a smaller aperture to show both (all) birds in focus, or perhaps switch to a shorter focal length. Alternatively, wait until one bird moves into quite a different plane of focus, use a wide aperture and deliberately make the bird(s)

behind well out of focus. With large flocks like grazing geese or waders at a roost, the best option is usually to focus on the front row.

Lines and edges

Diagonal lines and sweeping curves are usually more agreeable than strong horizontal or vertical lines, leading the eye gently into the picture, so exploit them where you can. For example, if you are photographing a bird on a tide line or stream edge, try to avoid the land/water boundary becoming a vertical or horizontal line in the photograph. Simply moving to one side or the other will transform the line into a more powerful diagonal, or exaggerate any curve. Where there is more than one straight line, look for convergences to make interesting triangles. These lines might be implied rather than real, a suggested link between the main subject elements.

Red grouse hen
Using a telephoto 'wide open'
results in a narrow depth of field.
Distant backgrounds are rendered
agreeably out of focus, while a
small amount of out-of-focus
foreground can help to frame the
subject and give the photograph
a feeling of depth.
Camera: *Nikon F5*
Lens: *500mm lens at f4*
Film: *Fujichrome Sensia 100*

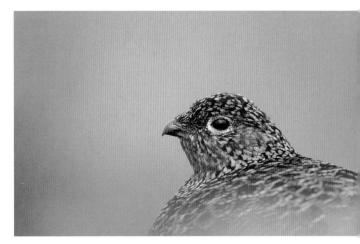

Atlantic puffin with sand eels
Head shots are the easiest close-ups to compose, but remember that with this sort of reproduction ratio you'll need to be stopping down to smaller apertures to obtain sufficient depth of field. I stalked this bird by creeping up on my stomach with a 200mm macro lens hand-held, using my elbows for support.
Camera: *Nikon F4S*
Lens: *Micro-Nikkor 200mm f4*
Film: *Fujichrome Sensia 100*
Exposure: *$^1/_{60}$ sec. at f11*

Close-ups

Close-ups of parts of birds need careful thought. If you've just clipped the subject outline it looks pretty clumsy, as though you couldn't be bothered to frame properly. Half a bird looks a bit odd too, as if you weren't sure whether you wanted a close-up or not. Head portraits are pretty safe – you would expect to concentrate the composition around the bird's eye. Larger, tighter close-ups where you can't see any defining outlines may be very successful, such as of a wing panel or speculum, or the facial disc of an owl. It's often better if there is some mystery to the photograph and the identity of the subject isn't immediately obvious, so the viewer has to think a bit to work it out. Remember that with these larger reproduction ratios you will need to stop down to quite small apertures to achieve sufficient depth of field, and this in turn may require additional lighting.

Most often, this sort of photography will be possible only with birds in captivity rather than wild birds, but there are occasional obliging wild subjects. Photographs of bits of dead birds are depressing and usually all too obvious – a conveniently spread wing or tail, even if sprayed with water droplets, is unlikely to fool anybody. However, a recently moulted feather photographed in habitat might make a sensitive study, likely to require the use of a macro lens or extension tubes. What about a more abstract approach, such as a trail of footprints in the mud, or a powder down imprint on a window following a collision?

Photographing bird action

Not so long ago, bird photographers would not have considered attempting anything other than a static portrait of an incubating bird on the nest, hampered as they were with quarter-plate field cameras and having to estimate a $^1/_{50}$ sec. time exposure (at best) for their single plate. There simply wasn't that much choice. Fortunately, modern cameras and films allow us to be much more

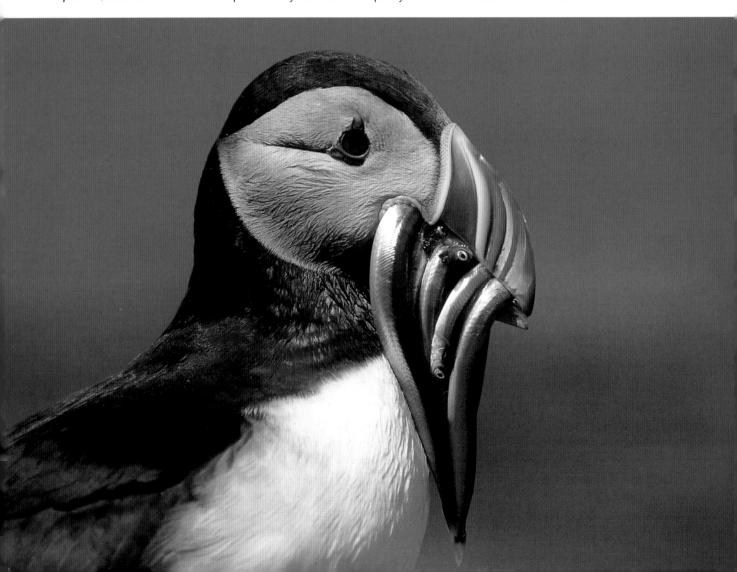

adventurous in our approach, and we can capture bird movement and behaviour in previously undreamed of ways. So rather than just illustrating a motionless subject on a fence post ('birds on sticks', as some editors rudely describe it!), try instead to photograph birds feeding, drinking, bathing, flying, singing, preening, or displaying. They do lots of interesting things, but you wouldn't always know it to look at the photographic record.

Action photography does of course call for some understanding of your subject, and an ability to anticipate its next move – skills you can only really gain through observation and experience. You will also need good reaction time and practice in the use of your equipment so that you are not fumbling around when the action does occur. The best advice is to be bold, and hit the motordrive whenever it looks as though something interesting is about to happen, and not be frightened about wasting film; you can bin the failures but you can't recover lost opportunities.

In practice, you will most likely be operating with a long focal length lens, though anything longer than 600mm takes some getting used to, just to keep your bird in frame. Start with the lens at its maximum aperture to obtain the fastest possible shutter speed in order to freeze subject movement. Use a predetermined manual exposure reading, or set to aperture priority automatic if shooting mainly mid-tones. You will probably need at least $1/500$ sec. to be confident of sharp results with moving subjects, and $1/1,000$ sec. or faster for birds in flight. Depending on the maximum aperture of your lens and the available light, you may need to opt for a faster film to be sure of a sufficiently fast exposure. With a 400mm f5.6 lens, a shutter speed of $1/800$ sec. or $1/1,000$ sec. ought to be achievable on ISO200 film in good light. Consider uprating ISO100 film to EI 200 for a sharper image and finer grain structure than a nominal ISO200 film, or use an even faster film if you can tolerate the grain. As you gain experience of action photography techniques, you will be able to judge when you can afford to use slower shutter speeds, and what is appropriate for particular activities.

Think ahead, and if you are within a couple of frames of the end of the roll, try to change films in advance of any action. Most probably, you will be photographing in the horizontal (or 'landscape') format for ease, but do try to think about whether the camera would be better in the vertical orientation. It's a good idea to frame your subject in a way that allows space for it to move into; not only is this the more pleasing composition, but it's the most practical way of keeping up. And if you don't have the bird too large in the frame, you'll have a better chance of following the action and allowing room for taking off, wing-stretching, or sudden changes of direction. If the bird starts to run, swim or fly, keep your lens moving at the same speed to maintain its position in the frame, striving to hold that space ahead of the direction of movement, and taking short bursts of pictures with the motordrive set at its fastest rate. This can be difficult at first, and with the mirror flapping up and down you can easily lose confidence as the viewfinder image flickers, but try to pan smoothly with the subject motion and don't falter when you press the shutter button. It helps to have a good tripod head for this, with a smooth panning action. When you become accomplished at panning, it's possible to use much slower shutter speeds, perhaps even as slow as $1/60$ sec., and keep the main areas of interest sharp while blurring the wing beats and background to really give a feeling of movement. Don't expect every shot to work out, but if the eye and bill of the bird are sharp it is surprising what you can get away with. Streaky backgrounds are good for illustrating the speed of a flying bird, and become possible when panning at shutter speeds of $1/250$ sec. or slower. Water spray from birds bathing, fishing, or taking flight also adds dynamism to an action photograph – individual droplets will render well at $1/500$ sec. or faster, while arcs of spray result from slower shutter speeds of $1/125$ sec. or less.

With all of these things to think about, you could do without having to worry about focusing the lens as well. This is where autofocus can be of enormous benefit – in particular the advanced autofocus systems that

as birds flying directly towards the camera, or low contrast subjects against high contrast backgrounds (shore birds flying against a background of breaking waves, perhaps) – and you will soon become aware of your system's limitations. Try setting the continuous film advance to a slower speed – perhaps six frames per second rather than eight frames per second – to improve AF and focus tracking capabilities. When it works, autofocus really does expand your horizons and lets you concentrate more effectively on other important aspects of your bird photography. The rewards are there for the adventurous.

With a manual-focus lens, your best bet is to pre-focus the lens and let the bird move into the field of focus, pressing the shutter just as (or just before, if the bird is coming towards you) the viewfinder image looks sharp. Again, this is something that takes practice and you should expect waste. Use shorter focal length lenses by preference, say 300mm or shorter. At seabird colonies I have found a 200mm macro lens quite dependable for manual-focus flight photography, but have occasionally made sharp flight shots in manual at focal lengths right up to 700mm.

The use of slower shutter speeds for action photography in nature has become quite the vogue in recent years. While there is clearly some loss of detail in outline and plumage, the most successful examples of this kind of work portray birds in a beautifully impressionistic manner. Perhaps such images are a better approximation as to how we remember having seen a bird, in fleeting glimpse, than the more usual action-stopping interpretation. Some people, however, simply hate the style. If you want to give it a go, expect to take rolls and rolls of film perfecting the technique. Usually it works best at shutter speeds around $1/15$ sec. or $1/30$ sec., but much depends on the size of bird and its range and speed of movement, so be prepared to experiment. Although it might not be immediately obvious, image stabilization can assist greatly with this style of photography, as it reduces the camera shake element of the exposure so any resulting blur is solely attributable to subject movement.

Photographing flight

Same bird, same place, same time – but different treatment. This feeding black skimmer was photographed at both $1/800$ sec. (top) and $1/25$ sec. (bottom) to produce quite different interpretations.

Camera: *Nikon F5*
Lens: *AF-S 300mm f2.8 with 2x teleconverter*
Film: *Fujichrome Sensia 100*

have 'focus tracking' capability. To some extent, these systems can predict the speed and direction of subject movement, but you still have to try to keep the selected AF bracket on the bird (although some claim to be clever enough to select the right bracket automatically, in 'dynamic AF'). It may take a frame or two for the system to get up to speed, so again you need to grit your teeth and keep the shutter button depressed in the hope that the computer chip is doing its job. While autofocus technology has developed at great pace, there are still many situations where the best systems can't easily cope – such

Perches

An ugly perch can so often ruin an otherwise fine photograph. It might be out of proportion to the bird, introduce unwelcome parallel lines (especially if it is a wall or fence post or some other man-made object), lie at an awkward angle to the plane of focus, or just be a cluttered mess of twigs and foliage. Conversely, the right perch can transform a relatively dull portrait into a beautiful composition – a mossy bough, a lichen-encrusted rock or a spray of fresh blossom should complement a bird subject without competing for the viewer's attention.

There are occasions when you might be able to gently manipulate the perch a bird uses, perhaps by introducing one of your own choice or removing those you don't like. If you're erecting a fence post or branch for example, consider its angle and don't just plonk it down vertically. And avoid using the same one over and over again. Leaf buds and shoots should be pointing in the natural growing position, with pruning and gardening kept to a minimum and as inconspicuous as possible. If an introduced perch is too perfect with everything slap-bang in the plane of focus it can easily look faked (as it is). Decorating the perch with ivy is usually a dead give-away, but if you are working in your own garden or at a regularly visited site you could, with judicious pruning, train the growth of branches and climbing plants in a more natural way over a period of time to suit your composition.

More likely, in real-life field situations you'll have no choice in the matter of where a bird perches, but you should still take it into account, look whether a better angle might be achievable or just hang around a bit longer in case the bird moves to somewhere more agreeable. Just occasionally all the elements come together and combine to produce something exquisite.

Depicting birds in their habitat

Your bird doesn't always have to be a frame-filler to make a successful photograph. Sometimes it's good to show how a bird relates to its habitat, and a relatively small bird image can look spectacular in the right

Mike Lane
European bee-eater, Almeria, Spain

This beautifully composed portrait earned Mike Lane the *British Birds* magazine title of Bird Photograph of the Year in 1995, and illustrates his painstaking attention to detail. Mike tells us how he made the photograph:

' *A single pair of bee-eaters were nesting in a bank, but I noticed that they were occasionally landing on a beautiful tobacco tree 200m (660ft) away from the nest. Droppings on the floor suggested that they sat here often, and I swept these away so that the following day I could judge if they had been back. They had, so I quickly erected my hide about 7m (23ft) away. The direction of the light meant I could only work between about three and six o'clock in the afternoon, and it took three afternoons before they landed in the right place. It was important to me that the bird was close to the yellow flowers, which so perfectly match the plumage, as do the green leaves. As a final touch, I smeared an ugly scar on the glossy black bark of the perch with a tiny drop of engine oil from the dip stick of my car, to disguise it.*

The background is an out-of-focus sand dune. As ever in such hot conditions the wind was blowing strongly and the thin branch was moving back and forth as well as up and down. Consequently, not every picture was sharp.

I used a Canon EOS 5 camera body with a 600mm f4 lens. The film is Kodachrome 64, exposed at $^1/_{250}$ sec. at f8. '

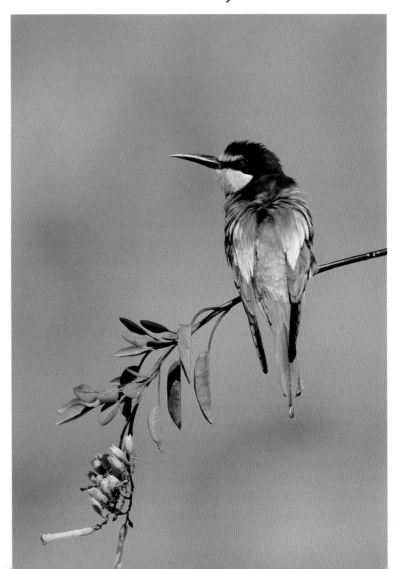

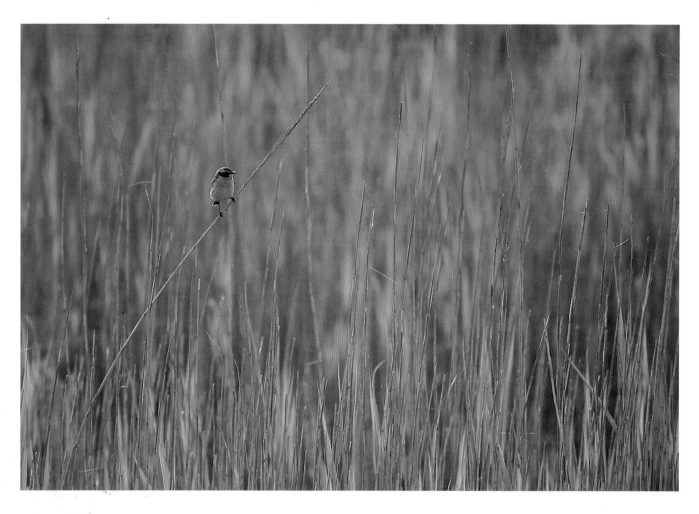

Male whinchat

Small bird images can make marvellous photographs, if conditions are working in your favour. The vibrant greens and backlighting tempted me to try this ambitious composition, but it was the single bent stem straining under the weight of the bird that really clinched it.

Camera: *Nikon F4S*
Lens: *500mm*
Film: *Fujichrome Velvia*

composition. It takes some courage and confidence to pull back from a frame-filling opportunity, but it could be exactly the right thing to do. Most probably, before you look for the potential in the smaller image size, you will have already satisfied yourself as to your own fieldcraft abilities, and will feel safe in the knowledge that you could get closer if you really needed to.

Strong design, interesting light or texture, and a complementary background are required for this approach to work. A narrow shaft of sunlight spotlighting a bird and isolating it from a low-key background might be the ideal scenario. This is where the photographer's 'vision' and creativity really have the chance to shine; when properly executed it will be obvious that the composition was intended, and not simply the result of the photographer being unable to get as close as he or she would have really liked. Such a shot can equally well be taken with a telephoto or wide-angle lens. Quite possibly, it could be regarded as an excellent landscape

photograph that just happens to have birds in it – they may be small in the frame, but they still play an important role in the integrity of the overall composition.

Some birds lend themselves to this treatment better than others, whether by their size, distinctive shape, gregarious behaviour, or preferred habitat. A rail skulking in a reed bed might not give you much opportunity for any kind of photograph, let alone a considered composition. However, be alert to the rare occasion when it emerges from the reeds and its smooth curves contrast neatly with the regular pattern of vertical stems – there could be a masterpiece in the making.

LIGHT AND METERING

Judging by questions I am asked at lectures and workshops, metering seems to cause more problems and anxiety than any other aspect of photography. Transparency film in particular is pretty unforgiving of mistakes, so the anxiety is not without foundation. Let's take it from first principles.

Janos Jurka
Red-throated diver, Ludvika, Sweden

The photographs of Janos Jurka exhibit a great appreciation and understanding of space, often making use of small bird images but always in a way that makes a complete, synchronous composition. Nothing is wasted. He told me about his technique:

❛ *Respectful bird photography requires a good knowledge of the species one works with. It is important to understand birds' behaviour patterns, as well as their individual traits, such as sensitivity to disturbance, aggression towards intruders, and so on. Individual birds of the same species can actually behave quite differently from each other.*

I have photographed red-throated divers near my home in Sweden for more than 15 years, without using hides. In the beginning I used to visit their breeding lake once or twice a day, following the same route on foot and always wearing the same clothes. If the birds showed any sign of nervousness about my approach, I would turn back or stop and sit down for a while until they calmed down. Gradually they came to accept my presence, so that today I can sit at a distance of 10–15m (33–55ft) without disturbing them. Amazing, but true.

This method allows me to move around and select the best distance, camera position, and lighting effect when composing my photographs. Of course it wouldn't be suitable for all types of bird, and even when your presence has come to be accepted it is important not to abuse the birds' trust. Patience and respect will eventually be rewarded with special experiences, and photographs that capture the habitat and whole atmosphere – in my opinion, this is more important than being able to count the feathers on a close-up. Besides, once you have built up a trusting relationship with your subject there will be plenty of opportunities to shoot close-ups too.

This photograph was taken with a Canon F1-U camera and 85mm f1.2 lens, on Kodachrome 64 film. ❜

How to use a grey card

When I photographed this outdoor scene including the Kodak grey card, a spotmeter reading indicated that the grass was actually 1 whole stop darker than the card itself. It is important to have the card angled correctly to minimize surface reflections and, significantly, Kodak recommends 'for subjects of normal reflectance increase the indicated exposure by $^1/_2$ stop'. This exercise also indicates that 'grass green' should not be taken as an absolutely accurate representation of mid-grey.

Understanding your meter

The most important thing to know and remember is that all lightmeters are calibrated to mid-grey, or 18 per cent reflectance (you can see how this looks by reference to a Kodak grey card). This is a long-established constant or standard of measurement, which is supposed to represent the average reflectance of the most commonly photographed scenes.

In a sense, it doesn't matter where the standard is set as long as you understand what it is and how to interpret it. Suppose, for example, your camera's lightmeter tells you that a given scene should be exposed at $^1/_{250}$ sec. at f8. Following this advice without any interpretation or amendment, most times you will get a fairly acceptable exposure. If you are photographing a family group, a landscape with some sky, or even a typical bird in its normal habitat, the average of the tonal range will most probably approximate to mid-grey, so you can pretty well trust your averaging meter. But were you to photograph a white swan in a snowfield or a raven in a shadowy cave on a straight meter reading, you would also get a mid-grey representation on film – not what you want at all. Of course, the meter doesn't know what you are looking at or how you wish to represent it in your photograph, and can only suggest the average setting. To keep your white bird white and your black bird looking black, you must over-expose or under-expose relative to the average meter reading. And, of course, there is a whole range of tonal variations in between that call for some amendment. More on this subject and how to expose correctly below.

The other point to bear in mind is that the human eye can perceive and allow for a much greater contrast range than any film. On a bright sunny day, the contrast range might be as high as 2,000:1, which might make you squint, but your eye and brain can adapt to and accommodate this brightness to make sense of the information. Colour transparency film emulsions can only resolve a maximum contrast range of something like 32:1 (or about 5 stops) in comparison, and colour negative about 128:1 (7 stops). Anything beyond this range will record on the film as blocked-in shadow or burnt-out highlight, with no texture or detail. Sometimes, this high-contrast effect can be desirable and work to your advantage, but it's best if you know when those times are while they're happening, rather than arriving at that end point by chance. More often than not, the effect of a high contrast range on film (and especially on transparency) is erroneous exposure and consequently the loss of important detail in key areas of your photograph.

You can measure the contrast range of a scene by employing a spotmeter and taking a reading of different tones from highlights through to shadows, to see for yourself just how great the range can be. Even if you had time to calculate all your exposures beforehand in this way, unfortunately it's not good enough just to work out the median reading and opt for that as your camera setting. It will still be wrong a lot of the time (but it is in essence what an evaluative meter reading does for you). Really, you have to make a value judgement about what is the most important part of your picture and expose for that accordingly, often at the expense of other elements.

Another method of working is to find a mid-tone in your picture and take a spot reading off that. Fine in principle, but how do you recognize an accurate mid-tone with any degree of consistency? Is it green grass? Blue sky? You can carry a grey card and try to meter off that, but it's slow and not very practical for bird photography. Alternatively, you could use a hand-held incident lightmeter, and get an accurate reading that way. But what happens if your subject is more than 2 stops lighter or darker than mid-grey? It will still be incorrectly exposed!

Sunny f16?

There is a popular rule of thumb advanced by a number of North American authors, and first popularized by John Shaw, known as the 'sunny f16' rule. This states that if the sun is shining, with your aperture set to f16, the shutter speed will be the reciprocal of your film speed or its nearest equivalent. Thus with ISO100 film you should set your shutter to

1/125 sec. (or 1/250 sec. at f11, and so on). While this might be fine if you work only in Florida, in the middle hours of the day, with the sun over your shoulder, it's unfortunately not universally applicable. It seems to me to be no more scientific than glancing at the tip sheet in your film pack and going by that. Neither is it an incentive to work with more interesting light at the ends of the day, or in a snowstorm, or in any way that might produce exciting, evocative photographs. Now this is no way a criticism of the formidable work of John Shaw and others – it's a technique that seems to have worked well enough for them, after all. I can understand that it's useful to have a comprehension of what light reading you might expect in normal shooting conditions, if only to be able to judge when some bit of equipment is failing, but that understanding will generally come with experience anyway. So, with respect to my American colleagues, I would urge you to give no credence to 'sunny f16'. In short, believe your meter and use your head.

Practical exposure control

I wish there were one definitive answer I could give to ensure perfect exposures at all times and in all conditions, but unfortunately it's not quite that straightforward. Even professionals don't get their exposures right all the time (and don't believe them if they say they do). However, there are some useful guidelines and tips to set you on your way.

Most of the time it is pretty safe to rely on your averaging meter in centre-weighted or evaluative mode (remembering to get used to using one or the other). Try to judge the tonal value of your subject and background as seen through the camera viewfinder. If it is a pretty

Redshank in summer plumage
With a mid-toned bird against a mid-toned background and frontal lighting there's really not a lot to go wrong, and an automatic meter reading can be relied upon.
Camera: *Nikon F4S*
Lens: *500mm f4*
Film: *Kodachrome 64*

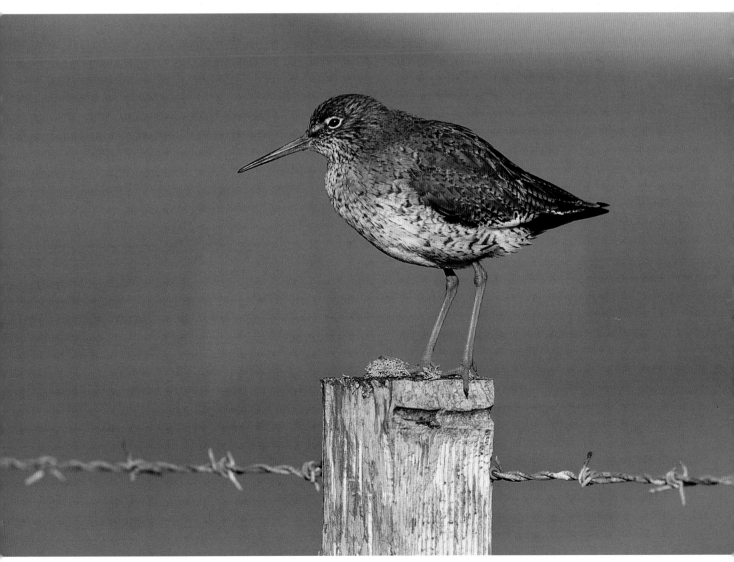

Mute swan on water

*For consistently reliable exposure
when photographing a white bird
on transparency film, begin by
taking a spotmeter reading of an
area of bright white plumage
where you want to retain some
texture or detail – here I would
have chosen the swan's forewing.
In manual mode with your
chosen aperture, set the shutter
speed ensuring the meter
indicator is $1^2/_3$ stops above the
centre point of the analogue
scale. This should solve the
problem, no matter what the
background reflectance or relative
bird image size.*
Camera: *Nikon F5*
Lens: *AF-S 500mm f4*
Film: *Fujichrome Sensia 100*

uniform mixture of light and dark tones, or a
mid-toned subject large in the frame, then it is
safe to proceed in aperture priority automatic.
As this will account for the majority of your
subjects, I would recommend leaving the
camera on this setting as a default, at least
until you get confident. Common exceptions
include particularly light or dark subjects, and
light or dark backgrounds.

When dealing with lighter or darker
subjects, their relative size in the frame
determines how much they will influence the
meter reading. Take the example of a white
swan swimming towards you on a background
of dark water. There is a point at which the
automatic averaging meter will calculate the
exposure just right, but it's decidedly risky to
leave it to luck. If the swan's image size is
smaller than that, the water will have a greater
influence on the meter and the swan will be
over-exposed. When the swan's image size
exceeds the critical point, it will reflect more
light to the meter and cause the camera to
progressively under-expose, if left on auto. You
don't know where that critical point is, but

you can judge it with a bit of practice. The
quick way to adjust exposure is to leave the
camera on auto and use the exposure-
compensation dial to make adjustments.
Continuing with the example of the swan,
assuming you are photographing this as your
main subject so it is pretty large in the frame
(about one quarter of the whole frame area),
you would want to add about 1 stop to the
autoexposure setting. Add more if the bird is
very large in the frame. With the converse
situation of a black bird against a lighter
background in similar proportion, you need to
subtract about 1 stop on the compensation
dial. This gives you a better chance of an
acceptable exposure on your subject, even if
the background loses detail to blocked-in
shadow or burnt-out highlight. Commonly
used by many wildlife photographers, this is
a fairly crude, pragmatic way of effecting a
solution. You get better with experience, and
can make finer adjustments with some degree
of confidence.

A more accurate way of determining
exposure, if you have time, would be to

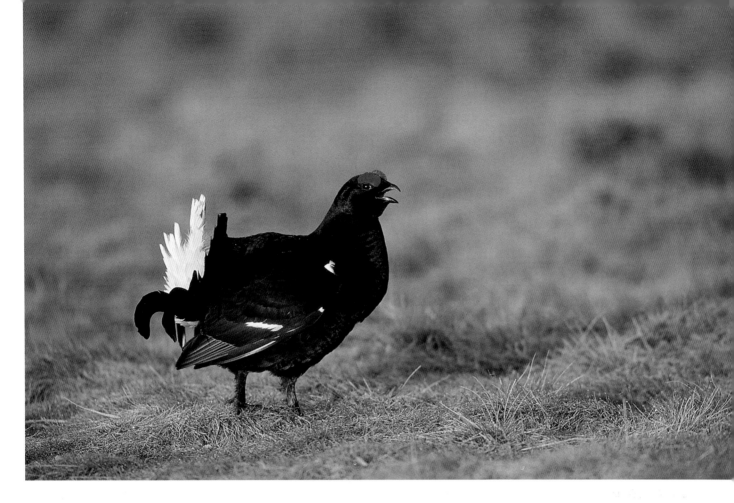

spotmeter in manual mode. To take the white swan example again, select an area of bright white plumage where you would just like to retain something of the feather detail (ignore small areas of glare or totally burnt-out highlight). Spotmeter off this area and set it at $1^2/3$ stops higher than the mid-point on your analogue meter bar, so that you are effectively over-exposing by this amount. It might work better for you at $1^1/2$ or 2 stops depending on your equipment, favourite film and so on, but this is a near foolproof way of keeping your whites white. And you can retain this setting for a short working session, using it for other swans in different positions, assuming the ambient light level remains constant. Periodically double-check the reading and reset your exposure as necessary. The most difficult part of the whole process is selecting an appropriate area of white plumage in the first place.

With a black bird such as a crow or raven, in manual metering mode, spotmeter an area of dark black plumage where you would like to keep some feather detail (not an inky black shadow where all is lost anyway), and set this to $1^2/3$ stops lower than the mid-point on the meter, or under-expose. Again, you may wish to adjust for your particular combination of camera and film. This will ensure you keep your blacks looking black, and not grey.

The number to remember is $1^2/3$. After that, the trick is to recall in which direction to compensate: over-expose light subjects, under-expose dark subjects. For light-toned birds that are not white, or dark-toned birds that are not black, estimate on a sliding scale between 0 and $1^2/3$ stops. With black-and-white plumaged birds you should aim to expose the white correctly and disregard the black.

A bright background such as a shiny water surface, snow, sand or cloudy sky, or a dark background such as woodland shade or deep blue ocean, can easily fool your automatic metering. Evaluative metering takes care of this to some extent, but is unlikely to give correct exposures in the more testing situations. Assuming the subject is reasonably well lit, ideally you should spotmeter in manual off a mid-tone – preferably some part of the bird's plumage – and keep that as your setting. It might be at the expense of burning

Black grouse male at lek

To expose correctly for black birds, place your manual spotmeter reading $1^2/3$ stops below the mid-point. It helps if you have low, angled sunlight to reduce contrast and show feather detail, and a catchlight in the eye always makes a big difference with black-headed birds.
Camera: *Nikon F5*
Lens: *AF-S 500mm f4*
Film: *Fujichrome Sensia 100 uprated to EI200*

out a background of snow, for example, but this shouldn't matter too much if the subject looks right. Failing this, look for another area of reliable mid-tone in the landscape, such as a branch, some rock, or foliage or grass. Assessing what is a good mid-tone is the crucial part. If in doubt, you might try spotmetering a few likely areas and averaging them, but of course this procedure uses valuable time. In practice, it's likely that you'll need to work more quickly, make a rapid

assessment of the scene and adjust with your exposure compensation dial. Again, over-expose against the averaged meter reading for light backgrounds, and under-expose for dark backgrounds.

With extremely bright backgrounds and a poorly lit subject, you probably ought to settle for a silhouette (or use fill flash). This can be pretty effective if the bird has a distinctive shape, or has assumed an interesting posture, and the background is something like

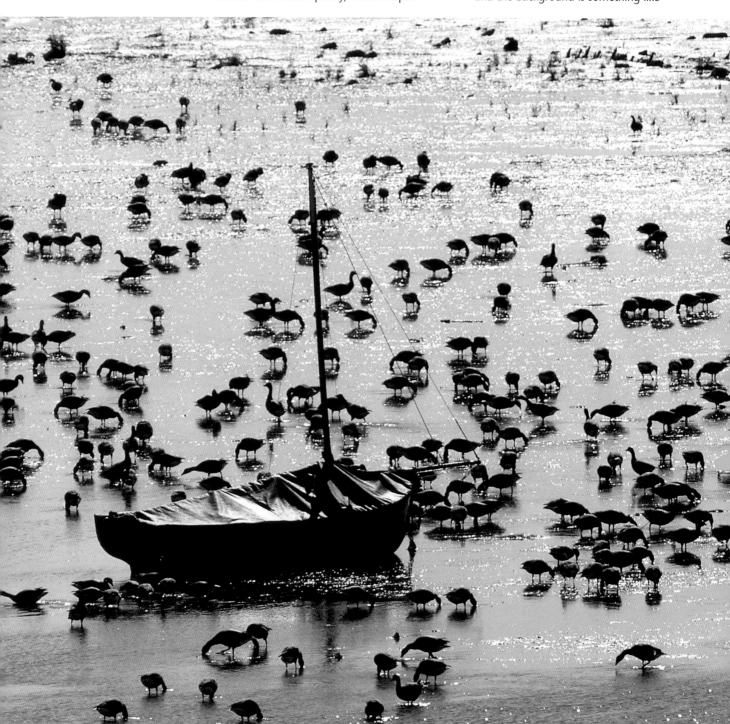

glistening water or mud. As a general rule, I would dial in an additional $^2/_3$ to 1 stop over and above the meter reading to keep texture in the background. Silhouettes against a dawn or sunset sky also look great and are easy to meter. A straight meter reading is quite acceptable, but tends to make the sky a little too well saturated in colour. I usually add $^1/_3$ or $^2/_3$ of a stop for a more realistic appearance.

For birds in flight against a white cloudy sky, you would need to allow at least $1^2/_3$

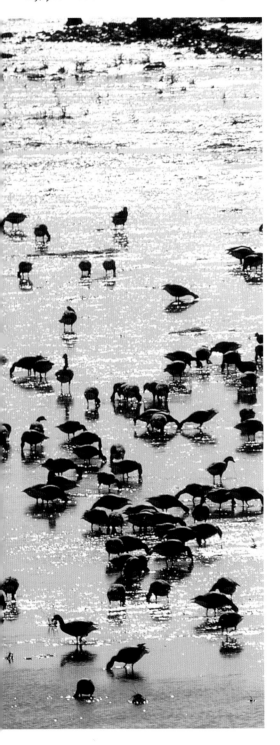

stops extra to keep detail in the underparts, and the results would still look pretty washed out and disappointing. Give it more exposure and the sky burns out to clear film. Sometimes you just have to tell yourself it's not worth taking the shot. Birds against a blue sky or leaden thunderclouds are a much better bet, especially if there is some light reflected underneath, say off snow, sand or water. Many photographers maintain that blue sky is a good approximation to mid-grey, but it varies considerably from the nadir to the zenith. At 45 degrees elevation, I would add $^1/_3$ or $^2/_3$ of a stop for a mid-toned bird. A meter reading that is taken off the ground (specifically green grass) tends to over-expose, in my experience. Best of all, spotmeter off a mid-tone area of the birds' underparts.

With dark backgrounds, again you would ideally want to spotmeter off your subject and let the shadows go. Alternatively find a mid-tone in the scene in order to achieve the same. If you're forced to stick to auto, under-expose by something like 1 stop (minus 1 on the exposure-compensation dial).

If you're still unsure, then bracket your exposures. There's no shame in this, especially if you're on an overseas, once-in-a-lifetime trip. A third of a stop either side may not have much effect, so go with $^2/_3$ of a stop each way. Over the long term, you will probably move towards manual metering as your preferred method. You will find that it gets quicker and easier, and you are rewarded with a higher percentage of correctly exposed photographs.

A creative approach to light

When you're beginning bird photography you'll probably be pleased to find a subject within camera range and in good light, and all the more so if you are able to take a sharp, correctly exposed shot. Thinking about more creative aspects perhaps won't be high on your agenda. As your skill and confidence develop, you will want to explore the possibilities of creating more 'artistic' photographs. Learning to see and appreciate the nuances and subtleties of changing light conditions will figure more prominently in your photography.

Brent geese

With the sun against me and strong reflections bouncing off the mud, I knew that it would be difficult to show any detail in the plumage of individual birds. Instead, I chose to show them as silhouettes to emphasize their shape and gregarious habit, and to keep some texture in the mud. By simply overexposing $^2/_3$ of a stop against the average meter reading I was taking a bit of a chance, but the birds were bound to come out black anyway.
Camera: *Nikon F4S*
Lens: *300mm f2.8*
Film: *Kodachrome 64*

Photographing in full sun near the middle of the day in high summer will produce the worst possible results. The light is harsh, contrast high, and usually birds are quite inactive anyway – doubly so in the tropics. Take a siesta for a couple of hours either side of true midday, or find something else to do, but don't bother taking any pictures. The low light of northern winters, early mornings and evenings is so much more flattering, giving better modelling, surface texture, softer shadows and an overall warmer coloration. Basically anything is better than midday sun, so try to be adventurous. Although we might curse cloud and rain because it makes photography more difficult, requiring longer exposures, it can sometimes be a blessing in disguise. The softer, diffused light of a bright cloudy day often makes for the best possible photography conditions. Rain showers are frequently followed by crisp, clear intervals with interesting skies. And falling rain or snow can transform an otherwise ordinary photograph into something quite special, providing you have a reasonable amount of light to work with.

Cross-light is where the main light source is from the side of the subject, and backlight is where it is from behind. Rim-light is that moody, fringing glow resulting from very low backlight. All of these conditions make for more compelling photographs than straight frontal lighting, if used wisely. Suppose you have a whitish bird, such as a tern, in quite strong sunlight, so that you might expect the glare on the plumage to threaten to burn out on the transparency; either you can wait until evening when the contrast has reduced considerably, or hope for the sun to go behind a cloud, or you can photograph the bird against the light, so the whites and pale greys are now in shadow and rendered well on film. A bright halo defines the bird's shape and makes it stand out from the background – instant magic. So who cares if it will never be used in a photographic identification guide?

Catchlights

A bird in frame might be swimming or walking around, or just turning its head from time to time, but watch the changing light and try to capture the moment when it looks best. This might mean changing camera position. In particular, a 'catchlight' in the bird's eye can make a huge difference to the success of a photograph, bringing life and sparkle to the subject. This is all the more important for black-headed birds, where the eye can so easily merge with the black plumage and be indistinguishable on a transparency. On the other hand, white-headed birds, large-eyed birds, and birds with a well-defined eye-ring tend to look good without a catchlight. In flat light conditions, a catchlight can be manufactured by punching in a small amount of flash. This looks fine if you don't overdo it, but out of place if the bird is obviously photographed against the light. A catchlight from a flash on camera can sometimes show in the lower part of the eye, and may therefore appear unnatural. Double catchlights look especially weird. These may result from the use of multiple flash guns, making the bird appear as though it has been photographed in a studio. They can also be entirely natural – for example, where the sun is reflected off water as well as directly in the eye.

MAKING YOUR OWN LIGHT

There are times when ambient light is simply inadequate to do the job, so you have to set about making your own. Tungsten lights are OK for studios but totally unsuitable for wild creatures, while we can pretty well discount mirrors and reflectors with mobile subjects like birds. What we're really talking about is electronic flash.

Electronic flash

A single flash on camera will provide you with a convenient bright light source for relatively close subjects. However, the light is 'hard' and emanates from a point source, giving rise to dense, black shadows with no modelling on the subject. Built-in pop-up flash, such as found on some of the lower-spec SLR camera bodies, is not powerful enough to be of any real use to bird photographers. Moving the flash off camera, or using additional fill flash can restore a more natural appearance, but the chances

Wendy Shattil and Bob Rozinski

Snow Goose Night Roost, Bosque del Apache, New Mexico, USA

This photograph was highly commended in the 1999 BG Wildlife Photographer of the Year competition. Wendy and Bob describe how they worked with the luscious evening light and translated their vision on to film:

❛ *Preparation, perseverance and luck are required to capture special moments like this. Careful observation of the snow geese taught us where and when the flock returned to a night roost. The photo was taken about 30 minutes after sunset when some birds had arrived at the roost and others were still approaching. No hide was necessary. We selected Fujichrome Velvia film to hold the whites in the warm light and register the pastel pink and peach of twilight. Because of the $1/8$ sec. exposure, the camera was on a tripod and we selected a corresponding f16 aperture for enough depth of field to include foreground and background birds. Our lens of choice was a Canon 70–200mm on an EOS 1-N body. The zoom simplifies compositional adjustments, which is beneficial with moving subjects. We used a slow shutter speed to give the scene a sense of motion. In this image the geese in the water are still enough to be sharp, while the ones flying in are less defined but recognizable as more of the same birds. From half a roll of film taken to document the scene, there was considerable variability due to the incoming waves of geese, movement of foreground birds, and changes in the light. Only one frame was exactly what we wanted. The least expensive aspect of photography continues to be film, so it makes sense to be generous with it. We've worked this location off and on for more than 15 years without having all the elements work together this well, so we took advantage of a great opportunity and shot as much as possible. The cloudless sunset, lack of wind, and perfect location for the birds combined with our knowledge of working with light and equipment to produce a memorable image.*

No filters or other manipulations were used. Nature provided all of the elements we needed. ❜

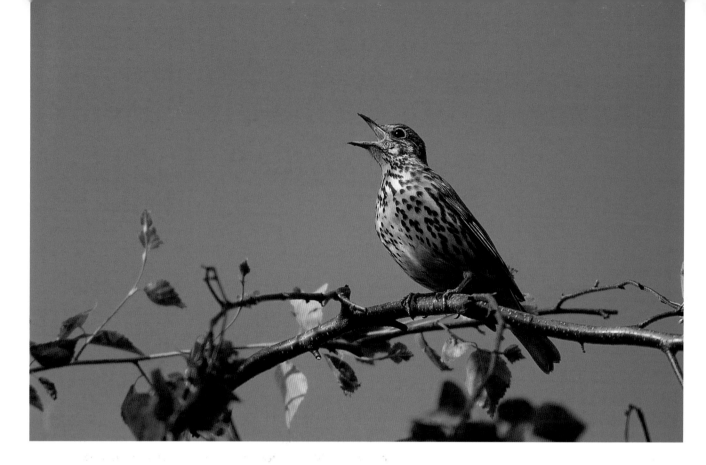

are that your photographs will still have a
nocturnal look, the black background being
caused by flash 'fall-off'. Remember the inverse
square law of light? If your subject is 10m
(33ft) away from the flash and the background
20m (66ft) away, the background will receive
only a quarter of the illumination reaching the
subject. Hence it records 2 stops darker on film
– this is quite a difference, and enough to
cause undesirable blocked-in shadows on
transparency. Assuming that you can't bring
the background and subject closer together,
you are left with two choices. Either illuminate
the background with more flash guns, or
balance the flash output with the ambient light
level, otherwise known as daylight-balanced fill
flash (see p.70). The latter is usually the more
feasible and produces the most natural-looking
results. Of course, if you are photographing
nocturnal subjects, such as owls, a black
background looks perfectly natural and flash
fall-off is not an issue, but it would still be
better to use more than one flash for improved
modelling on the bird.

Another difficulty about using flash in bird
photography is that you need either very close
subjects or a phenomenal amount of flash
power. You can see already that there are a

number of ways of setting about using flash,
and modern automated systems do make life
an awful lot easier. I still try to avoid using
flash in my bird photography wherever
possible, preferring the subtler nuances of
natural light, although daylight-balanced fill
flash can complement it quite sensitively.

Flash features and accessories

Dedicated 'smart' flash guns, such as those in
the Nikon Speedlight and Canon Speedlite
series, are powerful, sophisticated and easy to
use. They offer various refinements, such as
built-in fresnels for different focal length
lenses, automatic daylight-balanced fill flash,
infrared autofocusing, wireless through-the-
lens (TTL) control with built-in slave cells, rear
curtain (or second curtain) flash, strobe effect,
modelling light, red-eye reduction, and so on.
There is also a good range of independents on
the market, including those made by Metz,
Vivitar and Sunpak, and some of these models
are compatible with proprietary TTL metering
systems. For the beefiest flash output from a
portable system, look at offerings from
Norman and Lumedyne with their ability to
run multiple heads from a high power battery
pack. You can also improve your flash recycle

time by adding an external battery pack, either main brand or something like a Quantum Turbo battery.

There are a number of ways to diffuse or soften flash light. Studio photographers use brolleys or softboxes to scatter light rays and produce a softer lighting effect, but these are too large and impractical for most bird photography (except perhaps for birds in enclosed settings like an owl in a barn or a swallow nesting in an outhouse). There are miniature softboxes, which attach to compact electronic flash guns, but you do sacrifice quite a lot in light intensity with these and they are still somewhat cumbersome. More practical is to use a soft white cotton, gauze or glass-fibre diffuser material – a rough and ready solution is to wrap a handkerchief around the flash gun and secure it with an elastic band. Then you have the translucent plastic boxes that clip on to the flash gun, such as the Stofen diffuser, and various home-made equivalents. With all of these diffuser devices, your in-camera TTL flash metering will take account of the

modified light output. Note that diffusers are more effective if they are placed further away from the flash gun. All of these are effective solutions for improving light quality, but at the expense of light intensity.

More likely you'll be looking for ways to increase your flash output, especially when working with longer telephotos. For this purpose you can deploy fresnel screen flash extenders, which attach in front of the flash gun, usually with two connecting arms. These act to focus light into a narrower beam, similar to the angle of view of your telephoto, and gain you an extra 2 stops or so. But they do need to be aligned quite carefully. The Better Beamer/Walt Anderson flash extender is a lightweight, collapsible flash projector that attaches straight on to the flash gun, and is quite simple to set up.

Flash synchronization speed is basically a function of the camera body and how quickly the focal plane shutter operates. Until recently $1/60$ sec. was the standard flash sync speed, but nowadays $1/250$ sec. is more usual. This

Lesser noddys at nest
These tropical seabirds were photographed with automatic daylight-balanced fill flash, to combat the shade of the foliage but still appear as close as possible to natural light.
Camera: *Nikon F5*
Lens: *80–200mm f2.8*
Film: *Fujichrome Sensia 100*
Lighting: *SB-26 Speedlight on camera*

allows more flexibility for daylight-balanced fill flash with a greater range of shutter speed options, and is also useful in high-speed flash photography by minimizing ghosting effects. If ambient light is lower than the flash output, then the flash duration will determine the effective exposure time rather than shutter speed. Flash duration might range from about $1/1,000$ sec. at full output to $1/20,000$ sec. or even faster at reduced power on a typical compact flash gun. Even the slowest flash duration is fast enough to stop most bird movement, while the faster speeds achievable make it possible to use these modern units for seriously high-speed flash photography.

Normally, flash is synchronized to fire at the start of the shutter opening, but some flash guns can be set to fire at the end of the shutter sequence. This 'rear-curtain' flash lends itself well to creative action shots with slow camera shutter speeds, so that you can have a sharp image from the flash exposure with motion blur from the ambient light part of the exposure appearing to fall behind the moving subject (as opposed to in front of the subject with normal sync). Your flash gun might also have a rapid-fire strobe effect, allowing you to record several images of the same bird on a single frame, but to all practical purposes this is only an option with controlled or captive bird subjects. One of the more practical gadgets on modern flash guns is the infrared range finder, which can

autofocus your lens in total darkness as well as set the right flash exposure – I have used this feature to good effect when photographing shearwaters in dark nest burrows.

Determining flash exposure

The power or maximum light output of a flash gun is described by the manufacturer's guide number; the higher the guide number, the more powerful the flash. Before the advent of the smart flash, with its automatic TTL metering, all flash exposures had to be calculated by using the guide number, and it is still useful to know how to apply it (for example in high-speed flash work). The guide number when divided by the flash-to-subject distance in metres tells you the aperture you need to set when using ISO100 film. A typical modern flash might have a published guide number of 45 (metres). If your flash-to-subject distance (read off the lens-focusing scale if the flash is mounted on the camera hot-shoe) is 5m (16ft), then you should set your aperture to f9 (45 ÷ 5) with ISO100 film. If you happen to be using ISO200 film, don't double the guide number, but work out in the normal way and then expose at 1 stop less – f13 in this case, or f11 $1/3$. Similarly, if you have ISO64 film loaded, simply add $2/3$ of a stop to the calculated exposure.

A note of caution: manufacturers' published guide numbers tend to be optimistic, probably in the assumption that you'll be photographing relatively reflective subjects such as people's faces. I recommend that you work out your own guide number for your flash gun by making a series of test shots on a mid-toned subject outdoors (no reflective surfaces for the flash to bounce off) and carefully recording distance and aperture. This will almost certainly show that your true guide number is somewhat less than that advertised and give you a better understanding of your actual flash output, even if you have no intention of working out your flash exposures manually as normal practice.

For a more accurate flash exposure calculation you can use a flashmeter. From the subject position, point the meter cone towards the camera lens and trigger the flash by means

*Wedge-tailed shearwater
in nest burrow*

It's difficult to focus on a bird down a black hole in either manual or autofocus, if you don't have a torch (flashlight) to hand. However, an infrared rangefinder on a flash gun can automatically set the focus on a compatible lens and camera.
Camera: *Nikon F5*
Lens: *80–200mm f2.8*
Film: *Fujichrome Sensia 100*
Lighting: *SB-26 Speedlight on camera*

Blue tit and great tit on
peanut feeder
Multiple flash guns were used to
light this garden bird set, one
directed at the subject and two at
the background of shrubs. Flash
alone determined exposure
duration, and was fast enough to
freeze the wing movement of the
aggressive great tit –
approximately $^1/_{1,000}$ *sec.*
Camera: *Bronica SQ-Am*
Lens: *250mm f5.6*
Film: *Fujichrome RDP100*
Lighting: *Lumedyne flash system*

of an X-sync cable, or remote shutter release. This can give you a digital exposure read-out accurate to $^1/_{10}$ of a stop, and is very reliable, but only in fairly controlled photography 'sets'. Since you can't walk up to wild birds with flash meter in hand, it's not often a practical proposition out in the field.

In practice, it is more likely that you will use the flash's own automatic exposure facility, or better still the camera's integrated TTL flash metering. A TTL sensor placed in the camera measures light reflected off the film plane and regulates the flash output accordingly. Standard TTL flash is appropriate for dull light conditions, and the automatic metering is pretty reliable, provided the subject is within flash range – there is normally a warning light to alert you to under-exposure.

Multiple flash

Using more than one flash gun will expand your creative options considerably. So if you are working a regular site, such as a garden pond, bird feeder or nest box, it is better to light the 'set' with two or more flash guns. There should be one main light, which provides most of the illumination, and this is best set high and to one side of the camera to give an obvious directional light source. Your fill flash gun should be located nearer to the lens axis (or possibly slightly to the other side

of the camera) and be set at about one quarter of the power of the main flash (or double the distance from the subject), so that it softens the shadows but doesn't compete with the main light. Be prepared to experiment with the relative positions and try moving the fill flash so that it doesn't produce a second catchlight in the bird's eye. If you are working with nocturnal subjects like owls, a third flash firing behind the subject will produce a halo of backlight and make the subject stand out from the dark background, emulating moonlight when executed skilfully. Take care not to point the third flash directly at the camera lens giving rise to flare, and again you will need to experiment with relative flash positions and lighting proportions.

The only reason I can think of for using more than three flash guns is for illuminating backgrounds. So for instance, at a bird-feeding station photographed in daylight you want the extra illumination to give better depth of field, but you also need short flash duration at a high sync speed to stop bird movement. Two flash guns work fine on the subject, but you still have the old problem of flash fall-off with the background, and balancing to daylight would force the camera shutter speed too slow. The answer is to light the background with a couple more flash guns, balancing their output to that of the main flash. Test shots will

George McCarthy

Three barn owls, Sussex, England

These young barn owls were reared in a disused water tower, which they continued to visit after fledging. George McCarthy photographed them there, under licence, while a new business park was being built around them. Although the birds were successful this particular season, the loss of habitat has meant that the barn owls have since found somewhere else to nest, despite the fact that the developers subsequently incorporated a new clock tower in the park with special provision for owl nesting, with the photographer's help. George explains how he made this charming image, and how he lit the scene:

" *Photographs were taken from a 10m (33ft) scaffolding hide, which was built up over several days, carefully monitoring the birds' comings and goings each evening. At no time was there any problem with the adults accepting the hide, and in fact they and the young often used it as a staging post on which to land. Lighting was supplied by two Metz 60CT4 flash guns; the main light angled in from the left, with the fill flash positioned slightly to the other side and above the camera. I used a Canon EOS 5 camera with a 100–300mm f5.6L lens. The aperture would have been f11, which was calculated beforehand from a series of test shots using a white fluffy toy to ensure perfectly accurate exposures. My film was Kodachrome 64. I pre-focused the lens in daylight before each photography session, and was able to see well enough what was going on when the birds were present without the need for any artificial illumination.*

Although I was photographing over a period of several weeks, only on this one occasion did all three youngsters pose together, and then only for four frames as the recycle time for the guns was 13 seconds. I was delighted with the result, which continues to be one of my best-selling bird photographs. "

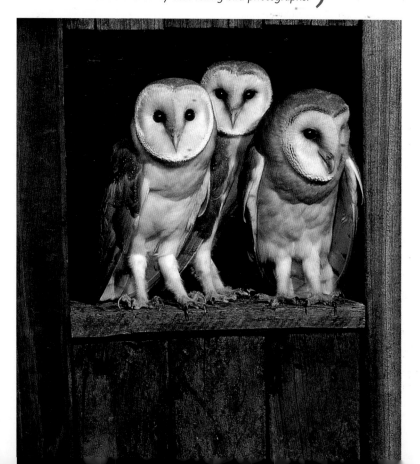

be necessary to check the light balance and make sure that no telltale shadows are falling on the viewable background.

To calculate exposure for multiple flash using guide numbers, just use the distance of the main flash to subject and disregard the rest, so long as you have set their output lower as recommended above. Really it makes better sense to take advantage of built-in TTL flash metering if you have one of the proprietary systems. The practicalities of using multiple flash means using off-camera flash brackets or flash stands, and TTL cables with multi-connectors or the use of photo-electric slave cells to fire all the flash guns simultaneously. Fortunately the latest wireless TTL flash systems with built-in slaves eliminate the need for lots of expensive and unwieldy TTL cable, and take care of exposure calculation.

Fill flash

Daylight-balanced fill flash (or fill-in flash) is quite an asset in bird photography, and its automation is a godsend. Use it to fill in deep shadows with bright midday sun, or with subjects against the light, and especially when working in dappled light conditions such as under woodland canopy. It will also bring life into a bird's plumage on dreary, overcast days and produce a gleam or catchlight in the bird's eye.

Calculating daylight-balanced fill flash isn't such a mysterious art. Set the ambient light exposure in your normal way, say in aperture priority automatic with centre-weighted metering, or in manual if you prefer, and then set the flash to deliver between 1 and 2 stops less light. In the past you had to think quite carefully about how to do this, and it meant cheating the autometering on the flash gun by setting a wider aperture or a higher film speed than that actually set on the lens and camera respectively. Now it's normally a simple matter of dialling in the appropriate adjustment on the flash compensation dial. Go for minus 1²/₃ stops as the standard for a mid-toned subject – this should be just enough to take the edge off the shadows without making your photograph appear too flashy or unnatural. With black birds, you will need to reduce this 1 further

The effect of daylight-balanced fill flash

For this series of photographs of a kingfisher the background was quite bright but the foreground in shade. An ambient light exposure with no flash (left) produced an acceptable result, but the bird still looked rather drab. The correct amount of fill flash (centre) showed a marked improvement, with shadows subtly filled and colours well saturated, but not too obviously taken with flash. Too much fill flash (right) gave rise to a 'washed out', unnatural light appearance.

Camera: Nikon F5

Lens: 500mm plus 1.4x teleconverter

Film: Fujichrome Sensia 100 uprated to EI200

Lighting: SB-26 Speedlight on camera

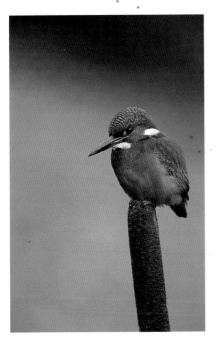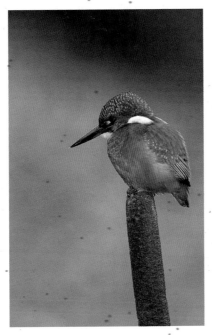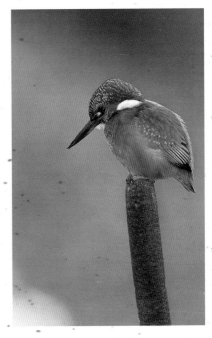

stop (minus $2^2/3$) to account for the subject's low reflectance. For white birds, minus $^2/3$ of a stop is nearer the mark. If you're doing it right, you still get a good exposure even if the flash hasn't fully recharged or you have a bad connection – you just don't get the flash element and will be stuck with the gloomy shadows. This can also occur if you simply don't have the flash power to reach the subject, so remember to watch for the flash under-exposure warning.

All of the above assumes that you are using the flash at its normal flash output or standard TTL setting, and not in the automatic daylight-balancing mode. The latter employs a pre-programmed fill flash level of about 1 stop below ambient light. It's perfectly OK to use this automatic mode, but you must take out about $^2/3$ of a stop to achieve the same look as described above. This is the quick and easy method of fill flash, and it's reliable most of the time. Again you will need to use the flash compensation dial to adjust for light subjects

(try plus $^1/3$) and dark subjects (try minus $1^2/3$), according to your own experience. For strong backlight, I tend to leave the compensation at zero. With the Nikon system, you can adjust the flash exposure (only) by making corrections on the flash gun, while adjusting the camera's exposure-compensation dial affects the whole exposure (both flash and ambient). With Canon, flash can be compensated on both flash gun and camera body but alterations made on the flash gun will override those made on the camera. Getting these two different flash modes (standard TTL and automatic daylight-balancing) straight in your own mind is imperative, and the key to mastering fill flash technique.

'Red-eye'

Some birds, particularly large-eyed nocturnal or forest-dwelling species, are prone to 'red-eye', caused by flash reflected off the retina. To overcome red-eye, the flash gun needs to be relocated away from the lens axis using an

off-camera bracket and lead. You might notice unnatural-looking catchlights with other birds at times, perhaps too low in the eye, and again this can be cured by moving the flash gun a touch higher relative to the camera. Unfortunately, you tend to notice these things only in the processed results, too late to do anything about it, but you can learn by experience to anticipate the problem with certain familiar subjects. Fill flash continues to work perfectly well with flash extenders and flash off-camera, if you use the right leads, because the camera's TTL metering measures light as it enters the lens and adjusts the flash output appropriately.

High-speed flash

The short duration of flash burst can be used to arrest the movement of fast-moving subjects and depict it in fine detail on film. It can be useful for photographing small birds in flight, for example. Purpose-built high-speed flash units deliver high illumination at fast speeds and still have a short recycle time, but they are neither cheap nor widely available. 'High-speed' flash generally means flash speeds of $^{1}/_{10,000}$ sec. or less – faster than the shutter on any standard SLR camera. Such

speeds might be necessary for flying insects and a few fast-flying birds, but you can achieve a lot with two or three basic flash guns set at low output if you can get them close enough to your subject. Look for manual settings that deliver $^{1}/_{2}$ down to perhaps $^{1}/_{64}$ power output, and check in the handbook what flash speed this represents. On a Nikon SB-26 Speedlight, full flash output (1/1) would have a flash duration of $^{1}/_{1,000}$ sec. while $^{1}/_{64}$ would be $^{1}/_{23,000}$ sec. – easily fast enough for working with birds.

The more practical difficulties lie in persuading wild birds to use a predictable flight path within your flash range, and synchronizing the flash burst precisely to the bird's position. These problems should not be underestimated, and you may need to devote the rest of your life to perfecting the technique!

To fire the shutter it is common practice to use an infrared beam trigger device, where the moving bird passes through the infrared beam, completes a whole circuit and effectively photographs itself. There are a few commercially available beam triggers, of varying sensitivity and range, usually effective up to a couple of metres. The trouble is, by the time the mirror has flipped up, the shutter has opened and the flash has fired, the bird will be well out of frame. This time-lag can be reduced by about 30 per cent by using camera mirror lock-up, but remember that this entails working in manual exposure and focus modes. Alternatively, you can use a Canon EOS-1N RS with the fixed pellicle (so no delay waiting for a reflex mirror to move out of the way) and retain your autometering functions. Whichever you use, there will still be a time-lag of some milliseconds to account for, and you will have to predict where the bird will be when the flash fires. This is a case of trial and error, and no small amount of luck, or getting into some very sophisticated electronics and specially designed shutters. Even when you are successful in getting the bird in frame, more often than not it will be in a poor position, with a wing across the head or something similarly unfortunate. Thus, high-speed flash photography undoubtedly requires a serious time commitment.

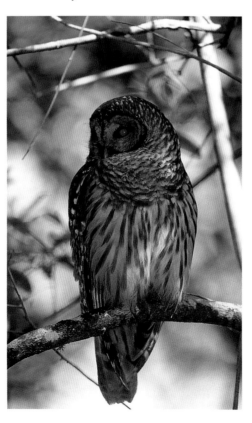

Barred owl, exhibiting 'red eye' syndrome
Flash located too close to the lens axis was responsible for this unpleasant phenomenon. I ought to have used an off-camera TTL flash cable to get around the problem, but that was one accessory left behind on this particular day.
Camera: *Nikon F5*
Lens: *AF-S 300mm f2.8 plus 1.4x teleconverter*
Film: *Fujichrome Sensia 100*
Lighting: *SB-26 Speedlight on camera*

Stephen Dalton

Wren in flight, Sussex, England

Stephen Dalton is a pioneer and recognized expert in high-speed flash nature photography. He insists that there are no trade secrets regarding his technique; in his own words:

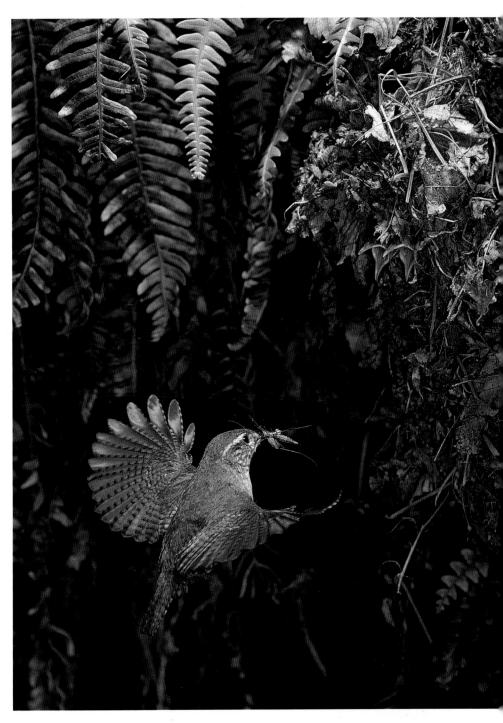

❛ *Both my techniques and equipment are pretty basic. The high-speed flash and triggering system were designed in the 1970s and virtually none of my gear has changed since. Certainly far more advanced stuff is readily available these days.*

The wren was photographed around 1975 and completed within a day! It was nesting in the bank of a stream about a metre up from the water among ferns, mosses and liverworts. Wrens are among the easiest birds to tackle because in my experience they take little notice of the photographer. Often, as in this case, the hide can be dispensed with altogether. I just stood a couple of metres away and watched, making the odd adjustment every now and again.

Three high-speed flash guns, with a flash duration of around $^1/_{25,000}$ sec., were carefully positioned to emulate natural lighting. Triggering was achieved by a conventional light beam and photo-electric cell, which in turn fired the camera via an external solenoid attached to a mechanical Leicaflex SL. The lens was a bellows version f4 Macro Elmar. Film used was Kodachrome II, an emulsion, which was superseded by the inferior Kodachrome 25. The aperture was about f11.

It is very unusual for high-speed photography of this nature to take only a day or so to complete. Most projects carry on for several days or sometimes weeks. Positioning flash guns and making adjustments at ground level around a co-operative creature, particularly a bird which frequently returns to one spot, is a totally different ball game to working with an owl 10m (33ft) up a tree – as you can imagine! ❜

Chapter 3
IN THE FIELD

Learning to visualize photographs is half the battle, but you also need to know where to look for birds, how to approach them, and generally how to get about and work in the field. This is the practical part of the book, the bit where you realize you have to get your hands (and more) dirty.

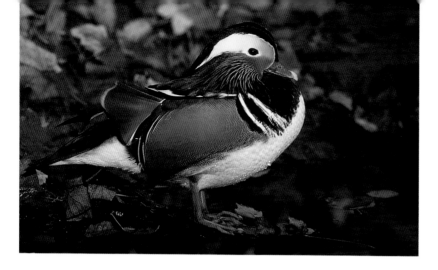

Mandarin drake
Wildfowl collections offer accessible bird subjects for practising your technique. But be aware that many of the birds may be 'pinioned' (some primary feathers removed to prevent them flying off). This handsome mandarin, a feral breeding species in Britain, was actually photographed on a river bank near my home, but the pinioned wing betrays its recent captivity. Observe the absence of a protruding wing tip on the near side.
Camera: *Nikon F5*
Lens: *AF-S 500mm f4*
Film: *Fujichrome Sensia 100*

(previous pages) **Black skimmers**
This post-roost flock in flight was photographed at approximately $^1/_{15}$ sec.

GETTING CLOSE TO BIRDS

The great mystique about bird photography seems to be, how on earth can you get close enough to wild birds to take any worthwhile photographs? First outings with a telephoto tend to reinforce this impression for most people, and the need for specialist field skills and boundless patience quickly becomes apparent as birds disappear into the undergrowth. I don't wish to dismiss these difficulties too lightly, and indeed all bird photographers, however experienced they may be, continually face frustrations, near misses, and being told 'you should have been here yesterday' – but let's face it, if it was easy it wouldn't be that much fun. Besides, there are a number of techniques that we can learn to improve our chances.

Getting started

Assuming that you are now equipped to a reasonable level as has been described in earlier chapters, you will want to find some birds you can photograph relatively easily to get used to your camera and fire your interest. At this stage, it's no bad idea to visit a park lake, or a wildfowl or other captive bird collection, where you have guaranteed subjects at close range. Other locations for more approachable subjects might be harbours, picnic sites, or gardens where birds are used to visiting bird tables and feeders and are habituated to people. Practise framing up on moving birds, experimenting with different lenses and camera positions, and generally familiarizing yourself with all the camera controls. If your equipment is totally new to

you, I would say it's even worth practising for a while without any film loaded until you feel more confident. But you'll have to expose film to determine whether you have mastered such crucial things as exposure control and critical focusing. Start with a faster film – say, ISO200 or 400 – and progress to slower, finer-grained emulsions as your technique improves.

When you have your first processed results, the chances are you'll be disappointed at the low proportion of good shots. Bin the rubbish and only show other people the better ones. This is basically the same editorial process as

used by professionals, and it's neither cheating nor wasteful, just a necessary part of your development as a bird photographer. Being hard on yourself now will lead to more rapid progress, and you will get better.

I strongly suggest teaming up with a friend with similar interests so that you can fuel each other's enthusiasm and share in the practical aspects, particularly early on. The mutual support will accelerate your progress and help to see you through some of the inevitable frustrations. You could also benefit from belonging to a camera club, especially if other members are interested in birds and wildlife photography. Without doubt you should join the BirdLife International partner organization in your country, and learn as much as possible about the birds you would like to photograph, their habitat requirements and where you might go to find them. Develop a network of birdwatching friends, perhaps through a local bird club, and ask them to alert you to any good photographic opportunities (though non-photographers tend to underestimate the distance of birds out in the open by a factor of about ten, in my experience).

Great bittern

Although bitterns tend to skulk in reed beds, they do emerge to feed in open water from time to time. This one was photographed from a public birdwatching hide at Lee Valley Country Park, Hertfordshire.
Camera: *Nikon F5*
Lens: *AF-S 500mm f4*
Film: *Fujichrome Sensia 100*

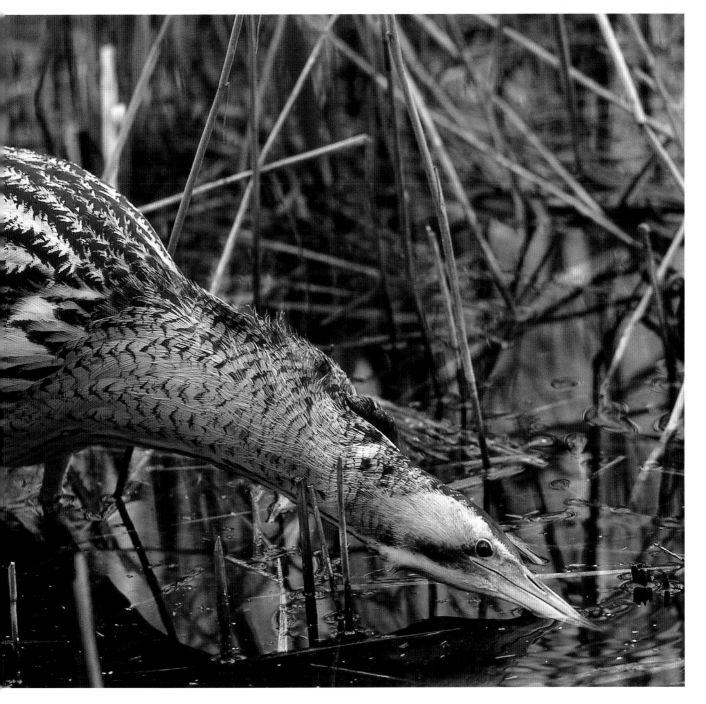

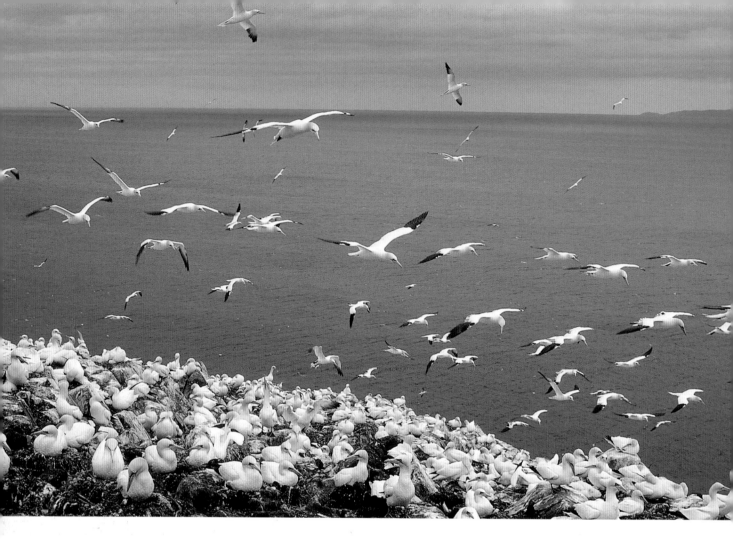

Gannet breeding colony at Bass Rock, Scotland

A trip to a seabird colony in summer is always a feast day for a bird photographer. Your greatest problem is likely to be the weather; if winds are unfavourable, boats may not be able to land safely at island sites such as the Bass Rock in Scotland's Firth of Forth.
Camera: *Nikon F4S*
Lens: *28mm f2.8*
Film: *Kodachrome 64*

Nature reserves with public observation hides frequently afford good photographic opportunities, particularly at wetland sites, and membership of a bird organization will give you free access to many of these. You do need to remember, though, that these are not primarily designed with photographers in mind, and you will have to be tolerant and considerate of other visitors, not least when movement over wooden floors makes your camera wobble. Perhaps you just need to get in earlier in the day to avoid the heavier visitor pressure. If you think the windows are too low or too narrow, or there is some annoying vegetation obstructing the view, by all means mention it to one of the reserve staff; if you do this politely, you might find some remedial action is taken. Many of my own favourite photographs have been taken from public hides such as these, usually just resting a beanbag on the window ledge.

Treat yourself to a visit to a seabird colony in the breeding season, and you will be thrilled at the approachability and sheer numbers of the birds and the chance to take lots of photographs in one session. This sort of experience can make up for a few disappointments and really lift your spirits. There are also a growing number of specialist holidays for wildlife photographers, and workshops with experienced professionals as tutors. Such holidays tend to go to destinations with reliable, good light and big, tame birds, but of course nothing is guaranteed. Tours such as these are not cheap, but are likely to suit people with limited holiday and leisure time.

Finding birds to photograph

As you gain in skill and confidence, you should be seeking out your own subjects rather than relying on organized activities. Inexperienced bird photographers often seem to believe that you have to be 'in the know' about the best locations, but this is really missing the point. True, you have to know enough about a particular bird to predict where it is likely to be found and in what season, and this is an

important part of your background research and developing field skills. There are a few 'honeypot' sites for certain species that are regurgitated in various publications, but you shouldn't expect others to do the work for you all the time, or you'll never really mature as a bird photographer. There are potential subjects and latent photographs all around you, wherever you live, and your challenge is to be able to visualize them.

An closer inspection of the published photographic record will soon reveal that many bird species and their behavioural activities are under-represented. Where are all the photographs of the commonplace, such as house sparrows and starlings; the small and secretive, like willow warblers and chiffchaffs; the fast fliers, like swifts and swallows? Not to mention icons such as a song thrush at its 'anvil' or a skylark in song flight – behaviour we are all familiar with, but still largely unphotographed. I agree that some of these are particularly challenging subjects, but the difficulty does not lie in the bird's scarcity, or an inability to locate it. As a sometime picture researcher and photo library editor, I can testify that it is very difficult indeed to find top-quality photographs of garden birds at feeders, bird tables and nest boxes. Such subjects are neither hard to find nor difficult to approach, but many photographers look instead for subjects that they imagine are more exciting or desirable. But commoner birds can be equally beautiful and at least as interesting as the more unusual ones, and there is certainly a market for the photographs.

Planning an assignment is a great way to focus the mind, whether it be for a camera-club project, national competition or simply a self-set goal. Perhaps it is your lifetime ambition to photograph the King of Saxony bird of paradise, or a similarly rare and exotic bird, in which case you probably know more than I about how to get on with it. If you are not quite so dedicated or single-minded, choose a bird to which you might have ready access, something you should have the opportunity to do better than others. If you live near the coast you might specialize in shore birds. You could begin by looking at

what other photographers have achieved with the same subject, and think about how you might do it differently – or better! Read the published references, and learn all about your chosen bird's habitat and its food preferences, distribution and migration, social patterns and behaviour, and its breeding ecology. You may also need to do some local research: it sounds obvious, but it really is no use turning up expecting to photograph a wader roost only to find it's low tide. Speak to some appropriate experts if you possibly can, whether these be academic researchers, farmers, gamekeepers or conservation managers, and pick their brains in order to gain further insights. Think more about what it is that makes the species attractive or interesting, and the behaviour or posture you would like to portray. You should begin to form a mental picture of how you would like your photographs to look, right down to details such as background and season, and then set about aiming to achieve it for real. Quite possibly you will need to spend more time conducting your background research than you actually spend on the photography, but it is certainly not wasted time – good preparation always pays off.

Explore possibilities of access at various likely sites, and secure permission from landowners to set up hides, if necessary. This might be more difficult than you would first imagine, and it helps if you can show some credentials that testify to your being a responsible and trustworthy photographer – some work you have done previously, perhaps, or a letter of introduction from another landowner. There is often a presumption against portable photography

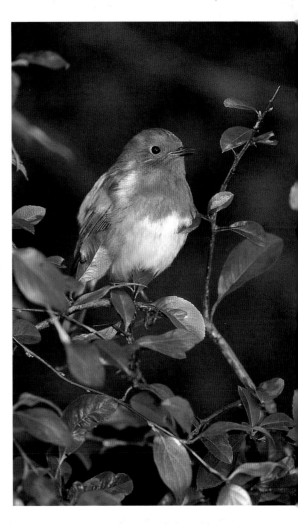

Robin in sub-song
Don't overlook photo opportunities close to home, where some types of bird may have become habituated to people. No hide or special preparation was needed for this portrait of a robin in my garden.
Camera: Nikon F5
Lens: AF-S 500mm f4 plus 1.4x teleconverter
Film: Fujichrome Sensia 100 uprated to EI200
Lighting: Fill flash from SB-26 Speedlight

hides being allowed on nature reserves, but it may be at the discretion of the site manager. Your chances will be much improved if you are known as a local supporter, the more so if you have given your time and help as a voluntary warden or helper. What else can you give back? The offer of duplicate or spare slides for staff to use in their lectures, or a print for the information centre display probably wouldn't go unappreciated. And if you make the offer, be sure to follow it up. Next time ought to be easier.

The concept of the 'home patch' is just as valid to a photographer as it is to a birdwatcher. Regular visits to known areas force them to yield up their secrets. I find that I am rewarded more often in locations that are familiar to me, and to which I have frequently returned, and somehow it is more fulfilling when you have taken the trouble to get to know a place and its birds. Furthermore, whatever your subject, and no matter how many times you have photographed it, you will never believe you have made the best possible photograph – there is always better to be had.

The photographer's hide

A photographer's hide (or 'blind') is a device for concealing the photographer and getting closer to a bird than you could without it. Hides work, not because birds can't see them, but because they don't associate them with people, and so perceive no threat. To maintain that trust and lack of suspicion, you must observe a few simple procedures and disciplines (more on this below). Hides are set up at locations where there is a better-than-average chance of a bird returning, whether for food, water or a favourite perch or a communal roost. Predicting these places and being there at the right time is the difficult part, but we'll look at that, too.

The main requirements for a hide are that it should be rigid (not flapping or moving about), opaque, and dark inside. There needs to be a way in and out, an opening for the camera lens, and at least one viewing window. Beyond this, it

can be any size and shape you like, and made of almost any material.

The traditional portable hide is a canvas or fabric structure on a wooden or metal frame. It is usually about 1.5m (5ft) high, with a base about 1m (3ft) square – just large enough to contain photographer, tripod and equipment. There are commercially available models like the Jamie Wood 'Fensman', but many photographers make their own, tailored to their personal requirements and preferences. A modern variation is the dome hide, with flexible poles, such as the LL Rue 'Ultimate' blind and Wildlife Watching Supplies dome hide. These are lighter, more compact and usually quicker to erect, so they are better suited to travelling, though they are not quite so robust for withstanding the elements over longer periods. Small tents and hooped bivvy bags can also be pressed into service as hides, and are great for low viewpoints, but there's a limit to how long you can lie on your stomach propped up on your elbows. Bag hides that are designed simply to throw over the photographer and camera on tripod are quite hopeless, because your shape and every movement are visible.

Lens openings need to be at a comfortable height when you are seated, and disguised somehow. A conical lens port can be sewn into one of the hide panels, with a drawstring for fastening tight around the lens barrel. These are good for concealing your hands and keeping out light, but when it's windy the movement of the hide material is transmitted to the lens so camera shake can be a problem. A better solution is the combined viewing window and lens opening, making use of two or more loose flaps of gauze or mesh material, so you can see out but the birds can't see in. I opt for a removable fabric panel making a rectangular window, which I then cover liberally with scrim netting that hangs loosely around the lens, and I find this gives me the best possible visibility with adequate screening.

There are a few other features you might pay attention to. Spiked poles driven into soft ground make for a very stable framework, especially with the addition of guy ropes; however, on a solid substrate you will need a

Wildlife photographer's
dome hide
This model from Wildlife Watching Supplies fulfils most of my requirements, and is very light and compact for travelling.

Niall Benvie
Eider drake, Montrose, Scotland

Niall Benvie is a hardy Scot who appears not to mind the cold, and regularly takes to the water with his favourite, home-made floating hide. I asked him to account for his preference:

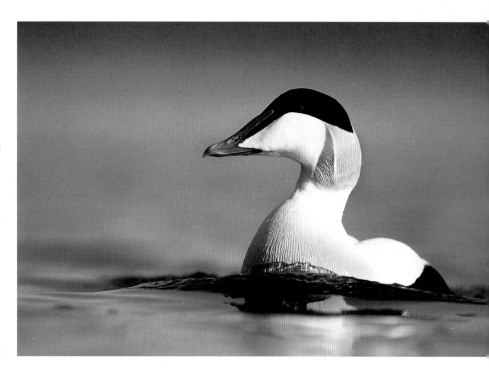

" *Of the different species of waterfowl I have photographed from my amphibious hide, eiders have proved to be the most trusting. Once the hide is beached, as the tide ebbs, it is sometimes possible to stalk the ducks by edging forwards a few centimetres at a time. Some confiding birds have allowed me to approach as close as 5m (16ft). I think the amphibious hide is generally more successful than a fixed terrestrial one because it appears to the birds from the water; many species appear to associate a human threat only with the land.*

As far as stability is concerned, the hide works best when it is grounded but, given enough light and fast film, it is feasible to shoot from the open water. The trick is always to keep your feet on the bottom of the estuary or lake. Not only is this type of hide mobile, allowing the photographer to advance, withdraw, and move on to another group of birds, but it also offers an intimate, low-angle perspective on the subject. My current model allows me to have the lens just 15cm (6in) above water level, supported by a beanbag resting on the hide frame. An angle finder means that I do not risk flooding my chest waders as I look through the camera, and autofocus keeps the image sharp while I concentrate on panning the hide to follow the birds. This is the last word in 'fluid action'.

For this shot I used a Nikon F5 and Nikkor 500mm f4 AF-S lens, Fujichrome Sensia 100 film uprated to EI200, with an exposure of $^1/_{1,000}$ sec. at f5.6. During courtship in March, eiders swim all around my hide, often approaching too close to focus. The speed of this one's approach can be gauged by the bow-wave. "

self-supporting structure. Flaps or pockets at the base of the walls can be usefully employed for weighting down with rocks to give extra stability. Flat-topped hides are better with roof support members, so that accumulating rainwater can run off rather than drip through. Interior pockets are most useful for stowing accessories, keeping them handy, off the ground and out of the dirt.

Semi-permanent hides for longer-term projects can be made from marine plywood or glass fibre, while improvised hides might be built from local materials, such as rocks or fallen branches, perhaps with a sheet of plastic and a turfed roof for weather-proofing. I have even known photographers who have made hides out of carved blocks of snow, like an igloo. For working at height, scaffold towers might need to be bought or hired, with a suitable platform for accommodating your hide, but ensure you observe safety guidelines. Further refinements and specialisms include amphibious or floating hides, which are mainly used for ducks and waterfowl. I like the North American model that is disguised as a muskrat lodge; this is one for the intrepid, involving a semi-submerged operator propelling the structure through the water with fins. A hybrid hide I once encountered on an estuary floated serenely through high water and then grounded so that it was stable at low tide, and featured an amazing revolving turret like a military tank. So your imagination is the only limit.

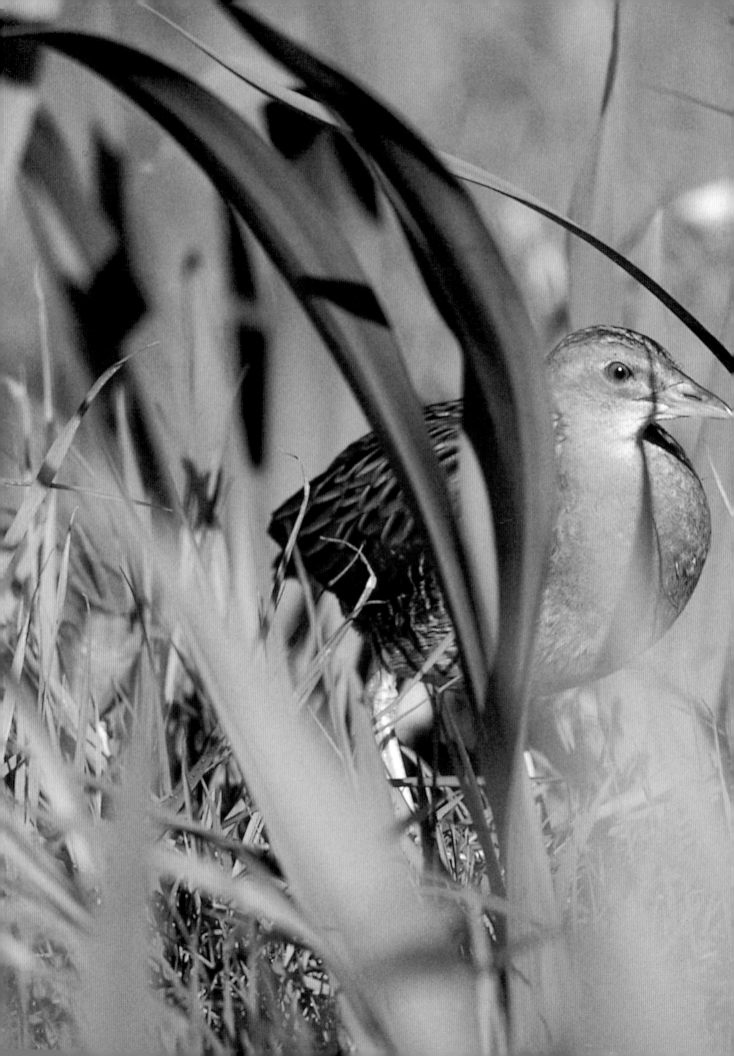

(previous pages)
Corncrake in iris bed
This corncrake was photographed from a car window in the Hebrides.

Hide camouflage
Made from locally available, natural materials, this hide (below left) blends with the surrounding topography. The traditional canvas hide (below right) employs camouflage netting and leaf screen to disguise its cuboid shape.

Hide procedures

Before installing a hide, it is imperative that you obtain permission from the landowner or their agent. Even in the most remote location, don't presume that nobody will notice you. You should also consult other interested parties before going ahead – the farm manager, shooting tenant, grazier, or anybody else who might come across you and wonder what's going on. Many national parks and nature reserves around the world forbid the use of photographic hides, so before visiting make sure you are aware of the park regulations with regard to photography.

In most countries there are statutory laws governing photography of wild birds at the nest. Disturbance is strongly discouraged, and you may need to obtain a licence to photograph some species. Erecting a hide near the nest would certainly count as intentional disturbance. Incidentally, possession of a licence confers no right of entry, so you must still obtain the landowner's permission. Different systems apply in different parts of the world, and in some countries all nest photography is against the law. You should assume that there are regulations in force unless you know differently. Unfortunately there is no central register where you can investigate the various international legal requirements, but the BirdLife International partner organization in the relevant

country ought to be able to enlighten you.

To ensure the birds' welfare and improve your own chances of success when using hides, follow best practice at all times and err on the side of caution. The guiding principle is that the welfare of the bird is more important than the photograph.

Hides should be sited so as to be away from the attention of casual observers, as far as possible. Use depressions in the ground and topographical features, such as boulders and fallen branches, as natural cover. Digging down might be an option to keep a low profile, but be mindful that heavy rain could flood you out. Camouflage with nets and leaf screen, or local vegetation, such as reed stems, heather or foliage, to break up the outline of the hide, particularly at sensitive locations where you don't want to attract people's attention.

Work out your hide position by framing up with your preferred telephoto on the likely bird position, and if you have difficulty imagining the relative size of the bird, refer to a field guide for its dimensions and place a similar-sized object *in situ* so as to determine range. Consider where the light will be coming from at the times you expect to use the hide. It is best to introduce a hide in stages, beginning by erecting it some way off and moving up gradually to the final working distance. Alternatively, start with the hide in a heap on the ground and slowly build it up. To do this

responsibly might take as little as a few hours with garden birds at a feeder, or a couple of weeks with a bird of prey at the nest. Check after each movement that the birds have accepted the hide by watching from a distance, and if there is any suspicion that the birds are being prevented from going about their normal behaviour because of the hide, move it back a stage or withdraw altogether. Only when you are positive that the hide is tolerated should you consider leaving it unattended. Secure against the elements, camouflage as above, and introduce a dummy lens for the birds to get used to before you commence photography. A black plastic plant pot is a good imitation of a lens hood, and cheaper to lose. If you think the birds might be especially sensitive, you could line the inside base with a reflective material such as aluminium foil to look more like a glass lens.

You must be sure that the birds you are targeting don't associate you with the hide, but it is difficult to be absolutely confident that you are not being observed entering and leaving. For this reason, it is customary to use an accomplice as a 'walk-away'. Approach the hide together. Your accomplice should remain close by until you are properly installed with all of your equipment. He or she then looks around and checks that you are completely invisible from outside, particularly when your hands are on the lens and your face is up close to the window. You may need to double up the scrim, or wear gloves and balaclava to cover up pale skin. Certainly avoid having any window or door opening letting in light behind you, otherwise your silhouette will be obvious. When all looks good, your accomplice can leave you to it. The idea is that the birds see the human disturbance arrive and disappear, and they return to their normal business. It does work, although photographers' folklore holds that with more intelligent birds like ravens you need to use several people as walk-aways. At the end of your session, the disturbance again arises away from the hide when your accomplice returns to collect you. Arrange to meet at an agreed time, and leave together as quickly and quietly as you can. If you can possibly co-ordinate it so that you are collected from the hide when no birds are around, so much the better. You can signal when the coast is clear by poking a handkerchief out of a side window, or maintain communication with a mobile telephone or walkie-talkie. Remember to replace the dummy lens when you leave.

So how long should you stay in the hide? In short, as long as you can bear it. Usually my minimum spell in a hide would be about six hours, but it depends on the species of bird and the situation. Two or three hours might be appropriate for a drinking pool or garden bird feeder, with different birds coming and going

A recessed hide
Situated at a bird of prey feeding station, this hide was partly dug into the ground and camouflaged with net, leaf screen and dead bracken to make it as inconspicuous as possible. Note the drink bottle that is used as a dummy lens in between photography sessions.

Swallow

A completely fortuitous accident resulted in this photograph. My hide was set up for a larger subject at greater range when this swallow landed just in front.
Camera: Nikon F3
Lens: 300mm f2.8 plus 2x teleconverter
Film: Kodachrome 64

(opposite) **Great bustard male courtship display**

Photographs like this can be achieved only through careful and sustained hide work (see pp.126–7).
Camera: Nikon F4S
Lens: 500mm f4
Film: Fujichrome Provia 100

all the time, but for more sensitive subjects, such as birds of prey or grazing geese, it would be more like twelve hours, and could be from dawn until dusk.

You want to avoid repeated disturbance at all costs, and it would be bad form to keep entering and leaving the hide, or have an accomplice attempt to flush birds on to a choice perch, make them fly, or otherwise harass them. Apart from being unethical, it's unlikely to produce the results that you want.

Settle into the hide quietly, try to avoid making any sudden movements of lenses, and on no account poke hands outside the hide. Do not allow the lens to protrude too far – a camouflage sleeve, tape or cover helps to make it less obvious. When birds first return within range, try to contain your excitement; it is usually best to give them a chance to settle and not just hit the motordrive. Leave the lens pre-framed and focused on a likely perch or resting position, make only minor movements at first and keep them slow and smooth. Perhaps try a single frame initially to test the birds' reaction to the noise of the shutter and film advance, and you'll begin to see just how much they will tolerate. As they become more confident you can take greater liberties, but this seldom means being able to swing the lens around indiscriminately; neither should you change lenses while birds are present. To attract a bird's attention and make it look up, you could try whistling softly, but I wouldn't do much more than that. Don't be lulled into a false sense of security if birds seem to ignore the hide and camera completely; if you overstep the mark and flush a bird, it is most unlikely that you'll be able to retrieve the situation.

When you withdraw your hide at the conclusion of photography, remove all rubbish from the site and make good, replacing turfs or anything else you might have disturbed. It should look as if you were never there.

The above describes a cautious and responsible approach to hide work, and it's the way I always try to work until I know a particular bird well enough to be sure I can

afford to relax a little or vary the routine. In some situations it might be possible to enter and leave the hide under the cover of darkness without the need for an accomplice – for example at a field used by grazing geese, which go to roost elsewhere at dusk. You have to use your common sense as to where shortcuts can be made without disturbing the birds unreasonably or spoiling your own chances. For a high-tide roost of shore birds there is no harm in setting up your hide at low tide when there are no birds around, sitting out the tide and exiting after they have all dispersed to feed again; but you would still do better if they have time to get used to the hide first.

Comfort in the hide

Whether your working session is six or twelve hours, it's a long time to sit still and be quiet. Hide sessions can be arduous and often boring, but there's no merit in enduring hardship for the sake of it. Anyway, if you are cold and restless it's going to affect your work, for the worse. The more comfortable you are, the longer you can persevere and the better you can concentrate on your photography.

First of all, make sure you have a comfortable seat. It needs to be light and portable, quite compact and low to the ground. I prefer a canvas chair with rails rather than pointy legs, so it doesn't sink into soft ground so easily – there's nothing worse than tipping over on one corner all the time. A back rest is a huge benefit so that you can relax in between spells of photography. Fishing tackle shops usually offer a good selection of folding chairs, if you have trouble finding them elsewhere.

Inactivity causes you to feel the cold more than usual, so dress well for cold-weather sessions and wear extra layers. Thermal underwear is highly recommended, as well as hat and gloves. Handwarmers are a good idea, either the charcoal-burner type, or chemical packs. In hot weather you just have to strip off and hope you don't get any surprise callers.

Food and drink will sustain you, but remember that what goes in must come out. Large plastic bottles can be useful in this respect, and they can also double as a dummy lens (when empty!). If you're not too fussy, just

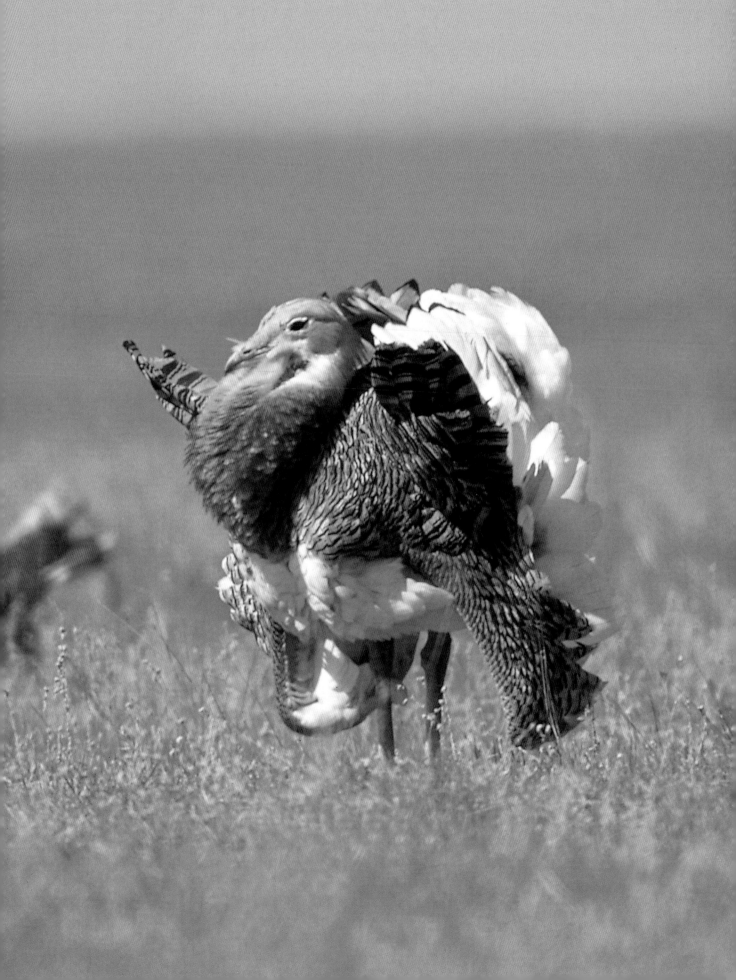

ensure you know which way is downhill and that the land drainage is good. For more serious calls of nature, I recommend you keep a plastic bag and some tissue paper standing by for emergencies. Mercifully, I have never needed to resort to this.

If you are ambitious, planning sustained hide sessions with overnight stops, you really want a hide large enough in which to stretch out and lie down. Bring a sleeping bag and mat. For five-star accommodation, you could even consider a portable gas cooker and chemical toilet, but it would have to be a pretty serious photography project to warrant this trouble. Sometimes I use a hooped bivvy bag pitched next to my hide with a camouflage net covering both, so I can crawl unseen from sleeping bag to hide and vice versa.

It helps if you are happy with your own company in a confined space. Some photographers I have tried to introduce to hides during workshops couldn't stand more than half an hour cooped up in there on their own; if you think you might be of a similar disposition, perhaps you have to admit you might not be cut out for hide work. Other photographers I know read books, listen to a personal hi-fi and even smoke a pipe in their hide. Personally, I think all of these distractions are ill-advised as they inevitably disturb your concentration. There might be long periods of bird inactivity, but you have to be ready to respond very quickly when some action does eventually occur. With limited visibility, audio cues become very important. At a golden eagle eyrie I once photographed, not only could I hear when an adult bird approached but I could identify the female before I saw it, from the hum of its wing where a primary feather had moulted.

It's a good idea to keep a log of bird activity observed from the hide. Such notes can be very helpful when planning future photography if you are trying to remember seasonal timing or frequency of feeding visits. You might also witness bird behaviour that deserves to be reported to researchers or written up as a note to a journal – quite possibly few people will have ever seen the things you are privileged to observe from your hide, so you can make a worthwhile contribution to the scientific record.

Other than a notebook and pencil and the usual camera accessories and consumables, there are a few other items you might find useful to have in a hide: a small torch for finding things in your bag or dropped on the floor, or checking more obscure camera settings; spare scrim for extra camouflage; safety pins for fastening scrim and emergency repairs; and a Swiss Army knife or Leatherman tool.

Photographing birds at the nest

It is a matter of historic convenience that until about the 1960s birds were almost always photographed at the nest. Large, heavy plate cameras with short focal length lenses, slow film emulsions and slow shutters dictated the technique. Birds would have to return to their nest to incubate their eggs and feed their young so, if you pitched up alongside, sooner or later you would obtain your photograph. Sometimes it was a risky business, leading to the desertion of nests when it was not carried out with sufficient care, but there were comparatively few bird photographers, and it was in an era when the fascination for nests and eggs was more widely tolerated. Nowadays, we have many more ways that we can go about our bird photography, and society tends to frown on what it sees as an unhealthy or misguided obsession with birds' nests. Moreover, editors are tired of seeing nest shots and want a change. Who can blame them, when nesting represents just a small part of a bird's life cycle and there are many more interesting types of behaviour to photograph? On the whole, it's better to look for alternative subjects to photograph.

Nevertheless, I don't believe that nest photography should be either outlawed or censored – the breeding cycle is an important aspect of bird biology and there are occasions when it is perfectly appropriate to use nest photographs, in context, even for promoting conservation projects to a wider audience. Whether we are allowed to continue the practice in future depends largely upon

whether responsible behaviour is demonstrated by photographers.

Birds at the nest will almost always need to be photographed from a hide, with the exception perhaps of a few species of seabirds. This requires keen field skills, not least in finding suitable nests to photograph. Follow the hide procedures as detailed above, exercising particular caution and with a few additional considerations.

The location of nest sites should be kept secret, as far as possible. As well as being discreet with sensitive information, that will mean concealing your hide from the public gaze – camouflage as best you can, and don't leave it up longer than you need to. The rarer the bird, the more important this is. It is particularly important to introduce the hide in stages when working at nests, and assess the birds' reactions to it after each movement forwards. Be prepared to move the hide back, or withdraw it completely if they show signs of not accepting the disturbance. For instance, in species where both parents normally feed young, you should ensure that they are continuing to do so. Avoid working on the hide when it is unusually cold or hot, or during wet weather. It is safer to commence hide-building after chicks have hatched. Birds are most sensitive and easily disturbed when first prospecting nest sites, during nest-building, and about the time of egg-laying. Visits to and from the hide should be as few as necessary to complete the job, with changeovers kept as brief as possible. Again, avoid entering and leaving the hide during poor weather.

Keep the 'gardening' of nest sites to an absolute minimum, so that only the most obstructive branches and foliage are gently tied back and then replaced after each photographic session. Opening up the nest makes it vulnerable to weather and predators, as well as inquisitive people, so the natural cover must be restored properly. Cutting back vegetation would therefore be very irresponsible. Sadly, it is still possible to see photographs of birds' nests where it is obvious that severe gardening has taken place, with

Hen harrier female feeding its young

No 'gardening' was involved in this nest photograph of a specially protected bird. This was vital for the birds' welfare and ultimate nesting success, but in fact I think it also works better aesthetically – it seems more respectful of the subject, and in keeping with its ground-nesting habit. The foreground obstruction of heather is better for being well out of focus, and makes us feel as though we are being granted a privileged peek into the harrier's private life.
Camera: *Nikon F5*
Lens: *AF-S 500mm f4 lens*
Film: *Fujichrome Sensia 100*

Golden eagle female and chick
Photographing this wild golden eagle at the nest (top) remains my most demanding ever photo assignment. I used a scaffold hide (above) to get near to the nest.
Camera: *Nikon F4S*
Lens: *50–300mm f4.5*
Film: *Fujichrome Sensia 100*

foreground heather or reeds literally mowed to the ground. There can be no excuse for this.

Blocking of nest holes to make birds perch in the open, removing eggs and young from the nest for photography, or other such blatant interference could have a harmful effect on breeding success and should not be done under any circumstances. With colonial nesting birds, work only at the edges of the colony to avoid trampling nests and causing unnecessary disturbance.

Keep notes during your photography sessions and record the timing of all bird visits to the nest. This information can be used to convince yourself (and others, if necessary) that normal incubating, feeding and brooding behaviour is continuing despite the presence of your hide. In the unfortunate event of a nest failure, it will at least be clear that you have taken every reasonable precaution.

Remember that a special photography licence may be required to allow photographer disturbance of rarer birds at or near the nest. You will need to demonstrate to the appropriate agency that you have the necessary experience to work with nesting

birds, and supply a reference. If you are lucky enough to obtain such a licence, it should not be regarded as a *'carte blanche'* to do as you please and ignore the usual safe procedures. Rather, it is a privilege that carries additional responsibilities. At the end of the season you will be required to submit a return form detailing all your activities around the nest; failure to comply with any of the requirements of the licence or any report of bad practice on your part would make it unlikely that you would receive another licence.

If all of this sounds like a heavy burden of responsibility, I can only suggest that you steer clear of nest photography until you feel you have the necessary field experience. Certainly it would be best to avoid photographing birds at the nest as a first option. Ideally, you should learn from an experienced nest photographer.

Adapting to bird behaviour

Different birds have different reactions to hides near the nest, and you should be ready to modify your approach in response. Even different individuals within the same species can vary in their behaviour quite markedly, so

be prepared to ditch any preconceived notions. It's not necessarily the commoner birds that are more tolerant of hides and photographers; for example, familiar garden birds such as robins and song thrushes, or screech owls in North America, can readily desert nests and eggs if disturbed during incubation. Conversely, some rarer breeding birds such as the avocet and dotterel can appear quite tolerant. However, their confiding nature doesn't automatically mean that they are not experiencing stress, so make sure you exercise the usual care and respect.

Most birds of prey are very sensitive at the nest. It is customary to wait until after chicks have hatched before introducing a hide, and then it is still best to wait for downy chicks to start to feather so they are better able to control their body temperature. An alternative method for traditional eyries is to build a semi-permanent hide over the winter months, but work should be complete by February as nest-site prospecting gets under way very early with the larger birds of prey. And if they choose an alternative site, you have to try again another year!

The most difficult, suspicious bird I have ever photographed at the nest was a golden eagle in Scotland. After obtaining a Schedule 1 photography licence and locating a suitable nest site, my hide and scaffold was built up over a period of two weeks, and well camouflaged. The adult eagles accepted each stage quite readily up to and including the addition of a dummy lens, but as soon as a real lens was substituted the birds became very touchy indeed. Even though the entire lens was contained within the hide itself, with a long tunnel of branches and foliage in front of it, I couldn't get them to accept a 300mm f2.8 lens – presumably because of its large object diameter. A 50–300mm f4.5 seemed to present a lesser threat, but I also found that I had to remove the front skylight filter, I assume because it was flat and more reflective than the curved front element of the lens. Still the eagles would not tolerate the slightest zooming action of the lens, even though the zoom mechanism was all internal, so any changes in focal length had to be made while

the birds were absent. Strangely enough, they never seemed remotely concerned about the noise of the shutter and motordrive.

The smaller, weaker chick died very early on, as is usual with eagles. As the surviving chick grew larger, the visits of the parent birds became less and less frequent, so that there were days when I was in the hide for ten or twelve hours but saw adults at the eyrie for a total of only ten or twelve seconds as they dropped off food for the chick. This is quite normal behaviour, but after all the effort I had put in to establishing the hide, and the long climb up to the crag each day, it was a little demoralizing. To end up with just a few static portraits of an adult eagle on the nest ledge seemed to be at odds with the glamorous reputation of the subject and my high expectations. It certainly made me appreciate how pioneers like Seton Gordon and Charles Palmar could have devoted their entire lives to obtaining a few remarkable images, without many of the advantages I had enjoyed. More to the point, if publishers ever ask me for photographs of golden eagles it's almost invariably a bird in flight they want to see.

Many of the photographs you see of adult birds carrying a bill full of insects or caterpillars are actually photographed only a short distance from the nest, as the birds return to feed their hungry chicks. This probably causes less disturbance than a hide that is set up to photograph the nest itself, as the photography can be conducted further away and without the need for nest gardening. You still need to proceed cautiously, use a hide and make sure your presence doesn't prevent chicks from being fed. Regular perches may be used on approach, and you can try introducing one of your own choice to see if it is accepted. Sometimes the birds like to look around from such a vantage point, to check that no predators are watching. Parent birds may also make use of perches as they leave the nest, possibly as they dispose of hatched egg shells or nestlings' faecal sacs.

Many ground-nesting birds in particular have young that are soon mobile and leave the nest within hours of hatching. These are dependent on their parents for some time

Skylark carrying food to its nestlings

Nest-approach perches are better alternatives to actual nest sites in most circumstances. Make sure that your presence doesn't prevent chicks from being fed.
Camera: *Nikon F5*
Lens: *AF-S 500mm f4 plus 1.4x teleconverter*
Film: *Fujichrome Sensia 100*

afterwards, whether for food or protection, so be vigilant. An agitated tern or wader might be bolder than usual and look like an ideal subject for photography, but think for a moment about why it is alarm-calling from a nearby fence post or above your head. You may be standing very close to its chicks.

Earlier in the spring, opportunities for photography may arise as birds seek out nest-building material. The soft mud at the edge of a puddle or garden pond could attract house martins or song thrushes; fallen twigs might be collected by rooks or pigeons; reed buntings like to line their nests with fluffy reedmace seed; long-tailed tits make use of soft feathers; hummingbirds use lichens and spiders' webs; great-crested fly-catchers collect snake skins; and goldfinches gather thistledown. Meeting these needs by creating a rich supply of raw materials might well pay dividends, and you can find many more favoured nest materials for different species. It's a little more imaginative than nest photography, and makes for more interesting results.

Remote-control photography

There are occasions when it's easier or more desirable to get a small camera closer to a bird than a hide and its occupant, and fire it remotely from a distance. The most straightforward way of doing this is by means of an extended electrical shutter-release cable. Some camera manufacturers can supply these, for a price, but it is a simple matter to make your own. Take a standard shutter-release cable for your camera body, cut it in half, and solder opposite phono plugs to each end (say 'male' to the camera socket end and 'female' to the switch end, but it works just as well the opposite way round). For your extension lead, use a length of two-strand bell wire, and again fit opposite phono plugs to each end. The extension can be at least 50m (165ft) without creating too much resistance, in my experience. This extension is easily deployed when you need it, and the rest of the time you can use your shutter release at its normal length.

A neater solution is to use an infrared release, which has a transmitter and a receiver unit and can operate typically up to a range of

(right) **Arctic tern feeding young**
This image was photographed with a remote camera and a 30m (100ft) cable release.
Camera: *Nikon F3*
Lens: *28mm f2.8*
Film: *Kodachrome 64*
Exposure: *$^1/_{125}$ sec. at f8*

about 100m (330ft), but requires a good 'line of sight'. Infrared releases usually have a choice of several channels (allowing you to operate more than one camera at a time), a test mode and confirmation light, and you can also select between single-frame and continuous film advance from the transmitter end. Radio releases can operate over still greater distances, even through a brick wall, but they tend to be enormously expensive and most countries require you to have a special licence for their operation at specified radio frequencies.

The camera itself will need to be set up on a tripod, stand or bracket, or even on the ground. A soundproofed box, or 'blimp', for the camera can be a great advantage in remote work as the bird will be so close. Make your own with plywood or similar, to accommodate your favourite camera body, and pack the spaces with foam rubber. You must incorporate a lens opening, shutter-release cable access, tripod fastening or adjustable feet, and a means of access to the camera viewfinder. Either install the camera through a removable back panel, or use a top-fitting lid and view through a waist-level finder or right-angle eyepiece attachment. A box will also offer some degree of weatherproofing and protection for your camera.

Most often, remote-control bird photography is undertaken with a fairly wide-angle lens (say, 24mm to 35mm range) and this does give an unusual perspective for a bird photograph. It's also easier to frame up and pre-focus for maximum depth of field with a wide-angle. Of course, you will have no control over framing, exposure or focus from your operating position, so all of these must be set in advance. Usually it's most dependable to set the metering mode to aperture priority automatic. I wouldn't use autofocus in these circumstances as you can't be really sure of the bird position when the shutter is fired, so the AF could easily lock on to the background by mistake.

Instead, use manual focus and set the lens to its hyperfocal distance. This is the distance setting for a particular aperture that gives maximum depth of field, right through to infinity. For instance, if you expect your subject range to be about 1m (3ft) using a 28mm lens, don't just focus the lens to 1m and hope for the best, as even at f16 your depth of field won't extend much beyond 2m (6ft). However, if you focus the lens to just under 2m, still at f16, your depth of field will extend from about 0.9m (just under 3ft) to infinity, easily keeping your subject in focus, as well as the rest of the scene. Since your subject will hopefully dominate the foreground it shouldn't be necessary to keep focus in front of that, but it is best to have the background sharp. Most wide-angle lenses have these depth of field scales inscribed on the lens barrel, so use them to your advantage for setting hyperfocal distance.

If you are not using a blimp, remember to close the eyepiece shutter before withdrawing, or cover the eyepiece with tape or something similar to prevent stray light affecting the automatic metering. Alternatively, use mirror lock-up in combination with a manual exposure setting; this is riskier with regard to exposure, but has the advantage of cutting down noise and the delay of shutter operation, which could be helpful with a very close, nervous subject. Perhaps disguise the camera with pegged-down scrim or netting, taking care not to cover the lens. Make sure you have a fresh roll of film loaded, set the film advance mode and fire a test shot to ensure everything is working before you leave.

Finding appropriate subjects for remote-control photography is not that easy, and it is a technique with a high built-in failure rate because of its inherent unpredictability. Ideally, you need to be able to pinpoint a spot to which a bird will return with some degree of accuracy. This might be a favourite feeding spot or a regular perch, but if the bird is even slightly suspicious of the camera it may not come back and may just use an alternative perch or food source. As with hides, begin with the camera at a comfortable distance and gradually move it up towards its final photography position. A dummy camera,

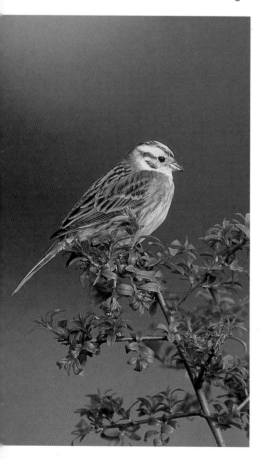

Yellowhammer male in summer plumage

Photographed using my vehicle as a hide, this yellowhammer was found down a local country lane in the early morning. A well-managed hedgerow provides a better wildlife habitat and more photogenic perches than a line of sterile fence posts.
Camera: *Nikon F5*
Lens: *AF-S 500mm f4 plus 1.4x teleconverter*
Film: *Fujichrome Sensia 100 uprated to EI200*
Exposure: *$^1/_{250}$ sec. at f5.6*

or your soundproofed box with the camera removed, can be left out over a period of days to allow the bird(s) to get accustomed to it. Some particularly tolerant ground-nesting birds, such as some species of waders and terns, can make suitable candidates for remote-control photography if approached with due care. Once again, move the camera up in stages and withdraw it if the incubating or brooding parent does not return and settle within a few minutes.

Viewing from a distance, it can be difficult to judge when the bird is in frame at the pre-focused range, and even more difficult to see when it is in a photogenic posture and in good light. Watch through binoculars to identify the optimum moment, and observe the bird's reaction when you take your first shot. Usually you can see a bird flinch slightly on the first occasion the shutter is fired, but it should soon calm down and accept the slight noise. Count off your frames, and don't be tempted to return to the camera to check it's operating properly or fiddle with the controls until you have used a whole roll or you decide to abandon photography for the day.

Using a vehicle as a hide

Photographing from a vehicle window may not be the most romantic idea, but it is often highly effective. A car makes a great mobile hide, and takes you closer to many birds than you could reach on foot. As with purpose-built portable hides, birds just don't seem to associate vehicles with people, though you may need to do a bit of discreet covering up to disguise the human form.

Park up by a likely perch or feeding spot, with your telephoto at the ready resting on a beanbag or car-window clamp. Most likely you will need at least a 600mm lens for this kind of work. Cover the window with scrim netting if you have the opportunity, and black out light from the window behind and sunroof above so your silhouette is not visible. Wait quietly for birds to return. It doesn't really need saying, but turn off the car engine to cut out noise and the risk of camera shake. If you spot a potential subject while driving slowly, you might get closer by turning off the engine a little in advance and coasting the last few metres.

Photographing birds from a car window
With your telephoto lens supported on a beanbag, you should be able to get sharp results at shutter speeds of $^1/_{250}$ sec. or even slower. When possible, screen yourself with scrim net and black out the sunroof and the passenger side window.

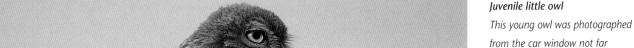

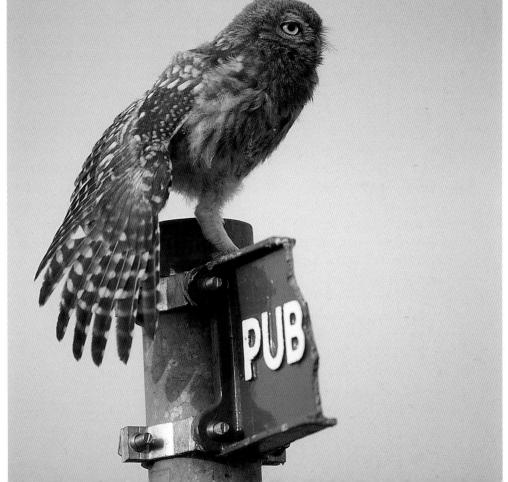

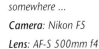

Juvenile little owl
This young owl was photographed from the car window not far away from the yellowhammer opposite. It was quite late in the evening by now, and I think there may be a message in here somewhere ...
Camera: Nikon F5
Lens: AF-S 500mm f4
Film: Fujichrome Sensia 100

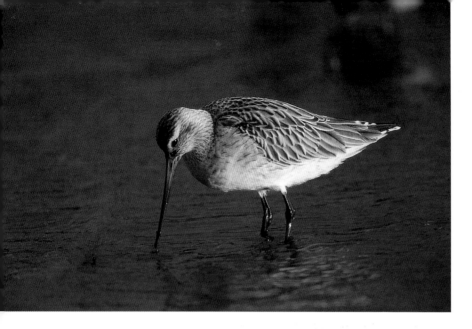

Bar-tailed godwit in winter plumage

Stalking shorebirds is generally more successful in cold weather, when they are anxious to feed, and tourist beaches out of season are often good places to find them. Low winter light distinguishes an otherwise straightforward shot.
Camera: Nikon F5
Lens: AF-S 500mm f4 plus 1.4x teleconverter
Film: Fujichrome Sensia 100 uprated to EI200
Exposure: $^1/_{160}$ sec. at f5.6

I have successfully photographed many species of birds from car windows in a whole variety of different habitats, from skulking corncrakes to waders in tidal creeks and singing corn buntings in hedgerows. Clearly you are limited in where you can go, and there are safety issues to consider, too – finding quiet country lanes with adequate roadside parking can be something of a challenge in developed areas, and you'll need to check your rear-view mirror constantly. Another disadvantage is that many of the birds you will be able to photograph are inevitably perched on boring fences or walls, or else out of sight behind them. Sometimes you can 'enhance' a perch such as a fencepost by placing a rock on top of it and framing so that only part of the rock perch is visible; birds often take readily to these modified perches. Is that cheating? Does it matter if nothing is harmed or misrepresented? Don't get carried away with this car-oriented technique. It is not meant to be a lazy person's charter.

Stalking

The term 'stalking' conjures up images of commandos in battle dress and face paints, or Native Americans with their ear to the ground listening for buffalo. Usually, when bird photographers talk about having 'stalked' a bird, they just mean they were lucky enough to have been able to walk up and photograph it without a hide. But for many birds in most parts of the world, this is going to be a difficult undertaking.

It requires patience and persistence.

Clearly you can't go about trying to stalk a bird with undue haste or noise. It is best to work alone, keep a low profile and try to avoid making a silhouette of yourself against the sky. Use the cover of bushes and rocks where available – even having these behind you is quite effective. In the latter stages of your approach, as you enter the bird's 'comfort zone', you might need to crouch or crawl, a little at a time. It often helps to approach at an oblique angle, zigzagging forwards and not looking directly at the bird, or pointing your lens at it. Sudden movement or noise would be disastrous at this stage. Remember that birds prefer to take off into the wind, so they feel more comfortable if you don't block their escape route upwind. Quietly take a frame or two as you come within camera range and gauge the bird's response; if it doesn't appear too concerned you can advance a little further in the quest for a larger image. You may ultimately reject a great many of these early photographs, but you never know how close you're going to finish up, so take a few insurance shots along the way. More often than not you will try stalking a bird and end up with nothing; it is worth persisting until you find the bird that doesn't object to the camera.

You need to be pretty mobile for successful stalking. Abandon your backpack and carry only the bare essentials, perhaps in a photographer's vest or gilet. A monopod might be more useful than a tripod to give you the versatility and mobility required, but for ground birds you will do best to lie down. Resting on a beanbag or directly on the ground is the most solid possible lens support and gives a terrific low-angle view, provided that you can find a line of sight with no obstructions. Mostly you will need to use the longest lens you can wield when working out in the open, so image stabilization can be a considerable help.

On the other hand, I can think of circumstances where approachability was not the main issue, but rather keeping up with fast-moving birds flitting through the bush. In the Seychelles, I found that an 80–200mm zoom hand-held with fill flash allowed me the

freedom and speed of reaction I needed to photograph some of the passerines. So you have to be adaptable.

Rather than chasing after a reluctant subject, lie in wait and let the bird move close to you. Sometimes you can successfully predict where a bird might return – for example, to a regular song perch or feeding spot. An advancing tide or the urgency to feed on a cold day might gradually push birds towards you. Make yourself as inconspicuous as possible and see if they will co-operate, but don't allow your presence to threaten their survival or breeding success. If you are sitting on a cliff top in summer and can't believe your luck when a peregrine repeatedly flies low overhead, calling loudly, it's because you are too close to its nest site! Keep aware of your actions and their potential consequences. Good fieldcraft is the most important ingredient, as ever.

Food

Birds respond to locally high concentrations of available food. In nature, this might be a swarm of emerging insects, a shoal of fish that is trapped behind a sandbar, or a crop of ripe berries. In the managed countryside, it could be gulls following the plough or herons congregating at a fish farm. You can think of lots of other examples. Use this knowledge and observation to plan photography assignments and possible hide locations.

Alternatively, you can create your own artificial supply of bird food; match the food with the birds you want to attract. You can even set up a feeding station for many different birds by providing a whole selection of foods in a natural-looking set within range of your hide. It may take some research and experimentation to work out the most effective food for a particular subject.

In a garden situation, sunflower seeds and peanuts seem to draw the widest range of species, but there are many other specialities. Robins and dunnocks find live mealworms irresistible, while goldfinches can be tempted by black nyjer seed, and great spotted woodpeckers love beef suet. Grain works for sparrows and buntings. Windfall apples and pears are good for winter thrushes and starlings. In North America, chickadees love sunflower seeds and peanut bits, while orioles and tanagers take oranges and other fruit from feeders. Hummingbirds come in for hummer nectar (sugar solution)

Osprey with rainbow trout
Abnormally high concentrations of food, such as trout at a Highland fish farm, are bound to attract hungry visitors. Fortunately, the ospreys are welcomed by the owners here. This was the best result from several early-morning hide photography sessions, in pre-autofocus days.
Camera: Nikon F3
Lens: 300mm f2.8 manual focus plus 2x teleconverter
Film: Kodachrome 200
Exposure: $^1/_{500}$ sec. at f5.6

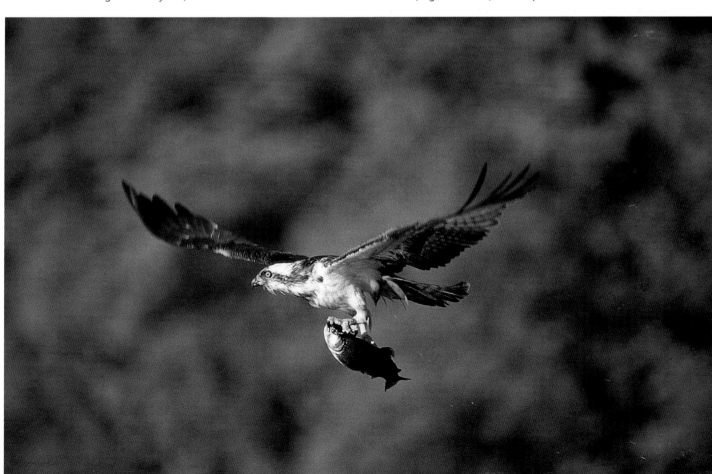

Laurie Campbell
Golden eagle on a dead stag,
Lochaber, Scotland

Influential nature photographer and author Laurie Campbell rarely works beyond his native Scotland, and is the most dogged and persistent fieldworker I have ever met. His summary of the circumstances leading up to this landmark photograph gives some indication of his determination:

❛ *After almost three years of working with golden eagles, this picture represented a real milestone for me as it was from my first-ever close encounter with a wild golden eagle away from the nest. It is from a sequence that I shot over a week-long period, covering a bird that I had managed to tempt with bait. I was working on a collection of pictures to illustrate a book on these birds and had already spent two summers photographing these individuals near to the nest, so I already knew something of their movements around this particular glen. It seemed natural therefore, to continue to attempt to photograph them on the same territory over the winter. I began in the autumn by building an igloo-shaped hide from rocks. It overlooked a stretch of ground that I knew the birds hunted over and that received good light – even in midwinter. It was also reasonably accessible, and I could drive my camper van to within a kilometre of the site – an important consideration, given that I needed to transport heavy camera gear and deer carcasses for baiting.*

By late December, the short days as well as the poor visibility caused by low cloud and snow forced the birds to look for quick and efficient ways of finding food. Once the eagles were coming to the bait regularly, to build their confidence it was really important for them not to see me anywhere near the hide. This meant that whenever I wished to use the hide I needed to both enter and leave under cover of darkness. My only problem then was remaining comfortable while waiting for the birds' daily visits. Not too difficult really given today's choice of outdoor clothing.

My equipment on this occasion was a Nikon F3 and 300mm f2.8 lens, using Kodachrome 200 film with an exposure of $^1/_{125}$ sec. at f4. ❜

With typical modesty, Laurie neglects to mention that he was snowed into the glen for the duration of the week and unable to leave even if he had wanted to!

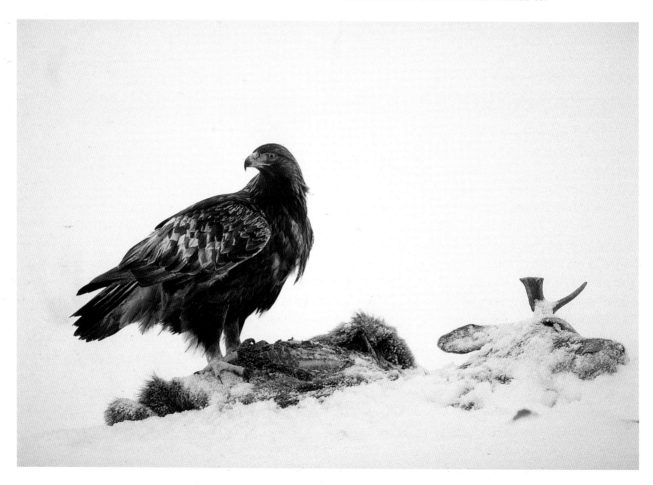

provided for them in a special feeder. There are many different types of foods you can try, and there are bound to be regional variations and preferences. You may even hear some photographers brag about their own 'secret' recipes, but stick with the evidence of your own eyes. Plain old sliced bread can be a useful contingency, not just for ducks and seaside gulls – many is the time I have sacrificed my sandwiches for the sake of a photograph.

If you don't want to show artificial feeders in your photographs, then cache the food in crevices in a tree trunk or branch. Locate feeders near to attractive natural perches, or introduce your own, and photograph birds as they approach the feeder. You might not wish exotic food items such as peanuts to be visible in the bird's bill, so replace them with wild foods such as acorns, beech mast or hazel nuts when the birds have got used to coming to a particular spot.

With wild foods, if you can create a temporary glut, somehow this can be very effective at narrowing down birds' feeding options. Digging over an area of flower border or even just watering a small patch of lawn makes lots of invertebrates suddenly available to ground-feeding birds such as robins and thrushes. When there is a good crop of acorns in season, collect and store a load somewhere cool and dry, and then put them out again a couple of months later when the natural supply has become exhausted. Concentrate them in a small area near your hide, cover with dried leaves, and watch birds such as jays and wood pigeons soon discover them. With ripening fruits and berries, you can try covering just one bush with netting until all its neighbours have been picked clean, but be careful that this doesn't entrap eager birds.

If you have a large enough garden or access to suitable land, consider planting specifically for birds; native trees and shrubs provide valuable bird food. Ivy is favoured by wood pigeons, mistle thrushes and wintering blackcaps, and makes a beautiful evergreen background, too. Sowing a patch of thistles, teasels or sunflowers will be sure to attract flocks of finches. Berry-bearing shrubs such as cotoneaster, pyracantha and berberis are also worth planting to tempt birds into your garden.

Some birds of prey and crows can be lured down to feed at carrion, especially in hard weather, but carcasses of large mammals like sheep, goats or red deer might be difficult to obtain, especially as some countries have laws about the safe disposal of dead livestock. A road-kill victim, such as a rabbit, is probably the easiest sort of carrion to come by, but smaller prey like this should be staked down with tent pegs or similar so as to prevent foxes removing it in the night,

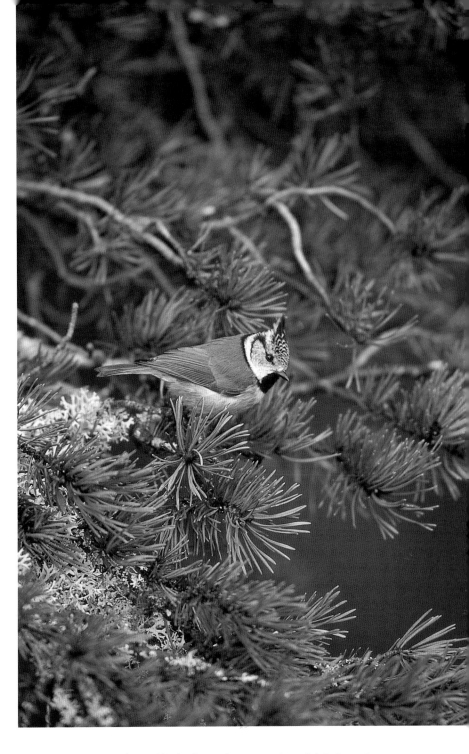

Crested tit in Scots pine
The peanut feeder is just out of frame, but the crested tit appears to be foraging in its natural habitat. Choose the bird's likely approach perches with care.
Camera: *Nikon F5*
Lens: *AF-S 500mm f4 plus 1.4x teleconverter*
Film: *Fujichrome Sensia 100 uprated to EI200*

Redwing feeding on hawthorn berries

An early autumn migrant, tired and hungry after its journey, is keen to replenish energy reserves. Native berry-bearing shrubs can be planted in your garden to attract a wider range of bird visitors to photograph.
Camera: Nikon F4S
Lens: 500mm f4 plus 1.4x teleconverter
Film: Fujichrome Sensia 100

or larger birds from dragging it away. Place a perch, like a fence post or boulder, nearby and birds may be persuaded to use this on their approach. Expect a baited site such as this to take some time to become established, and make sure you get your hide up well in advance of your proposed photography. Day-old chicks from poultry farms are commonly fed to birds of prey and owls, but again it's a lengthy process to establish regular feeding patterns for photography.

Dead fish can be used successfully to attract some fish-eating birds, and this can be spectacularly effective at sea. Some birdwatching pelagic, or open-sea, voyages rely on the use of 'chum' to draw in seabirds like petrels and shearwaters – this is an evil-smelling brew of fermented fish offal and oil, mixed with popcorn to help it float. Apparently, tuna oil works very well indeed, and chopped shark's liver is another really choice ingredient if you can get it. The Procellariiformes (tubenoses: albatrosses, petrels and shearwaters) are able to detect certain chemicals over some kilometres, and quickly arrive on the scene from an apparently birdless ocean. It has been found that storm petrels in particular respond to dimethyl sulphide (DMS), which is a substance emitted by phytoplankton that attracts the zooplankton on which the storm petrels feed. Neat dimethyl sulphide is a very potent attractant and is sometimes used on these pelagic expeditions, although it would be cruel to use DMS alone and not reward the birds with some food.

These are just a few ideas of feeding projects that can be attempted, and are not meant to represent an exhaustive list. Of course, the feeding patterns of many birds don't lend themselves readily to photography. For instance most insectivorous birds, especially those that feed on the wing, will nearly always be out of camera reach. And whatever can you do about diving ducks?

The use of live prey to bait birds for photography raises several ethical questions. While most people wouldn't think twice about using the odd worm, or even a few small fish, anything larger or warm-blooded moves us into controversial territory. Few of us would wish to cause pain or suffering to a bird or mammal, and wouldn't dream of deliberately baiting with them. Indeed, there are cruelty laws that forbid this in most Western countries. However, by putting out food for small birds in our gardens we might inadvertently create a food source for sparrowhawks and other raptors. I guess the difference is that you're not restraining the potential prey, which have a fair chance of escape. Personally, I can't think of anything more exciting than being able to photograph a predator capture its prey in the wild. But when it comes to live bait, I think I'll stick to worms and fish.

Water

Just as birds need to feed, so they need fresh water for drinking and bathing to keep their feathers in good condition. Seek out regular watering holes – the more concentrated the water source, the better it will be for photography. It is best if there is a shallow beach or entry point, or some emerging branch or rock for birds to perch on. Areas where fresh water is an otherwise scarce resource will be the most productive. Freshwater outfalls at the coast are good for attracting birds, particularly those that can't utilize saltwater.

A near-dry Middle Eastern desert *wadi* might look unpromising, but for ten minutes at the same time every morning thousands of pin-tailed sandgrouse may converge from miles around to collect water in their breast feathers and then carry it back to their chicks. It's rarely as spectacular as this, but photographing at waterholes can be quite exciting as you never know what is going to appear next. On one trip to Spain, a friend and I found a tiny puddle

in a farm track where a few rock sparrows were drinking following a recent rain shower. We introduced a hide, and over the following three days of dry weather we kept the puddle topped up from a water bottle and were rewarded with 24 different species coming to drink. As they ranged in size from serin to booted eagle, a high-ratio telephoto zoom would have been useful! Waterholes are good for attracting birds you might have difficulty getting close to by other methods. Seed-eating birds in particular need to drink quite frequently, and tree-top species such as redpolls and crossbills are easier to photograph when they come down to water than at any other time.

A dripping tap or sprinkler in the garden can be all it takes to bring down birds to drink, but a birdbath or garden pond is a better way to ensure regular visits. You can make your own pond quite easily with a plastic or butyl pond liner – keep it small and compact with shallow edges, and line with sand or gravel to make it appear more natural. You will need to replenish the water often. Emergent perches make convenient stopping-off points, and help to separate birds from their background. Try to photograph birds on their way in, as they can look pretty scruffy and bedraggled when saturated after a good bathe. However, action shots of bathing birds with arcs of spray and water droplets can look very dramatic. Following a soaking, birds will usually rest up on a nearby perch to preen and dry.

A small sheet of plastic, about 1m (3ft) square, is a useful supplement to your field kit. It will enable you rapidly to improvise a drinking pool for photographic purposes almost anywhere you go.

Roosts

Roosts are safe locations where birds regularly return to rest or sleep, often in large flocks for security. Most species of birds go to roost at

Sparrowhawk harrying coal tit
Concentrations of small birds at garden feeders attract predators, which can become quite regular and predictable. I was just grateful for the opportunity to witness and photograph the chase. The coal tit escaped on this occasion, though I'm not sure if it was helped or hindered by the squirrel-proof basket.
***Camera:** Nikon F4S*
***Lens:** 300mm f2.8 manual focus*
***Film:** Fujichrome Provia 100 uprated to EI200*
***Exposure:** $^1/500$ sec. at f4*

Bob Glover

Oystercatcher bathing, Essex, England

Bob Glover is very much his own man, not easily tempted by foreign travel and technical gadgetry. Well known for his splendid photographs of waders on the East Anglian salt marshes, Bob is secure in his local knowledge and technique. Here he gives us an insight into how he prefers to work:

❛ *I have been photographing birds along the Essex estuaries for the past 16 years, and I rarely travel outside the county to take photographs. Working a local patch so thoroughly brings with it a knowledge of bird behaviour that pays off in the long term. It also helps in building relationships with landowners, who allow me to set up hides on private land.*

A fair proportion of my time has been devoted to capturing shots of waders and wildfowl bathing. Although they spend much of their time far out on intertidal mudflats, waders prefer fresh or brackish water for bathing. This might be an outfall on to the mudflats or a brackish pool inside the sea wall. Inland pools are easier to work, preferably with some shelter from the elements, since I use cloth hides and generally leave them up for several weeks at a time. I set my hides as low as possible, to reduce the birds' suspicions but also because I like very low profile photographs.

My photographic equipment hasn't changed much since I started bird photography and I still use the same manual focus 600mm f5.6 Nikkor lens. Until recently, I wouldn't have trusted the capability of autofocus in all situations. Autofocus also didn't used to work well with teleconverters, and in my estuary work I can rarely get by without one of these. For the oystercatcher photograph I would have been using the 600mm lens with a 1.4x teleconverter wide open at f8, and by pushing Fujichrome Sensia 100 film one stop would have just squeezed a shutter speed of 1/500 sec. ❜

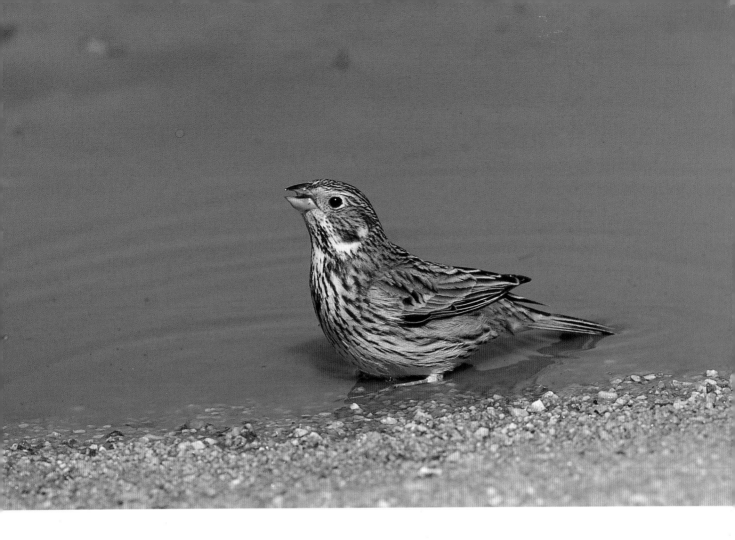

dusk and depart again at dawn, but gulls and shore birds roost when high tides make their feeding grounds inaccessible. Nocturnal birds such as owls tend to roost during the daylight hours, and are often quite approachable then, if you can find them – sometimes owl roosts are given away by the cacophony of scolding blackbirds and robins that have detected the presence of a predator. Vast flocks of starlings roost in trees and, in urban areas, on the ledges of high buildings. In North America, blackbirds and American robins gather in large numbers at dusk. Geese congregate on open water, swallows and pied wagtails frequently choose reed beds, while wood pigeons and stock doves prefer dense woodland. Treecreepers sometimes nestle in the soft, ridged bark of wellingtonia trees, but can be very difficult to find by torch light. Well-used roost sites of any kind of bird might be betrayed in daylight by droppings on the ground beneath the perches. All of these sites represent potential photo opportunities for the enterprising photographer, some more difficult than others.

If you are dealing with large flocks, it makes sense to attempt to portray the spectacle of the roost. Shore birds such as knot make an absolutely magnificent sight as they swirl around and turn in unison, often likened to a smoke cloud or amoeba, white one second, turning grey in an instant. This is just the pre-roost gathering and, if you do your homework on seasons and migrations, times of high-water spring tides, and favoured roost locations, you might be lucky enough to get a hide up in the right place well in advance of the flock landing and settling. Many times you might wait out a whole tide cycle only to be disappointed at the total absence of birds. If by chance they do land close to your hide, even if not close enough for photography, you will have to sit it out until after they disperse at the end of the roost; it can be a long wait watching a dense flock of tens of thousands of birds all with their heads tucked under their wings. But after an hour or two, as they begin to get restless again, some birds might break away from the group to bathe and preen,

Corn bunting drinking from a puddle
This was just one of 24 species that came to drink here over a three-day photography period. The puddle was refreshed each day from a water bottle.
Camera: Nikon F4S
Lens: 500mm f4 plus 1.4x teleconverter
Film: Fujichrome Velvia

103

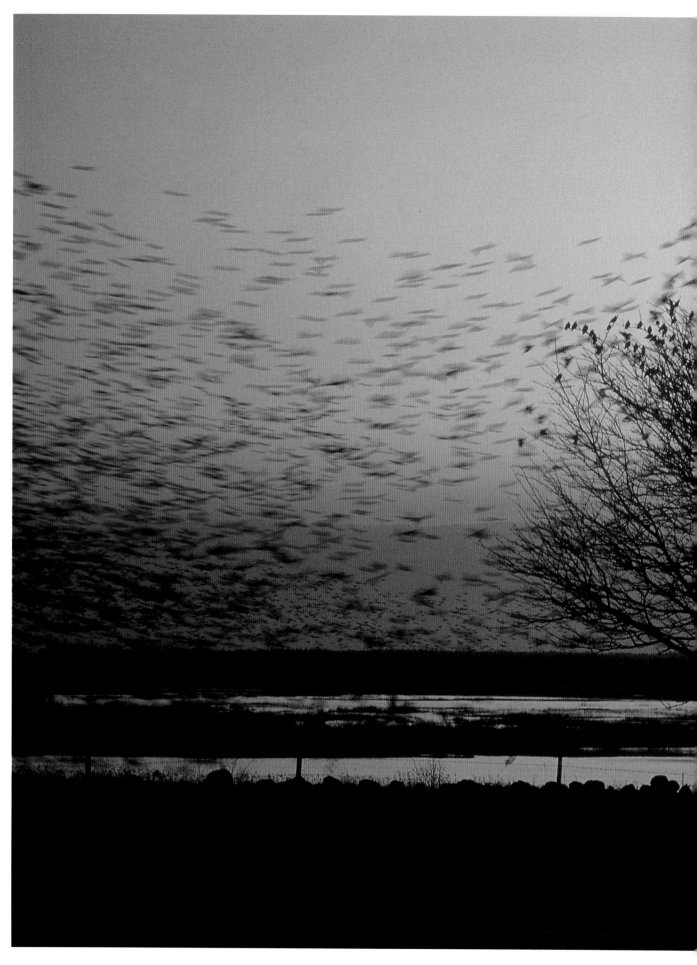

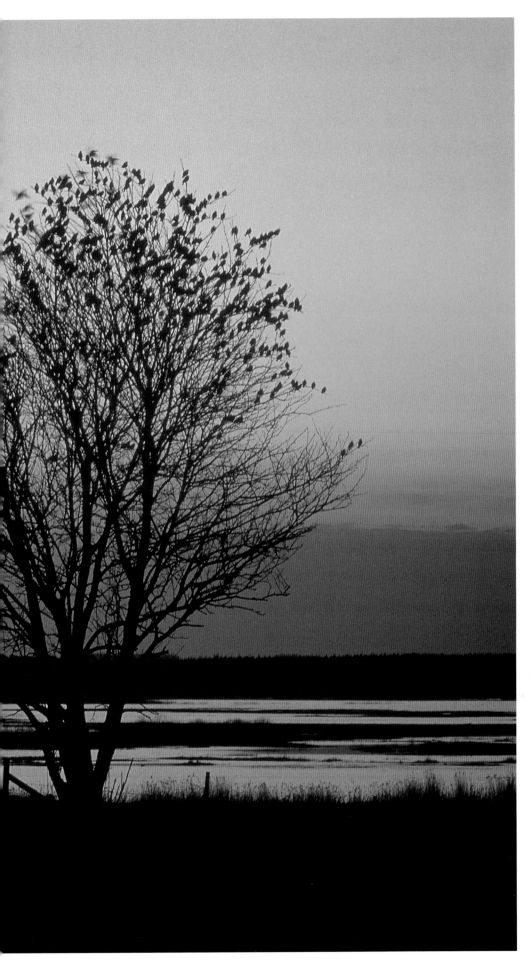

Jan Töve
Starlings going to roost, Lake Hornborga, Sweden

Like many Scandinavian nature photographers, Jan Töve makes the most of the light in his photography. He is just as happy photographing landscapes and wildflowers as birds, working with medium-format cameras as well as 35mm, which he often carries with him on cross-country skis during the winter months. Jan describes his photographic interpretation of this starling roost:

‘ I took this photograph at Lake Hornborga in the southern part of Sweden late one evening in April. The starlings had just left the field where they had been feeding. On their way to their night-time roost in the reeds that border the lake they gathered in a tree, and I saw the possibility of taking a picture that told the story of this behaviour. It looked like a flood of wings streaming from the tree. To capture that impression, I used a slow shutter speed of $^1/8$ sec. on my Pentax 645 camera with a 200mm f4 lens. The film was Fujichrome Velvia. And of course I used a tripod. ’

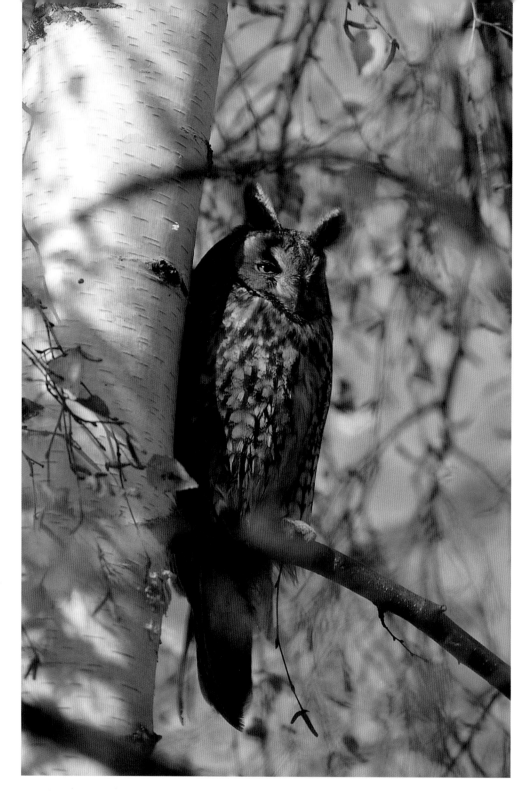

Long-eared owl at daytime roost
It was a surprise to be told that this normally elusive bird was roosting in a birch tree just a few metres outside my office, quite open and approachable. More often long-eared owls remain undiscovered in thicker cover.
Camera: *Nikon F4S*
Lens: *500mm f4*
Film: *Fujichrome Provia 100*

offering fresh photography opportunities. Occasionally, there may be a commotion as a passing predator disturbs the roost, and the whole lot suddenly takes flight. That certainly makes you sit up.

Working at dusk or dawn, light is going to be in short supply, so you might need to use shorter, faster lenses, and consider using faster films or uprating and push-processing. Making silhouettes of flight flocks against a sunset sky can keep the shutter speed fast enough to retain sharp outlines. An alternative technique would be to use slower shutter speeds to show movement in the flock, and the pattern it creates, but with individual birds blurred. For this to be successful probably requires some experimentation, and it helps if you have an interesting sky of variable colour and texture, or some other feature in the landscape, such as a silhouetted treeline or reflective water.

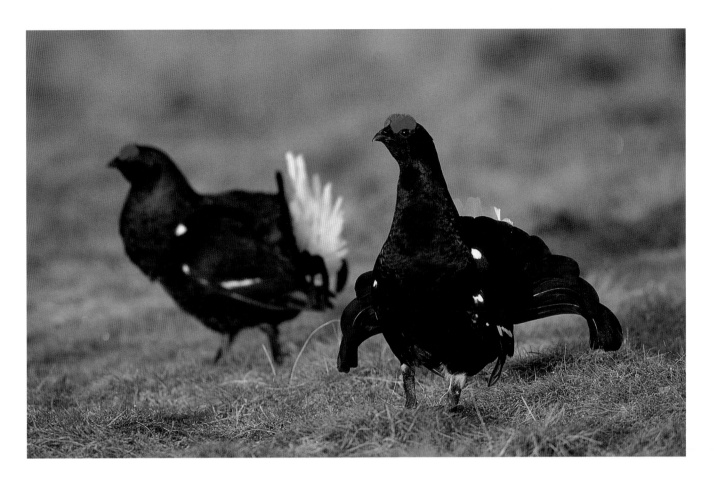

Leks and display grounds

Some species of birds, especially grouse and other game birds, have traditional display grounds known as leks, where the males congregate to compete with their rivals and seek the sexual favours of females. There are some waders that exhibit this complex breeding behaviour, too, such as ruff and great snipe. The displays can be very elaborate with dramatic changes in plumage, and sometimes fighting between males, and the conclusion might be that successful males get to copulate with one or more females. This all makes for very exciting photography.

Lekking is a temporary, seasonal phenomenon, occurring in spring (in the temperate regions), sometimes lasting for just a few minutes over several consecutive days, in other species extending to several hours a day, week after week. Generally this activity occurs in the very early morning before dawn breaks, though unusually it can take place in the evening – in the great snipe, for example. The lek itself is usually a more-or-less fixed location to which the birds have a very close affinity. This makes it a fairly reliable location for photography, but also means that extra care must be taken not to disturb such a crucial event in the birds' breeding cycle. Hides should be introduced the night before for morning leks, and occupied during hours of darkness. This could mean camping out at more remote locations. The first males could arrive long before dawn in nearly complete darkness, and well before you have any realistic chance of photographing them. It is an agonizing wait watching these entrancing displays and strange postures through the gloom, and it can be frustrating to witness copulations in front of your hide when the meter reading indicates a 4-second exposure, wide open, but the whole event lasts less than a second! But as the season progresses and lekking behaviour becomes more intense, it may continue longer into the daylight hours and give better opportunities. Only remove the hide after lekking behaviour has finished and the birds have dispersed for the day. It's not a good idea to leave hides in place at leks for prolonged periods as you will only draw unwelcome attention to the site.

In the US, greater prairie chickens, sharp-

Black grouse males at lek

To be in position to photograph this bizarre but beautiful display meant sleeping on location in a hooped bivvy bag, pitched next to my hide, all under cover of a camouflage net. When woken by the bubbling calls of the black grouse males, or blackcock, still some hours before sunrise, I crawled from my sleeping bag into the hide. Eventually, it became light enough to work.
Camera: *Nikon F5*
Lens: *AF-S 500mm f4*
Film: *Fujichrome Sensia 100 uprated to EI200*

(opposite) **Robin singing**
*Robins are with us all year round
and hardly seem to stop singing.
No hide or tape lure was necessary
for this bold back garden resident.*
Camera: *Nikon F5*
Lens: *AF-S 500mm f4 plus
1.4x teleconverter*
Film: *Fujichrome Sensia 100*
Lighting: *SB-26 Speedlight*

Nightingale singing
*Normally unseen and most active
in hours of darkness, nightingales
can best be glimpsed in daylight
soon after they arrive in spring.
Here, I simply sat down with my
tripod and waited quietly for this
singing male to move into shot.*
Camera: *Nikon F5*
Lens: *AF-S 500mm f4 plus
1.4x teleconverter*
Film: *Ektachrome E100VS*

tailed grouse and wild turkey are all good
candidates for photographing lekking
behaviour. In the UK, regular leks exist only for
black grouse and capercaillie; both species are
in decline, and the few known leks come
under intense pressure from birdwatchers and
photographers alike. The best recommendation
would be to leave these well alone until
populations recover sufficiently, or to
photograph them elsewhere where they are
more common, for example in Scandinavia.
From time to time there are reports of rogue
male capercaillies that behave particularly
aggressively, as a consequence of a hormonal
imbalance. They are strongly territorial, display
throughout the day, and attack people and
cars as well as other male capercaillies. These
rogue birds are the most accessible photo-
graphic subjects – but definitely not
for the fainthearted.

Song perches

Many male birds sing from prominent spots in
spring, in order to announce to other males
that they are holding territory, and to attract
females with which to pair and breed. The
perches they use for singing are confined to
the relatively small area of the breeding
territory, and the same few perches tend to be
used repeatedly, with the territorial male
circulating between them. Song perches of
woodland birds are often quite high up and
therefore difficult to photograph, but you may
be lucky and find more accessible ones. Clearly
it's helpful if you are able to identify birds from
their song to enable you to locate them, and
there are useful recordings available on CD
and tape for reference.

Once you have identified a suitable song
perch, introduce a hide or set about stalking
on foot or from a vehicle. Don't delay too
long, as the males soon become silent as
nesting gets under way. Early morning is
usually the best time, though many birds sing
in the evening, too. If your bird goes quiet
temporarily, or moves off to a different perch,
don't chase after it but give it time as it may
well return to the same perch to sing after a
short absence.

Most likely you will need a long focal
length telephoto, possibly with teleconverter
or extension tube fitted for smaller song birds.

Fill flash will help with birds in shade or dappled light, or against strong backlight. It's common to see photographs of singing birds with the lower mandible blurred as it can vibrate at great speed, so keep your shutter speed fairly fast (1/250 sec. or faster), and take short bursts of photographs on the motordrive to try to capture the momentary pauses when the bill is wide open.

Migration routes

Spring and autumn migration are great times for bird photography. Large numbers of birds can concentrate in quite small areas, and there might well be chances to photograph birds you don't often see. Tired migrants freshly arrived from over the sea can be more approachable than usual, and while it is exciting to witness such a 'fall', remember that these birds will have just lost a huge proportion of their body weight, consuming fat reserves over their long journey. They desperately need to feed and rest, and there is a very real risk of hounding them to death. Rarer vagrants blown well off their normal course tend to attract even more attention from birdwatchers, and it is significant that many of these celebrated rarities have ended up falling victim to birds of prey or domestic cats. So approach with sensitivity, and keep the birds' welfare in mind.

If you are attempting to photograph at the site of a birders' 'twitch', do consider other people and don't try to approach closer than everybody else. Use the longest lenses you can muster, and stack teleconverters if necessary. Alternatively, try to return on a weekday after the excitement has died down a bit. But frankly, don't expect to produce any masterpieces at these busy locations.

There are some well-known migration hot spots, which often have bird observatories associated with them. Within the British Isles, the Isles of Scilly and Shetland, Cape Clear, Portland Bill and the north Norfolk coast are famous for their migrant birds. In North America, Cape May in New Jersey and Point Pelee in Ontario are renowned. Birds of prey in particular tend to follow migration routes that avoid long sea crossings, so the Straits of Gibraltar, the Bosphorous, Eilat in Israel, and

Falsterbo in Sweden are terrific viewpoints for vast numbers of migrating raptors, though conditions need to be especially favourable to bring birds close enough for photography. The island of Lesvos in the Aegean Sea has been popular in recent years because of its high concentrations of spring migrants, often at close range.

There are also the wintering grounds, notably the wetland sites, which host great numbers of wildfowl. In the UK, try Islay and Caerlaverock in Scotland for barnacle geese, the Ouse Washes in Cambridgeshire/Norfolk, and Slimbridge in Gloucestershire for Bewick's and whooper swans. In North America, good sites include Arkansas National Wildfowl Refuge (NWR) for whooping cranes and Red Rock Lakes in Montana for trumpeter swans. Other excellent wintering grounds include Bosque del Apache, New Mexico for snow geese and sandhill cranes, and Extremadura in Spain for common cranes. There are many others throughout the world. Most of these destinations feature regularly in the birdwatching magazines and have quite detailed birders' guides pointing out where to go and the best times.

At the more local level, watch for pre-migration gatherings of such birds as swallows and house martins on telegraph wires, or massing flocks of post-breeding lapwings. Certain weather patterns may give good indications of impending falls of migrant birds. For example, the north Norfolk coast in autumn is often good following a strong easterly blow and low cloud overnight, while in the Scillies and Cornwall westerly squalls are eagerly awaited in the hope that they might assist North American vagrants. In the US, warm fronts from the south bring migrants north in spring, while the opposite happens in the fall following cold fronts from northwest to southeast. Storms at sea can often lead to quite unlikely birds, such as divers (loons), auks, skuas (jaegers) and shearwaters, turning up at inland lakes and reservoirs, and this could be the best chance you ever have of seeing them at close quarters. Cold weather spells also account for movements of flocks of lapwings, golden plovers, fieldfares and redwings as they

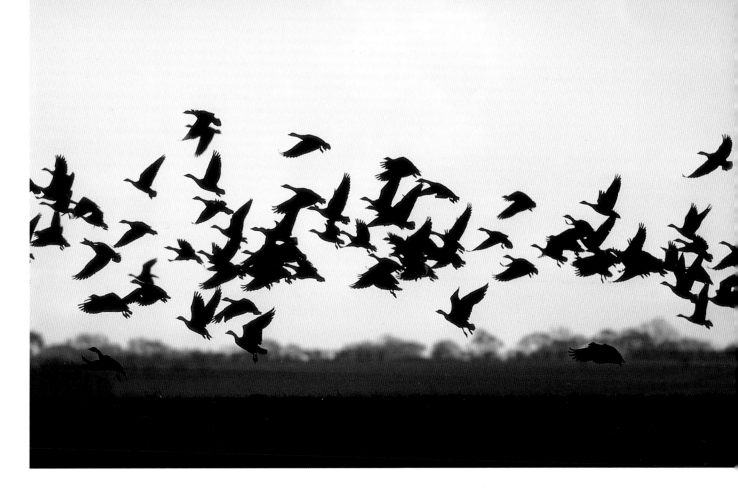

retreat towards the warmer southwest. You should always be prepared to capitalize on these favourable conditions.

Decoys, models and tape lures

There are various props and lures that bird photographers might employ from time to time to aid them in their photography. I hesitate to include reference to some of them as they can be somewhat controversial, but conclude that it is better to discuss them in a responsible way rather than ignore them, or gloss over the subject.

One controversial example is the use of tape lures, which emulate rival males singing or the calls of receptive breeding females. Amplified tape loops or CDs are widely used by birders, particularly in North America, as they can make birds that are often difficult to see come out into the open. In effect, they are looking for an intruding bird. This is not a problem if the playback is of brief duration and the bird is then left alone, but persistent or repetitive playing of tapes amounts to unreasonable disturbance and could cause birds to invest too much time investigating the

'threat', and lead to ultimate breeding failure. There is clearly a temptation for photographers to overdo this in pursuit of an ever-better shot. If you try this technique, use it with discretion – doubly so if you are in a known breeding territory. Avoid using bird-call tapes or CDs altogether at well-known birding locations where others might be doing the same thing. And the use of tape lures near the nest of a protected bird would qualify as intentional disturbance within the meaning of the law, and you should therefore first obtain the appropriate photography licence.

On the few occasions I have tried tape lures the results have been rather disappointing, with one of two possible outcomes. Either there is no visible response (although I do believe that it is more often effective in other parts of the world), or birds become very agitated and behave quite out of character, albeit closer than usual. So quite apart from the fact that I am obviously upsetting their normal behaviour, it's not really the kind of photograph I want to take. The one species for which I know tapes do work astoundingly well is the cuckoo. Males arrive in spring on average

Winter flock of pink-footed geese
North Norfolk is well known for its wintering population of pink-footed geese, which like to feed on arable fields in the daytime, and roost on the mudflats of the Wash estuary at night.
Camera: *Nikon F4S*
Lens: *500mm f4*
Film: *Kodachrome 64*

Tony Hamblin

Goldcrest singing, Warwickshire, England

You don't see too many photographs of tiny birds like goldcrests, and to find one captured in full song in such perfect surroundings is quite exceptional. I asked Tony Hamblin how he did it:

❛ *This goldcrest sang high in a blue spruce tree 5m (16ft) from my front door all through one summer, so early on I erected a 4m (13ft) high scaffold and topped it with my hide. But although the goldcrest continued to sing, he now moved to the opposite side of the tree! The problem was solved when I made a tape of a goldcrest singing from a pre-recorded CD, and played it back through a loud speaker for brief periods, at moderate volume. This encouraged the goldcrest to sing well for me, in view of the camera, on and off for over an hour. I was able to take a number of photographs with my Canon EOS 1-N and 300mm f4L lens. The exposure was $^1/_{125}$ sec. at f8 on Fujichrome Sensia 100 film.*

Sadly, in the autumn I discovered the body of a goldcrest in a flowerpot under a window. Presumably it had died as a result of a collision with the window, and I guessed it to be the mate of the singing male that I had photographed. ❜

about two weeks before the females, and if you play the bubbling calls of the female within about a kilometre (half a mile) of a singing male, it will home in on the sound very quickly indeed, eager to find a mate. But it won't necessarily perch where you'd like it to.

Playing tapes is not so very different from hunters using duck calls to attract their quarry, and there are other specific sounds that work just as well. In the north and west of Scotland, it is well known that corncrakes can be attracted through imitating their rasping call by drawing a comb across the edge of a credit card. Some country people also claim to be able to pull in hunting short-eared owls by making a squeaking noise with pursed lips, which is supposed to sound like a rabbit in distress. Another birders' device is the practice of 'pishing' – a softly repeated 'psshhh, psshhh, psshhh' sound, which can flush out certain skulking birds like goldcrests, reed warblers and sedge warblers. Just why this should happen is somewhat obscure, but the best theory seems to be that it sounds like the alarm call of a bird reacting to a predator, so others come to join in the mobbing behaviour. Again, pishing seems to work for a wider range of birds in North America than in Europe.

Rivals can also be falsified by means of model birds, and even reflections in mirrors. You may have seen birds attacking their own reflection in a car wing mirror or polished hub cap, mistaking it for a rival male. Robins are notoriously aggressive to intruders, and respond quite dramatically to a mirror placed in their territory, displaying back to the strong stimulus of the red breast. Quite crude models can also have a similar effect with a number of species of birds, if you can identify the crucial colour or plumage feature that elicits the threat display. Models of ducks or geese grazing in a field might persuade other birds flying over to join them on the ground, instilling the confidence of the flock. Carved, painted decoys of ducks are traditionally used by wildfowlers to lure live birds down to open water in the same way.

The frontiers

There are various other more-or-less reliable locations for photographing birds relating to particular aspects of their behaviour, but too numerous and diverse to detail here. Some of the more obvious ones include sunbathing spots and dust baths, and plucking posts where sparrowhawks and goshawks pluck their prey

before feeding it to their chicks. Some are less obvious or well known, such as the forest tracks where grouse or pheasants come to take grit, which aids in their digestive process. In the New World, one thinks of the 'salt licks' where macaws come to ingest vital minerals, and the bizarre but beautiful bowers of the bowerbirds. All offer great opportunities for you and your camera. In the end, it will be down to your own powers of research, observation and field skills to locate and depict these natural wonders through your photography.

Beyond these relatively accessible sites, we have the bird subjects that are always going to be 'out of reach' to some extent – those that are restricted by virtue of their geographical range, habitat or behaviour. Future challenges will be to find ways of photographing such subjects as birds of prey away from the nest, seabirds at sea (rather than on land where they appear out of place and out of character), and high-flying insectivorous birds such as swifts, which spend almost their entire lives on the wing. We could well expect further technological advances to come to our aid. Smaller, lighter telephotos that have faster autofocus and even better image stabilization will make us more responsive and able to work with subjects at greater range. Digital cameras

will provide the means to work at lower ambient light intensities, amongst other things. But there will always be a basic need for both ingenuity and field skills on the part of the photographer.

Some of our 'frontiers' will be issues of style – so although it might be possible to achieve ever sharper, bolder images, we might still prefer to make sensitive studies with soft light and small, blurred subjects. Whatever the preferred style, it is hoped that these innovations will be used wisely and in a way that celebrates birds and their place in nature.

CAMERAS ON LOCATION

We've dealt with the theory, but what about when you're cold, wet, tired and hungry, and the midges are biting, too? Real-life working conditions for wildlife photographers can be quite testing, so you need to go properly prepared. Some practical suggestions follow.

Organizing your field kit

Early decisions need to be taken about what to take out with you in the field. There is a temptation to try to carry everything you might possibly need to cover all eventualities, but this would be a mistake. It is better to limit yourself to what is easily manageable when

Swifts screaming display
The aptly named swift is not hard to find but quite a challenge to photograph. I wanted to portray the typical social behaviour of the flock as the late evening sunlight glanced off the birds' wings. Hand-holding my 500mm f4 telephoto was the only way to keep up, and in continuous servo AF the waste proportion was high, but I managed to obtain a small number of sharp shots.
Camera: *Nikon F5*
Lens: *AF-S 500mm f4*
Film: *Fujichrome Sensia 100 uprated to EI200*
Exposure: *$^1/_{1,250}$ sec. at f4*

Doug Allan

Guillemots diving under the ice cap,
Baffin Island, Canada

The underwater world certainly represents something of a physical frontier for all photographers. Here is a remarkable photograph from the very limits of human endurance, and illustrates the lengths to which some people will go to get a placing in the BG Wildlife Photographer of the Year competition (Winner, 'Underwater' Section, 1996)! Doug Allan is a professional underwater film cameraman, and one of the few who also takes his own stills photographs. On this occasion he was working for a National Geographic TV special called *Arctic Kingdom – Life at the Edge*. Doug takes up the story:

❝ *The shot was taken in June in the Canadian Arctic at north Baffin Island, where I was filming at the 'floe edge', that wonderful margin where the open sea meets the winter sea ice still frozen in the big bays and inlets. There's a magic window of opportunity for about two weeks when the ice edge is accessible and the water is gin clear, before the plankton bloom starts.*

The guillemots were swimming in a couple of groups, about 50 birds in each, paddling into the ice edge before diving for two to three minutes in search of fish. I found them pretty wary to approach, even when I was only snorkelling, and most of the time there would be a minute or more between the first bird of the group and the last leaving the surface. However in this case they all suddenly went down together, and the shot manages to capture that starburst explosion effect of the synchronous dive. The clarity of the water and its surface stillness, and the looming presence of the ice lumps in the background rather than simply open water, also somehow enhance the drama of the moment.

The water temperature was –1.3˚C (29.6˚F), but with a dry suit I could stay in for up to 90 minutes before getting too chilled. I spent three hours in the water shooting movie and one roll of stills, using a Nikonos 5 camera with 20mm lens, available light, Kodachrome 200, 1/$_{250}$ sec. at f5.6. ❞

you are fresh and fit, and should still be just manageable when you are tired. You are more likely to be able to keep within sensible limits if your backpack isn't too large in the first place.

For a typical bird photography assignment on foot, I would expect to carry the following main items in my backpack:

- camera body and back-up
- 500mm telephoto
- one shorter telephoto or zoom
- 1.4x and 2x teleconverters
- standard lens or mid-range zoom
- wide-angle lens or short zoom
- one flash gun
- stock of films of various speeds
- spare batteries
- two shutter cable releases
- blower brush, lens cleaning cloth, chamois leather
- notebook and pencil
- plastic bags

I would also carry the following vital additions: a hefty tripod, which I normally carry in the hand or over the shoulder, and binoculars, worn around the neck.

Depending on circumstances, I might add or substitute some or all of the following:

- extension tube(s)
- flash extender and off-camera TTL flash cord
- macro lens
- additional lens filters
- scrim netting and lens sleeve
- waterproof
- food and drink
- pocket torch, penknife, safety pins
- toilet tissue
- small sheet of plastic to improvise a drinking pool
- beanbag
- monopod

A back-up camera body is useful when fitted with a different lens, or to load a different speed of film. If both bodies are the same model (a sensible move), do something to enable you to distinguish one from the other at a glance – I use a coloured sticker on the pentaprism of one camera, and make that my 'slow film' body. A back-up is also there if something goes wrong with the main camera, or you simply haven't got time or opportunity

to change batteries when they go down.

To maintain your state of readiness, have films and batteries unpacked in preparation for rapid reloading. Four 35mm film cassettes fit neatly into a plastic slide box, which keeps them clean, and the cassettes can be inverted and replaced once exposed so that you don't mix them up. Batteries can also be repackaged in appropriate quantities in zippable plastic bags so that you don't have to spend ages removing them from blister packs when called for. These simple preparations also help to cut down on unnecessary bulk.

When uprating films, so that I know which need push-processing by the lab, I mark cassettes on removal from the camera with a permanent marker pen, or by scratching the casing with a key or penknife. If there is no time to do this immediately, I always put uprated films in the same coat or shirt pocket so I know to mark and separate them later.

Travelling

Travelling by car means that weight isn't too much of an issue, but security is. Try to avoid leaving any camera gear in an unattended vehicle, even out of sight in the boot, and don't have telltale camera club stickers displayed in the window! Your insurance cover will probably be of higher value if your car has a factory-fitted alarm. The chances are that insurance will be invalidated if equipment is left in a vehicle overnight, or indeed at any time – check the small print on your policy.

Overseas trips call for stringent measures. Keep your kit down to an absolute minimum, and carry all cameras and lenses as hand luggage. You must also carry spare batteries as hand luggage, and preferably film, too. Airlines seem to be getting increasingly strict about weight allowances for hand luggage, so this can be quite tricky. So far, I have always been able to carry my Lowepro Photo Trekker on to the plane, and it does fit snugly into an overhead locker, but I suspect it might have been more difficult if I had been travelling with a party of similarly equipped photographers. As a back-up I wear a photographer's vest loaded with films and ready to accept cameras and lenses from my backpack if need be.

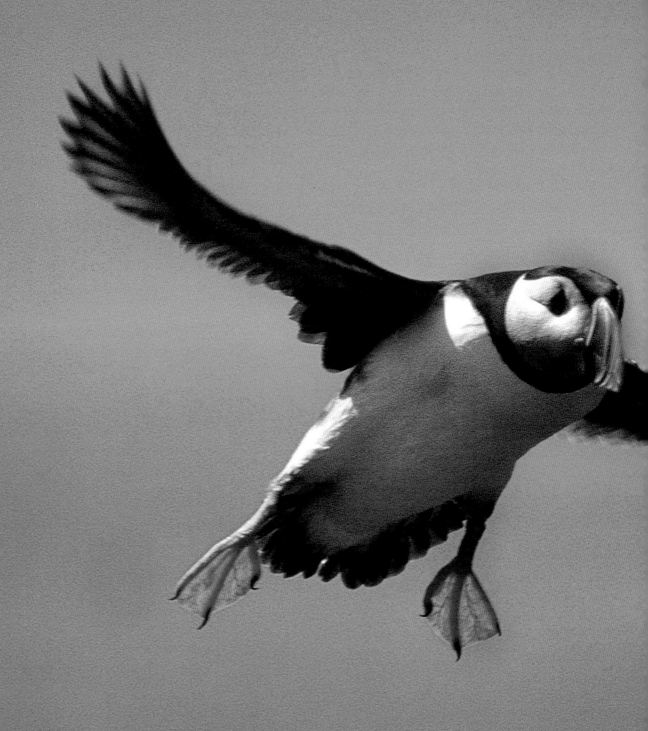

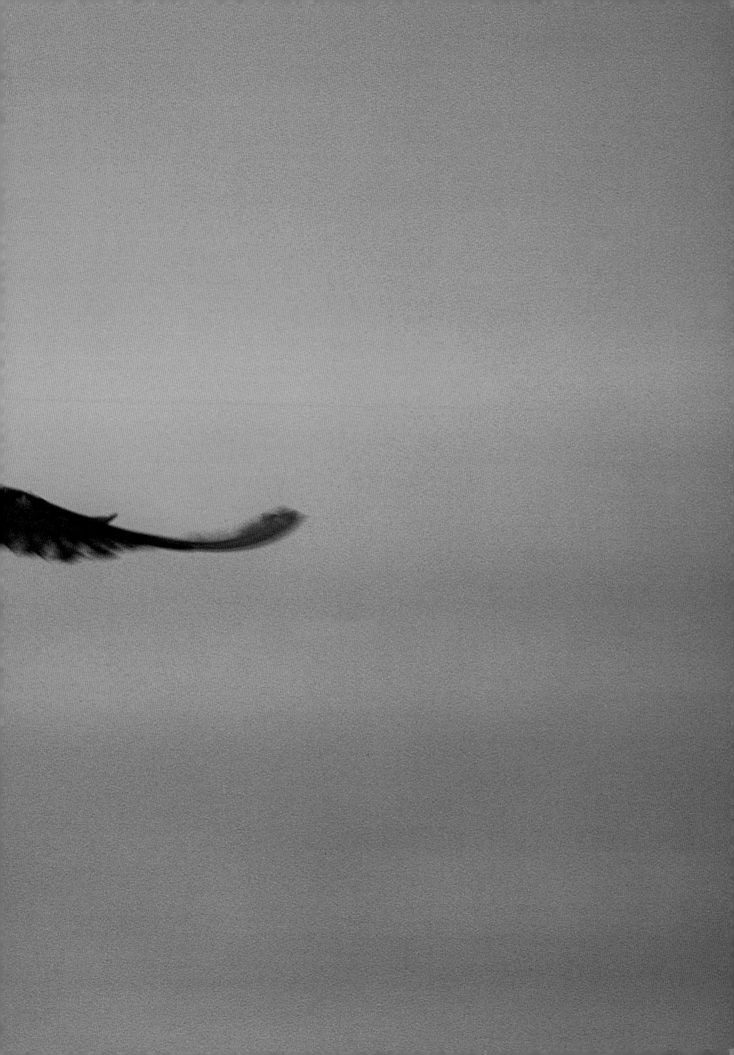

This was photographed with a hand-held, manual-focus 200mm macro lens. After practising on a few flight approaches to the breeding colony, I pre-focused the lens for the desired image size, and depressed the shutter button just before the bird came into sharp focus. Plenty of out-of-focus efforts were rejected in editing.

(opposite) **Female osprey on nest**
This osprey was photographed from a hide installed on a conveniently adjacent slope. I generally expect to put in a 12-hour shift when photographing birds of prey at the nest.
Camera: *Nikon F5*
Lens: *AF-S 500mm f4 plus 1.4x teleconverter*
Film: *Fujichrome Sensia 100*

Use zooms in place of prime lenses to keep the number down, and you may be able to use slower, more compact lenses if you are travelling to destinations where good light is guaranteed. Image-stabilized lenses mean smaller, lighter tripods can be considered.

Tripods and tripod heads should pack into hold baggage, well padded; carbon fibre helps keep down the overall weight. A lightweight portable hide can go in the hold too, if needed, and throw in a couple of empty beanbags ready to load with the cheapest available pulses when you arrive at your destination. I used to be quite confident of packing spare film in my suitcase – even super-sensitive ISO1600 films that had passed through several airport security checks showed no ill effects, but recently upgraded X-ray equipment for hold baggage at certain airports means this can no longer be relied upon. Make every effort to carry films as hand baggage, as these scanners are still quite safe. You can try asking for a hand search, but it's at the discretion of the airline.

Allow me to make a suggestion about photographing birds in developing countries. If you come away with some good results, why not donate some duplicate slides or a selection of scanned images on CD for the local use of conservation groups such as BirdLife International? Good photographs are vital but all-too-often scarce resources, and such a contribution could make an enormous difference to the effectiveness of fledgling conservation programmes. Just because photographs of these birds seem to be quite commonplace in Europe and America, it's very easy to assume that they are freely available worldwide, but so often that isn't the case.

Tough conditions

Usually, maintaining your equipment involves little more than dusting off the lens and an occasional spray of 'canned air' with the camera back open. Gentle rain showers can be shrugged off, as long as you dry the gear thoroughly before packing it away. To wipe water droplets from the lens filter, use a small piece of chamois leather (incidentally, it's actually cow leather these days). For heavier or

persistent rain it makes sense to cover up, and a large plastic refuse bag is ideal for this. Damp and condensation can penetrate deep, and I have found this to my cost when leaving lenses out over a clear, chilly night – as the sun warms everything up the next morning, a cloud of fog appears on internal lens elements and is very difficult to dispel.

The corrosive effects of saltwater spray are more serious still, and if you are working on a boat or a windy seashore you should take precautions against it. A quick and inexpensive remedy is to cut the corner off a plastic carrier bag, making a hole just large enough to slip over the lens barrel. Tape the small opening around the lens hood, and the longer part of the bag should cover the camera leaving ample access at the back to carry on working. Use chamois leather again to keep lenses clear. For amphibious landings with your camera gear, the ubiquitous plastic refuse bag is useful, but if you do this kind of thing regularly investigate the heavy-duty plastic camera cases with O-rings for a perfect waterproof seal.

A cut-off carrier bag is quite effective against wind-blown sand, which is a real menace anywhere near cameras – be especially careful when changing films not to allow sand into the camera back, as the merest speck on the pressure plate can scratch roll after roll.

In the tropics, high humidity can be a hazard, and sometimes interferes with electrical functions. It is sensible to carry a back-up camera body. For extended visits you might want to consider an all-manual back-up, but for two or three weeks here and there I wouldn't worry too much, especially if you can retire to an air-conditioned hotel room at the end of the day. Working in rainforest, carry industrial-size packs of silica gel and place them in a sealed bag with your cameras overnight. The gel can be reactivated every few days by warming in an oven.

At low temperatures, cameras can become very sluggish or even pack up altogether. The use of lithium or Ni-MH batteries is usually recommended, and these should give you more films between battery changes anyway. Keep spare batteries somewhere warm, such as an inside pocket, and again make sure that

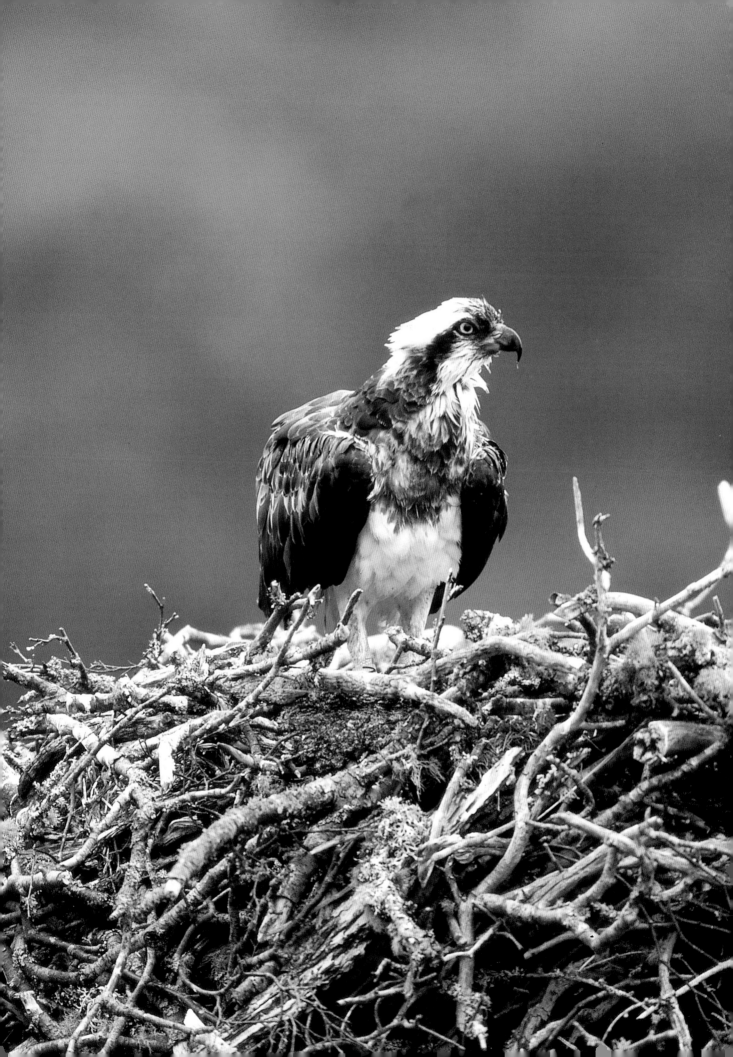

This shot shows several practical ways to reduce camera shake with a long telephoto. Keep the tripod low and centre column down; use a cable release; place a wedge between the lens barrel and tripod head; tie a rock on to the tripod; place a beanbag on top of the lens; lock up the camera's reflex mirror; use a monopod as an additional support for the camera body. (The lens hood and carrying straps were removed for the illustration.) Alternatively, get an image-stabilized lens and dispense with all of the above.

you have a back-up camera body available. Another effect of extreme cold is to make film leaders brittle and liable to snap, so reload carefully and keep your motordrive on a slow setting. If you have a metal tripod, cover the legs with foam pads to protect your hands; water-pipe insulation is good for this purpose. You will need to work the camera controls with your gloves on; inner glove liners are ideal for this and you can cover them with outer mitts when not shooting.

Handling long lenses

When you are working with long focal length lenses, camera shake is the main enemy and the commonest cause of out-of-focus photographs. It's tempting to believe that you can easily hand-hold a compact, lightweight lens like a 400mm f5.6, but actually the sheer mass of a larger, faster lens is likely to make that the more stable. There are a number of steps that can be taken to combat camera shake, apart from the obvious use of faster shutter speeds.

Firstly, use a substantial tripod and tripod head, and remember to leave the centre column down. With stationary or relatively inactive subjects, once you have framed and focused, lock down the tripod head, use the camera in hands-free mode, and trigger the shutter via a cable release. With obliging

subjects at slower speeds, mirror lock-up can be a real lifesaver, since mirror vibration is the primary cause of camera shake at shutter speeds of around $1/15$ sec. In extreme circumstances, a tripod brace or monopod can be used as additional support for the camera body, but this doesn't leave you with much room for manoeuvre.

More often, you will want to keep your hands on the camera and your eye to the viewfinder to follow the action. In this case, grip tight, press your face to the camera back, hold your breath and gently squeeze the shutter button. Short sequences on the motordrive can improve your chances of getting at least one sharp shot.

For extra stability, you can place a beanbag on top of the lens over the centre of gravity, or you can suspend a heavy rock under the tripod, fastening with a scrim net or string bag – this is an especially useful technique when the tripod is on soft, spongy ground like heather moor. Ensure all fastenings are tight and secure; some telephotos have alternative tripod attachments, and I use the smaller, lower attachments on my Nikkor AF-S lenses as they seem less prone to vibration. A simple wooden wedge can also help to overcome lens wobble when using pan-and-tilt tripod heads.

The longer your effective focal length, the nearer that your shutter speed is to $1/15$ sec., and the windier the day, the more of these contingencies you are likely to need. Finally, of course, image-stabilized lenses can give you 2 or 3 extra stops to play with before camera shake becomes a problem – this must be the way forwards.

For safe handling when carrying your telephoto mounted on camera, always use the lens strap rather than the camera strap, as the latter would place too great a strain on the lens mount, possibly causing it to buckle or give way. Don't leave a camera unattended on a tripod, especially with a telephoto fitted: a sudden gust of wind catching a big lens hood can easily topple it over. Similarly, beware when you are changing camera bodies with a large lens mounted directly on the tripod – removing the camera body can unbalance the set-up, with disastrous consequences.

Fritz Pölking

Toco toucan, Pantanal, Brazil

There are few, if any, more experienced or better-travelled wildlife photographers than Fritz Pölking. I tried to find out if Fritz encountered any special difficulties with the climate on one of his South American expeditions:

❛ *This toucan came every morning between seven and eleven o'clock to check the papaya trees, in the hope of finding* a ripe fruit. *If there was something ready he would stay on for a while, wrestling the fruit with his enormous bill and consuming the sweet flesh; otherwise, he just flew away and there would be nothing to photograph.*

I worked from a hide with a Nikon F5 and 500mm f4 AF lens and 1.4x teleconverter, on a tripod. The film is Fujichrome Sensia 100. This photograph is the best result from seven mornings' work. ❜

When I persisted with my line of enquiry, Fritz replied simply, 'no problems with heat and humidity – sorry!'

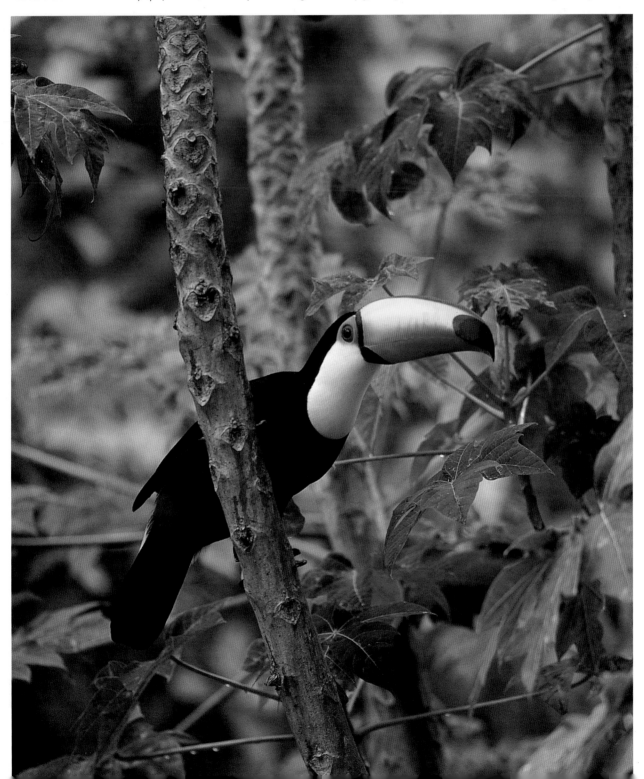

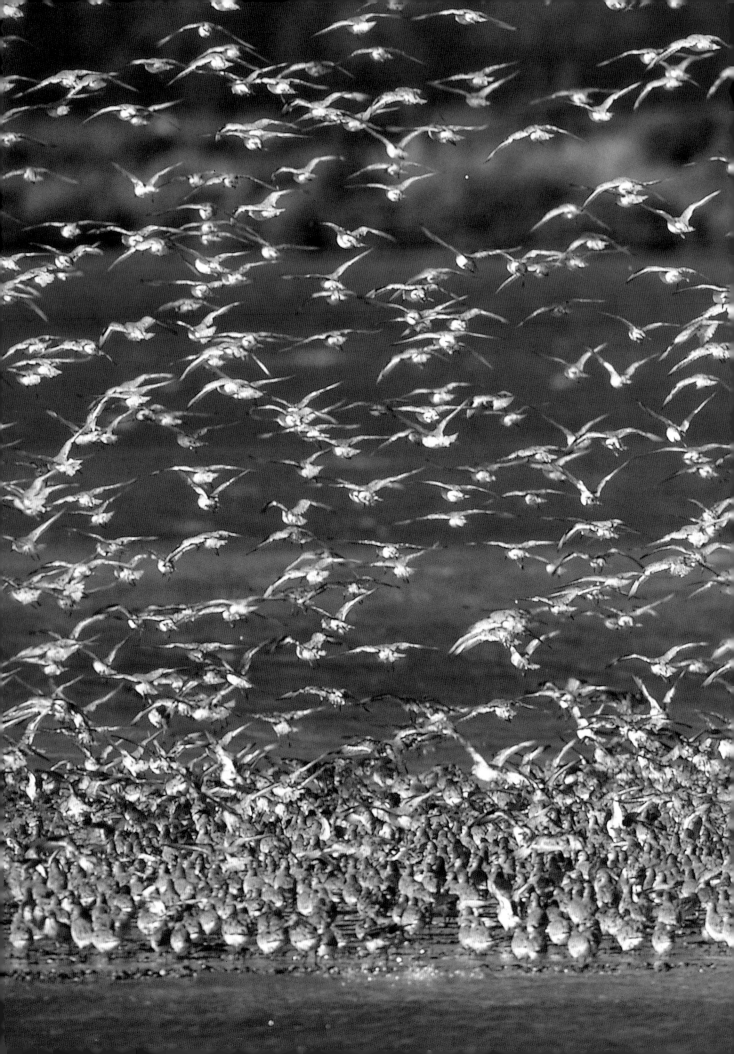

Chapter 4
CASE STUDIES

A series of case studies now follows, illustrating

some varied photography assignments and

projects from my own portfolio, and featuring a

range of different subjects, methods and

working conditions. These are the stories

behind the pictures, if you like, from concept

through to execution. Most of these

photographs were taken to support specific bird

conservation initiatives.

The kingfisher
A classic 'bait and perch' project

(previous pages) **Pre-roost gathering of knot**

Hidden in nearby sand dunes, I waited for the advancing spring tide to push this flock of knot towards me.

A female kingfisher

This kingfisher observes a potential predator overhead (above right) and on another occasion is seen poised to dive for fish (below). The hide-to-subject distance was dictated by a relatively open and well-lit location for the perch, and a suitable platform to accommodate the hide; ideally for such a small bird the perch would have been at about 5m (16ft), near to the minimum focusing distance of the lens.

Camera: Nikon F5
Lens: AF-S 500mm f4 lens
Film: Fujichrome Sensia 100 uprated to EI200

With its stunning plumage and secretive manner, it's hardly surprising that the kingfisher is such an alluring subject for photographers. Many photographers tend to assume that the best time to photograph a kingfisher is in the breeding season when the adults are feeding young, but this is not the only way. Apart from the fact that there are restrictions on photographing in the breeding season in many parts of the world, I think that autumn and winter actually offer better opportunities: the birds tend to prefer shady, wooded river courses, so there are fewer problems with extremes of light and shade when the leaves have fallen.

I got my chance to photograph kingfishers upon moving to a new house with a small stream running adjacent to the garden. Early sightings were comparatively few, usually of a bird in flight whizzing along the stream below the level of the bank, making its flight call. One of the first things I did was to place a branch low over the water, but just visible from the house, to encourage the birds to perch. They seemed to love the chance to fish a new stretch of water, and pretty soon became regular visitors. Then I introduced my hide at about 7m (23ft) from the perch, and simultaneously began to bait with fish. For this, I simply used a plastic storage box weighted with gravel and filled with river water, standing slightly proud of the water surface near to the perch. The fish were locally caught minnows and sticklebacks. (Incidentally, when baiting you should never import fish from another water course or introduce exotic – pet – species.) Finally, I substituted the branch with a reedmace stem in order to make a more attractive perch, appropriate for the habitat, and proportionate to the size of the bird.

The careful preparation paid off, and I was

(opposite) **The effect of light**

The warm autumn light really shows off the bird's metallic colours. The addition of a 1.4x teleconverter gave an effective focal length of 700mm, but with a shutter speed around $^1/_{60}$ sec. I was obliged to use mirror lock-up to prevent camera shake, which in turn called for manual focus and metering.

Camera: Nikon F5
Lens: AF-S 500mm f4 lens
Film: Fujichrome Sensia 100 uprated to EI200

able to take simple portraits on a few occasions before the birds moved on to fish another part of the river. Surprisingly frequently the kingfisher was happy to use my perch but chose to ignore the bait box and found its own fish in the stream, which suggested to me that I could probably have succeeded with the perch alone. But until I knew that, it seemed sensible to try everything I could think of to maximize my chances of success.

On reviewing the photographs, it is quite pronounced how the changing seasons and shifting light over just a few short weeks have had a big impact on the colours, background and overall mood. I was able to observe these qualities over the period of photography, but still underestimated their effect on film – even when you think you're taking large numbers of similar photographs, they can turn out quite differently.

Had the birds stayed around for longer I should have liked to vary the type of perch, perhaps by introducing an alder spray in the early spring or something to complement the colours of the kingfisher. Well, there's another project for the future ...

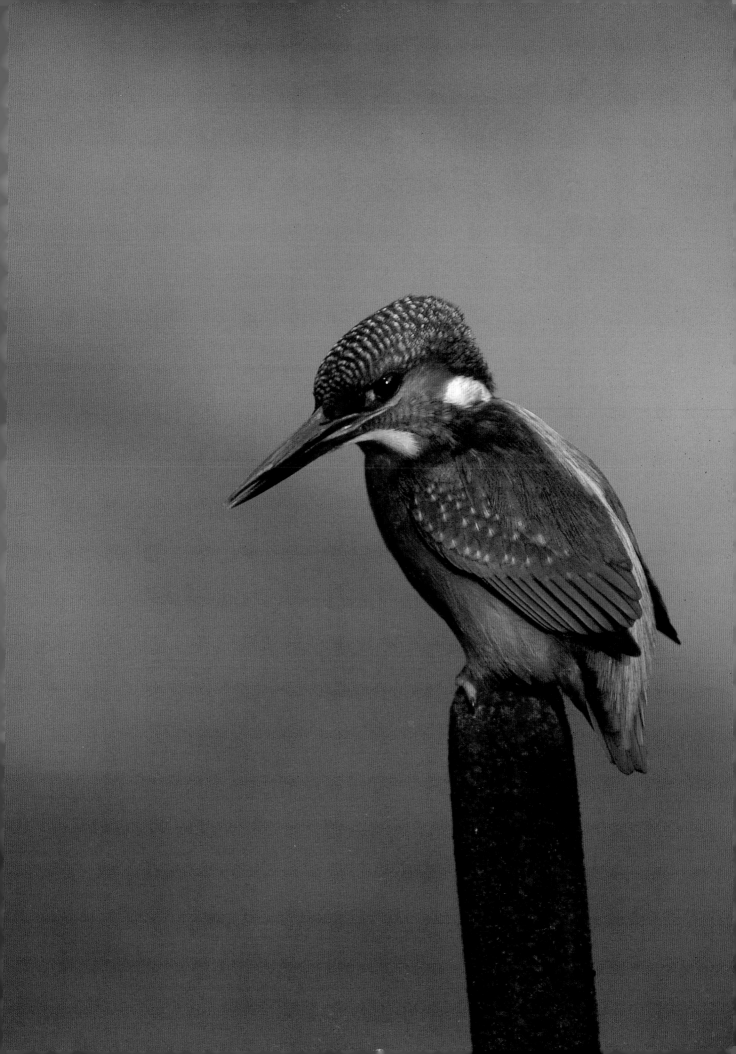

The great bustard
Stake-out on the Spanish steppe

The location

Bustard feathers in this alfalfa crop (top) were a good indication of recent activity, possibly resulting from fighting between males. The hides (above) were dug in to present a low profile and camouflaged with straw bales and dead vegetation. A flower pot was installed as a dummy lens. The distant copse of umbrella pines was used as cover for my vehicle.

(right) **Female great bustards**
A 'drove' of female great bustards is depicted feeding in alfalfa.
Camera: *Nikon F4S*
Lens: *500mm f4 plus 1.4x teleconverter*
Film: *Fujichrome Provia 100*

The last European stronghold for this magnificent but threatened bird is the grassland 'steppe' of western Spain. The bustard's majestic stature and plumage, together with its endangered status, mean that it's a frequently requested photograph in conservation publishing. I was somewhat surprised, therefore, to discover that there weren't too many photographs available of great bustards through the usual picture library sources. Usually this is a reliable indication of difficulty, so I knew that I couldn't just expect to turn up and 'burn' film.

With this in mind, I set aside five weeks in the spring of 1995 to attempt this demanding assignment. I liaised with BirdLife International experts, and staff at the Sociedad Española de Ornitología (SEO), the BirdLife International partner organization in Spain, who put me in touch with local ornithologists and other photographers 'in the know'. They in turn advised me that it was necessary to get

permission to photograph the bird from the regional Junta of Castilla y León. I also spoke to film cameramen who had experience of the species, and of course read everything that I could find on the subject. So it was with considerable assistance and after much preparation that I set about my task.

Arriving on location, I spent a few days with my new Spanish friends watching the birds and getting to know a little more about their behaviour. In spring, the bustards roam around in same-sex droves, preferring to feed on cultivated vetch and alfalfa – normally away from roads, overhead power lines and active irrigation. It didn't take long to realize that these birds wouldn't be easily approachable by car, possibly because they are still (illegally) hunted as trophies and this is generally done from four-wheel drive vehicles. Consequently I set about 'digging in' three hides at some of the more promising sites, where we had either seen early display activity from a distance or found other encouraging signs such as the birds' gigantic droppings or lost feathers. Favourite sites seemed to be along the margins of 'set-aside' fields bordering a cereal crop, and I was hopeful of the fallow fields bursting into flower as the spring progressed to provide a complementary background – a forlorn hope as it turned out, since the winter had

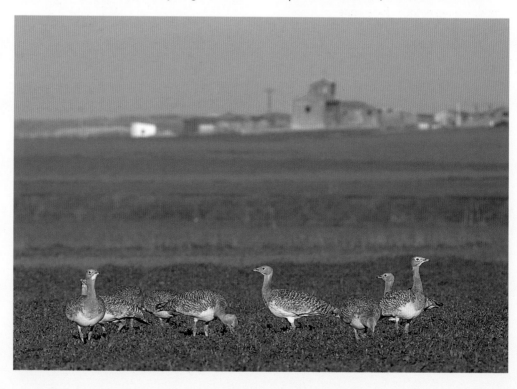

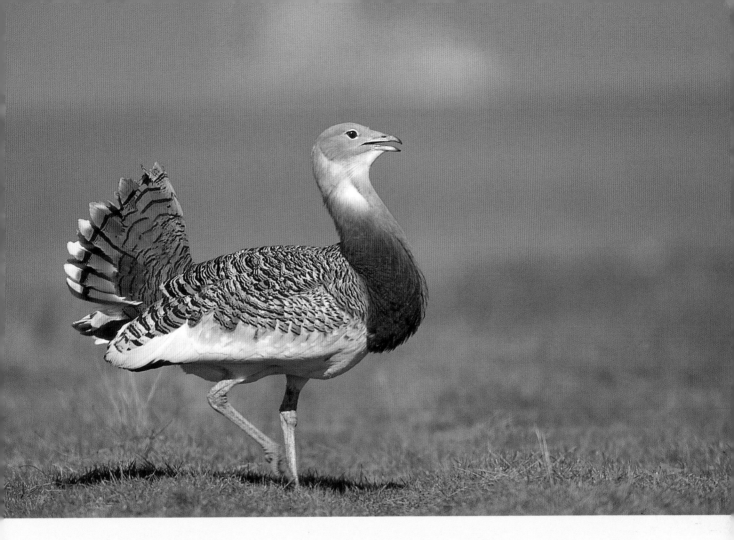

been too dry to provide such a spectacle.

My routine for the following weeks was to arrive at my chosen hide at least an hour before first light, deposit my camera gear and tripod, then park the vehicle under cover of trees about 1km (half a mile) away, returning to the hide on foot. If there was no sign of the birds by early afternoon, I might give up for the day. More often there would be some tantalizing bustard presence, too distant to photograph but close enough to make it impossible to leave without disturbing the birds, and I would be stuck there until after dark. Quite often I would glimpse displaying males on some distant rise, flashing like beacons as they turned and caught the sun. Although the birds favour traditional display grounds, these cover quite large areas, and days passed without any photography. The other birds were no more obliging; there would be the odd calandra lark or short-toed lark in the same field, or perhaps a passing lesser kestrel, but nothing to really get to grips with. Temperatures ranged from below zero at

dawn, sometimes rising to 30°C (86°F) by midday, making conditions uncomfortable. There was lots of time to worry about what I might be doing wrong.

After a total of about 120 hours in the hide, a small group of female bustards arrived in my field one morning, casually feeding on young shoots and unconcerned about the hide. In close pursuit were a few males, the mature birds sporting fine moustaches and rich cinnamon-coloured breasts, their tails cocked in semi-display. There were birds in camera range for about 20 minutes in all, and I was able to run off four or five rolls of film as they continued to feed and eye each other up. Reassuringly, they still ignored the hide, apparently oblivious of my fevered activity.

Some time later, towards noon, the males returned and to my excitement one began to display very close to the hide. The light was quite fierce by then, but it was immaterial as they all promptly sat down and went to sleep for three hours! That was to be my final opportunity to photograph.

A male great bustard

Five weeks of fieldwork was rewarded with 20 minutes of photo opportunity, as this splendid male in its fine spring plumage strutted before my hide.
Camera: *Nikon F4S*
Lens: *500mm f4*
Film: *Fujichrome Provia 100*

The kestrel
An elevated position

Setting up the camera
This view of one of the west towers of Peterborough cathedral (above) shows my mesh screen in place at the top and the CCTV camera pointing down towards the kestrels' nest entrance. The Bronica SQ-Am in position (right), with Metz 45 CT4 flash gun fitted on a side bracket and all supported by a Benbo Mark 1 tripod. Note the tape player and the remote shutter-release cable.

One year, high above the historic vaulted ceilings of Peterborough cathedral, a pair of kestrels nested. Tall buildings frequently provide secure nest sites for birds of prey such as kestrels and peregrines, so this was not really unusual, but this particular year the Royal Society for the Protection of Birds (RSPB) had installed a CCTV camera looking down towards the nest to provide a public-viewing facility in the cathedral below. Publicity stills were required. The idea of photographing kestrels here appealed to me and I wanted to show something of the magnificent setting. As the cathedral is not too far from where I live, regular visits would present no special problem. However, photography would have to be conducted with even more sensitivity than usual because my every move would be in the public gaze, and I would be working on a protected, historic building where normal worship couldn't be disrupted or disturbed.

Having agreed terms of access with the cathedral's Dean and Chapter, I climbed the spiral stone staircase and clambered out on to a ledge near to where the birds had been seen landing with food. As kestrels normally nest in

holes, I wasn't too surprised to discover that the birds had exploited a tunnel in the stonework which was part of the roof drainage system, and the nest was completely hidden from view. There didn't seem to be any regularly used perch nearby, so it looked as though I would have to try for shots of the flight approach. The ledge was too small and unsafe to accommodate a hide, and afforded a poor angle of view – the camera really needed to be suspended over the edge looking inwards. Since there was no convenient viewing window from the adjacent stone tower, this assignment was developing into something of a challenge. The possibility of using a remote-controlled camera began to take shape in my mind.

I could hear the calls of chicks begging for food, so I knew the timing was right. Wasting no time, I returned the next day to begin to set up my remote camera. I decided to use a Bronica SQ-Am medium-format camera, for two main reasons. Firstly, the larger film format would allow more room for framing a flying bird, and the 6 x 6cm film could be cut down to 35mm size if necessary. Secondly, because the site was in shade for much of the day, I wanted to use fill flash. At that time, the Nikon F3 (and all of its rivals) had a flash sync speed of only $1/60$ sec., but the Bronica's leaf shutter would allow flash sync at all speeds right up to $1/500$ sec. I framed up with the standard 80mm lens, leaving space for the anticipated line of approach, mounted the camera on a Benbo tripod, and fitted a single Metz 45 CT4 flash gun to provide the fill light – there was nowhere really to attach a second flash if I had wanted to. It was also impossible to rig a beam trigger because there were no fixing points for a transmitter and receiver. So it would have to be a hit-and-miss affair with a remote cable.

The remote cable was made from about 30m (100ft) of bell wire with a jack plug one end and a button switch the other. This was routed back from the camera, up the cathedral tower to a viewing position about 10m (33ft) above. From here I could look down on the kestrels flying in with pretty good all-round visibility, and hoped to see the birds with sufficient notice to fire the shutter.

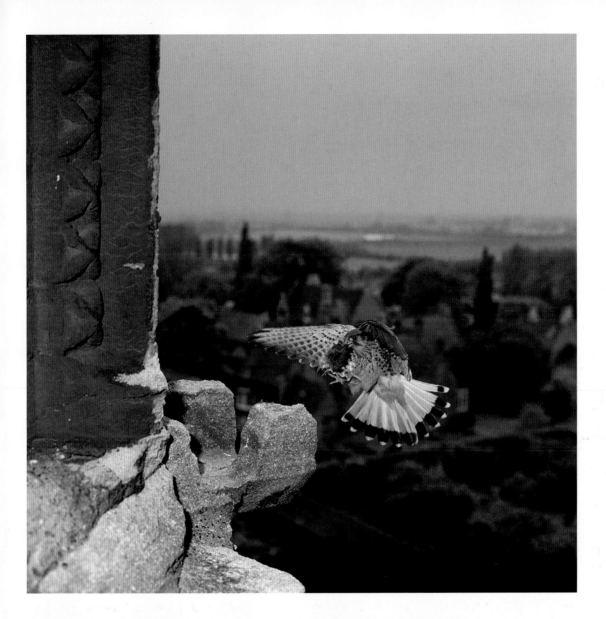

Further preparations were necessary. I needed some screening to cover myself up, and sought the co-operation of a local tent maker who provided hides for me from time to time. Together we rigged up a screen of fine gauze netting, which had to be fastened with elasticated ropes to avoid any possibility of damage to the ancient masonry. It wasn't an ideal colour, but was only required for a few days and seemed to be readily accepted by the birds. Finally, I had to do something to get the birds used to the terrible noise of the camera's motordrive – it was much louder than the contemporary 35mm motordrives, and was going to be operated at close range. For this purpose I recorded the sound of the camera on to a cassette tape, and played it back continuously over a few days and nights, using a tape player left out alongside a dummy camera.

On the first day of photography, the camera was set up and pre-focused to the estimated range of the bird. A manual exposure was set for $^1/_{500}$ sec. at f5.6–f8, using Fujichrome RDP 100 film uprated to EI200, and the camera mirror then locked up to cut down the shutter delay and keep the noise and vibration to a minimum. The flash gun was set to f4 on auto so that it would deliver $1^1/_2$ stops less light than the ambient reading at a short flash duration.

Amazingly, my very first attempt resulted in the photograph you see here. Although I continued photography for a few days more, I never seemed to be able to replicate my early good fortune, and subsequent photographs had the bird out of focus, with its wing across the head, or partly or wholly out of frame.

Returning with prey
The male kestrel arrives with a nestling bird it has captured, to feed to its young. The fill-in flash and $^1/_{500}$ sec. sync speed has been sufficient to arrest movement without too much 'ghosting' and has also killed the worst of the shadow on the bird and the stonework. Fortunately, the ambient light did not fluctuate too much during my photography session and the pre-set exposure of f5.6–f8 held true.
Camera: *Bronica SQ-Am*
Lens: *80mm f2.8*
Film: *Fujichrome RDP100 uprated to EI200*
Lighting: *Metz 45 CT4*

The bald ibis
A globally threatened bird

A bald ibis feeding

This ibis was photographed from a vehicle as it fed among the shooting cereal crop. However it didn't seem to me that this was the best way to endear the bird to a wider public.
Camera: Nikon F4S
Lens: 500mm f4 plus 1.4x teleconverter
Film: Fujichrome Provia 100

(right) **Ibis in flight**

This image of a flock of bald ibis shows the Atlantic sea cliffs of the Souss-Massa National Park where they nest and roost.
Camera: Nikon F4S
Lens: 80-200mm f2.8
Film: Fujichrome Provia 100

The wild breeding population of the northern bald ibis totals no more than 250 birds, almost entirely confined to the Souss-Massa National Park in Morocco, so this is a bird on the very brink of extinction. There are a number in captivity, where they do breed quite well, but so far attempts at reintroduction into the wild have not been successful.

Plenty of photographs existed of bald ibis from the captive collections, but there were not too many of them in the wild, so this was my challenge. The Moroccan birds nest on the ledges of rugged Atlantic sea cliffs, and are quite inaccessible except to climbers with ropes, so nest shots were discounted. Instead I went to photograph them in the late winter, shortly before their breeding season commenced, at the invitation of the National Park managers and the BirdLife International bald ibis research team.

The bald ibis is a gregarious bird, with foraging flocks advancing through areas of semi-desert and sparsely cultivated land as they hunt for insects and small lizards on which to feed. They are reminiscent of a herd of sheep as they move forwards with their heads down, not easily diverted from their path. By anticipating the movement of the flock, and with the aid of a four-wheel-drive vehicle, I was able to get ahead of them on a few occasions and photograph a few individuals that passed close by, using a 500mm lens with 1.4x teleconverter resting on a beanbag. This wasn't too difficult given enough time, but I didn't want to keep harassing the birds in this way; in any case, it didn't really show them at their best. The harsh sunlight showed off the iridescent

plumage reasonably well, but the overall contrast of the black bird against the reflective sand was a bit of a problem. Many birds had their feathers soiled by the droppings of other birds from the night-time roost, and the nictitating membrane, which protects the eye from blowing sand, was often apparent in the photographs. Plus, you have to admit, they do look pretty ugly.

The flocks flying to roost at dusk seemed a much better prospect, although the low light conditions would present their own difficulties for photography. One evening I concealed myself among some rocks on a cliff top facing west towards the setting sun, and waited for the birds to arrive at their regular roost site. Using a 500mm manual-focus telephoto mounted on a tripod, and my Nikon F4S loaded with Fujichrome Provia 100 uprated to EI200, I began to photograph the assembling roost. Uncertain of where to land at first, and sometimes disturbed by sea anglers on the shore below, the birds circled over the sea a few times, giving me plenty of opportunities for flight shots. Their flight silhouettes made a much more evocative sight than the birds on the ground, with their distinctive curved bills and shaggy crests outlined against the sunset sky. There seemed to be something almost prehistoric about their appearance.

To begin with, shutter speeds of $1/500$ sec. were easily attainable with the lens at its widest aperture, and allowed me to run off a number of 'safe' shots. Nevertheless, I wanted to make the most of this rare opportunity and take a range of different types of photograph, so I set a smaller aperture and tried panning at shutter speeds around $1/30$ sec., then $1/15$

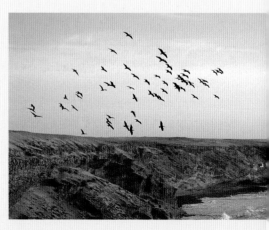

sec. and $^1/8$ sec. The greater depth of field meant that focusing wasn't quite so critical, and I could concentrate better on my panning action. As the sun set and light faded fast my options narrowed, and quite soon the lens was wide open even for the slowest workable shutter speeds. Using a second camera body I also tried a couple of rolls of Fujichrome Provia 1600 film pushed to EI3200 in desperation, and in due course even this was being exposed at $^1/8$ sec. Eventually, the birds settled down for the night and I had to admit that photography was over.

Since I made these photographs, a mysterious mass mortality occurred in 1996, accounting for the deaths of more than 20 per cent of the bald ibis population in the space of a week. Despite great efforts and many analyses to ascertain the cause, results have been inconclusive, but the most likely

possibilities are an obscure virus or toxin. Fortunately however, a couple of good breeding seasons have resulted in the recovery of numbers to something like 220 birds. A great deal has been learned about the bird's biology in the interim, the appointment of local fishermen as wardens has mitigated the effects of casual disturbance, and the development of sustainable 'ecotourism' in the Park is now a high priority. Let's hope their future is assured.

Getting dark
This group of ibis were photographed long after sunset using fast film stock and a shutter speed of about $^1/8$ sec. The graininess of the film and slow shutter speed imparts a feeling of bleakness.
Camera: Nikon F4S
Lens: 500mm f4
Film: Fujichrome Provia 1600 uprated to EI3200

A bird joining the roost at sunset
This shows the bald ibis in 'prehistoric' silhouette.
Camera: Nikon F4S
Lens: 500mm f4
Film: Fujichrome Provia 100

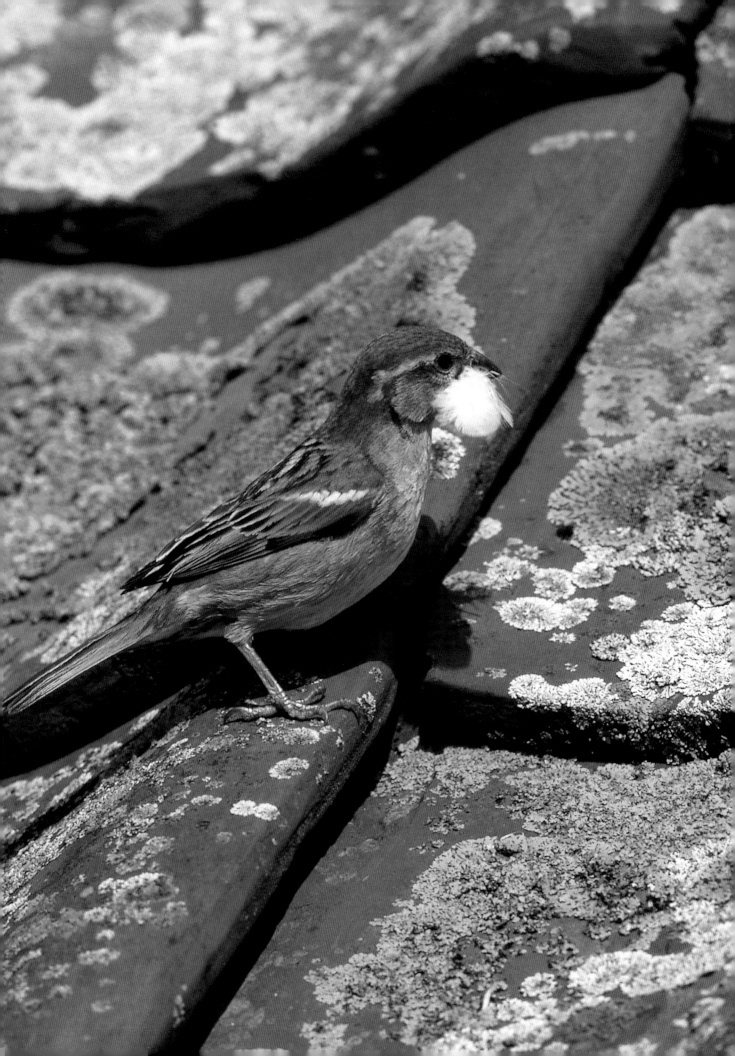

The house sparrow
A stable residence

The house sparrow is a common bird in most parts of the world, usually associated with human habitation. It is also quite drab in appearance, so it is easy to take for granted and overlook as a potential subject for photography. Recently, concern has mounted in Britain that its numbers are in decline. Changes in farming practice are thought to be a contributory factor (although the birds are also declining in towns and cities for reasons as yet unknown), so it was heartening to be introduced to a farmer who was taking practical steps to improve the fortunes of house sparrows on his own farm.

Generally speaking, modern, efficient farming methods mean that little grain is spilt and left lying around fields and farmyard, hedges are less numerous than they once were, and outbuildings are maintained in a much better state of repair than formerly. As elsewhere, High Ash Farm in Norfolk previously supported great numbers of house sparrows, but witnessed a steady drop in numbers until there were only three birds remaining. The difference here is that the farmer was alert to the problem and prepared to do something about it. Addressing the birds' requirements for food, shelter and a place to nest, a few dense hedgerows were recreated around the buildings, and seed hoppers were provided. One other crucial step was taken: when re-roofing an old barn and riding stables, the farmer incorporated a total of 50 nest boxes underneath the pantiles. This worked incredibly well, and there was a slow but steady recovery in numbers of house sparrows. After eight years, there were 35 pairs nesting in these two buildings alone. Now, I understand, all of the nest boxes are occupied.

I came here in the spring when nest-building activity was at its peak, and indeed there was no shortage of house sparrows to photograph. There were possibilities for photography at or near the seed hoppers, or in the dry corner of a horse paddock where the sparrows frequently dust-bathed. But I was most attracted to the traditional pantiled roofs with their colourful tiles and encrusting lichens. To gain height and achieve a better vantage point, I was installed in a tractor bucket, which was then raised to roof level, and I crouched low with my 500mm lens and 1.4x teleconverter resting on a beanbag on the edge of the bucket. Some scrim netting thrown over my head completed the makeshift hide.

Nest-building must have been well advanced as there were relatively few comings and goings. However, I noticed that occasionally birds were arriving carrying downy feathers – preferred items for lining nests. During a break, I searched around the farmyard for any more loose feathers, but they were hard to find as the house sparrows must have collected most of them. I mentioned this to the farmer, and resumed my position in the tractor bucket. Still nothing much happened for a while, but then there was a sudden flurry of activity with house sparrows arriving from all points with feathers in their bills. This went on for 15 or 20 minutes, and I was able to take quite a few photographs. It turned out that, since our conversation, the farmer had gone to the tractor shed where he knew there was a pigeon roost in the rafters and swept out all of the discarded feathers from the floor below. Great to have such a perceptive accomplice!

Sparrows on the farm
A female house sparrow approaches her nest entrance with one of the feathers provided (opposite). This male sparrow (below) is shown pausing on the stable roof.
Camera: *Nikon F5*
Lens: *AF-S 500mm f4 plus 1.4x teleconverter*
Film: *Fujichrome Sensia 100*

The white-tailed eagle
Documenting a successful reintroduction

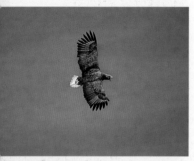

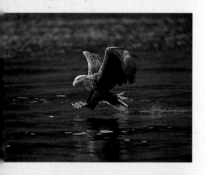

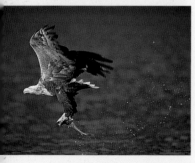

After a period of extinction as a British breeding bird due to human persecution, the magnificent white-tailed eagle (or sea eagle) flies wild and free in Scottish skies once again, thanks to an ambitious and dedicated programme of reintroduction spanning 25 years. There are currently thought to be about 20 breeding pairs in Scotland, rearing about a dozen chicks a year, with numbers increasing all the time. There would be more if not for the malicious depredations of egg collectors.

My first serious association with these awesome birds came in 1985, when as the RSPB's staff photographer I was privileged to be able to witness the maiden flight of the first young reared in Scotland for some 70 years. Photography at the secret nest location was certainly not an option at that time, with so much at stake, but I returned to the area during the following winter, full of optimism, and set up a hide and feeding station down by the shore.

For ten cold days I watched and waited in the hide, photographing buzzards feasting on the rabbit carcass bait as a consolation prize. Since my range was predetermined for a much larger subject, my 400mm Nikkor ED telephoto began to feel pretty inadequate, so after several days I was tempted to switch to a 1,000mm mirror lens to improve the image size of the buzzards. Hard to believe now that I should have considered such an option with an f11 lens in that pre-Kodachrome 200 era, but it seemed the right decision at the time. So with my ISO64 film and an unremembered but agonizingly slow shutter speed, I had to

make the best of the circumstances when a juvenile sea eagle eventually landed between me and the bait.

After all that effort the results were a bit of a disappointment, as the close-up head portrait at near enough minimum focus could easily be mistaken for a bird photographed in captivity. It was indeed the surviving juvenile fledged earlier that year, and I had at least made a passable shot for the historical record, but I felt a bit cheated. Not at all what I had in mind! He didn't stay down for more than a few moments, clearly uneasy about the hide, and after I'd taken a couple of frames he flew to a new perch beyond the bait before flying off for good. So all in all, I suppose I had about 5 minutes of photo opportunity for my ten days' work.

For some years afterwards I tried to stay alert to any new photographic opportunities that might present themselves, but without much success. There were a few occasions when I was able to accompany RSPB fieldworkers under licence as they checked known nest sites for signs of breeding success at remote sea cliffs in the Western Highlands and Islands – this usually entailed long hikes of three or four hours carrying heavy equipment over the hills, occasionally rewarded with a glimpse of an adult taking off some distance below us. A 500mm telephoto with a 1.4x teleconverter sometimes sufficed, but there were never more than a few minutes for photography before we'd have to move on and leave the birds in peace.

Then, in the mid-1990s, I began to hear vague reports of a particular pair of white-tailed eagles that had become accustomed to feeding from the discarded by-catch of local fishing boats, which I also knew to be quite a common habit in the Norwegian fjords. Gradually the rumour became increasingly substantial, and in 1997 I arranged to follow it up with my RSPB Scotland colleagues, hardly daring to hope that this might be the big opportunity I had been waiting for.

Equipped with a photography licence from Scottish Natural Heritage, and supervised at all times by an officer of the sea eagle project team, I set about getting to know the area and meeting the fishermen. I learned that

White-tailed eagle in action

A white-tailed eagle emerges from the morning mist (top). An adult eagle in fine plumage flies from its sea cliff eyrie (top middle). The eagle about to seize a fish, photographed at approximately 1/250 sec. (bottom middle). Success (bottom).

commercial fishing for Dublin Bay prawns (or langoustines) was a fairly new enterprise in that part of Scotland, as the fishermen were trying to adapt to new market demands, and these were the people who were seeing most of the sea eagles.

It soon became clear that moving about by boat was an awful lot easier than going overland, not only in terms of personal comfort, but also because the eagles were so much more approachable from the sea, having become habituated to the 'creel' boats, which operate close inshore. On one especially calm morning, we saw an adult bird sunning itself on a large boulder close to the shore, and we were able to come within about 40m (130ft) of him (until the water became too shallow) without disturbance. This was a phenomenal revelation. Standing on the open deck with my 700mm lens combination supported on a monopod, motordrive whirring and changing

films at will, it was hard to believe that this was a wild bird – the same bird that would fly off before you could come within a kilometre of it if you approached overland.

Nevertheless, there was still a lot of time spent waiting around as there are not so many fine, calm mornings in the west of Scotland, even in midsummer. Even when the weather was fair, the eagles didn't always oblige by flying to feed. Sometimes we could see that one or other parent had recently arrived at the eyrie with a freshly killed rabbit or fulmar, at other times they would chase after a great black-backed gull and force it to disgorge its fish some distance from the boat. After many early mornings and evenings, at last everything came together and we made our long-overdue rendezvous with a sea eagle on its feeding flight. It was a truly magnificent experience, and happily one that I have been able to repeat on a few occasions since.

The triumphant ascent
Sea eagles don't plunge into the water like ospreys, but just skim the water surface with their talons. This captured pollack will be quickly devoured by hungry chicks, once the adult has removed the head. The viewpoint was intentional, and worked for, to be able to show the eagle's tail and water spray against the light.
Camera*: Nikon F5*
Lens*: AF-S 500mm f4 with monopod*
Film*: Fujichrome Sensia 100 uprated to EI200*
Exposure*: ¹/1,000 sec. at f4*

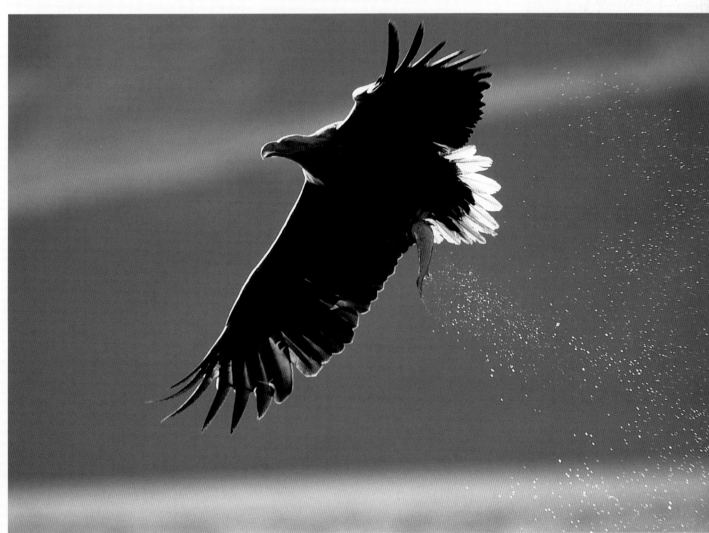

The waders

Angles on a high-water roost

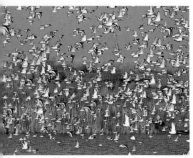

High tide

A purple sandpiper roosts on a breakwater (top). These knot and oystercatcher (above) were photographed from a public hide at Snettisham RSPB reserve in Norfolk.
Camera: *Nikon F5*
Lens: *AF-S 500mm f4 (for the sandpiper), 80–200mm f2.8 (for the knot and oystercatcher)*
Film: *Fujichrome Sensia 100 (uprated to EI200 for the sandpiper)*

The Wash estuary is an internationally important feeding ground for hundreds of thousands of wading birds in winter (it is a listed wetland under the Ramsar Convention, as well as a European Union designated Special Protection Area), and the massive flocks flying to roost at each high tide are really quite spectacular. For many years I have returned to a favourite stretch of the Norfolk coast to watch in wonder, and to try to capture something of the magic in my photographs.

It's always something of a dilemma deciding whether to commit to a hide and hope for some close-up encounters (at the risk of missing out entirely), or to stay out in the open with the freedom and mobility to follow the flocks to some extent, albeit at greater range. Both methods have their merits and drawbacks, and both have rewarded me in their different ways.

At one regular roost in an excavated shingle pit just above the high-water mark, I have often used a purpose-built photographic hide close to one of the main roosting islands, which is made of driftwood and half buried in shingle. Here, I know from experience that I have to get in the hide at least two and a half hours before high water to be in position before the birds start to arrive, and will likely have to stay for at least as long afterwards. As the best high-water spring tides tend to occur before eight o'clock in the morning, this is yet another of those projects that calls for an early start. It also means that it's often a struggle for light, especially in the depths of winter. The low angle is great for candid portraits of single birds, if you can separate them from the main mass, but not ideally suited for showing the sheer numbers of birds involved – you just can't get the depth of field you want through the flock. I have tried to work around this in a number of different ways.

One solution was to use a remote-controlled camera located rather hopefully on a favourite roosting island, leaving it in place for several days over an early autumn tide series in the hope that at least some birds would settle nearby. The 28mm wide-angle lens was pre-focused on a shallow stretch of water previously used for roosting, estimating where the sun would be at the time of exposure, and up-wind of where the birds should be, so they ought to be facing the camera. The camera was contained within a soundproof box, covered with pebbles, and left on aperture priority automatic mode at f8 – with ISO200 film, this should allow for shutter speeds of $^{1}/_{250}$ sec. or perhaps faster, given reasonable light. I made some compensating adjustment, about plus $^{2}/_{3}$ of a stop as I recall, to allow for the area of bright sky in frame. An extended cable release was routed back to the hide position, and then it was just a question of waiting. Not surprisingly, two or three tides passed without any birds coming anywhere near the camera, but I was equipped with another camera and telephoto in the hide so I was able to carry on photographing other things. Then, one morning, a small group of dunlin began to build up around the remote camera, and as more birds arrived they shuffled closer and closer. From my hide, it looked as though they were really packing in tight, so I waited for a few flying birds to fill the space at the top of the frame and took my first shots. There were a few more chances like this on the same tide as more birds joined the roost, but the group soon evaporated when a passing marsh harrier disturbed them all.

Another experiment involved the use of a Linhof Technikardan 5 x 4in camera. I wanted to use the camera movement properties of this monorail, large-format camera to make the plane of focus coincide with the receding flock of birds (the Scheimpflug Principle: subject, lens board and film planes must be parallel to each other or meet at a common point for optimum definition at a large aperture). By tilting the lens downwards and tilting the film back independently, I could see the focus plane shift until it was parallel with the ground. The depth of field would now

extend above and below the resting flock, rather than front to back, so all the birds on the ground would be in focus. But the lenses normally available for these cameras are quite short, with relatively slow shutters; the longest I had was a 260mm Schneider Tele-arton, which is barely longer than the 150mm standard lens for the 5 x 4in film format. So I had a special back panel made for the Linhof incorporating a Nikon F mount, which replaced the ground-glass focusing screen and normal film holder. Now I could attach my Nikon 35mm camera body to the back, using its own focal plane shutter and restoring the moderate telephoto effect of the 260mm lens, while still being able to exploit the large-format camera movements. It meant measuring exposure manually using a handheld lightmeter, setting the aperture on the Schneider lens but the shutter speed on the Nikon, and bracketing like crazy to allow for bellows extension. But it worked!

Sometimes I have tried portable hides on the intertidal mudflats to get close to different species, such as curlew, grey plover and bar-tailed godwit. This demands exceptionally good local knowledge of tides and potentially dangerous creeks, and even then it's a very unpredictable affair; one day you are left stranded high and dry with the roosting birds a long way off, the next you get thoroughly

soaked. Variations to this technique involve mounting a hide on to an inflatable dinghy, or making a rigid, portable hide that you can pick up and carry with you as the tide laps around your feet. Either way it's a messy business, and bound to be time-consuming.

Often, a more straightforward approach has produced very worthwhile results. Some roosts I have been able to stalk by crawling through sand dunes and lying in wait overlooking a sandbar as the tide pushes the flocks closer and closer. The more populated beaches of the holiday resorts can be excellent for photography, as the birds tend to be habituated to people and allow a close approach. At high tide, I have often found small groups of sanderling and turnstone tucked up asleep on the beach, or using the breakwaters, and been able to crawl up within telephoto range, to the amusement of passers-by. There are also several nature reserves along this coast with excellent public viewing hides which, if you time your visit right, give fantastic photo opportunities of wader roost flocks. Even standing on the shore at choice vantage points can give great views of large flocks of waders wheeling over the mudflats, and streaming low over your head as they fly into the roost. These venues tend to be well publicized, often with guided walks laid on for those less familiar with the area.

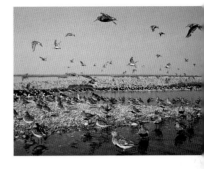

Remote control
These summer-plumaged dunlin were photographed by means of a remote-controlled camera in aperture priority automatic metering mode. The wide-angle lens shows a somewhat unusual perspective, with a more spaced-out flock than was apparent from the hide.
Camera: *Nikon F3 with MD-4 motordrive*
Lens: *28mm f2.8*
Film: *Kodachrome 200*
Exposure: *Approximately $^1/_{250}$ sec. at f8*

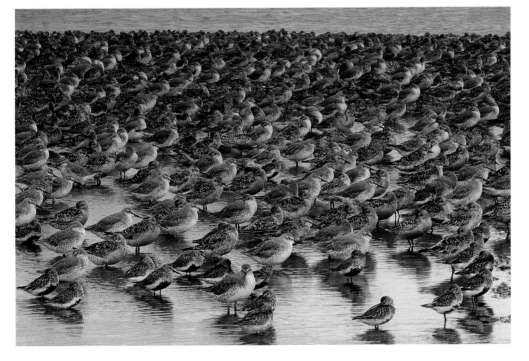

Camera movements
These knot and dunlin were photographed using the Linhof/Nikon hybrid with a 260mm Schneider Tele-arton lens. The Scheimpflug Principle accounts for the overall sharp focus through the flock.
Film: *Fujichrome Sensia 100*

The seabirds
A life on the ocean wave

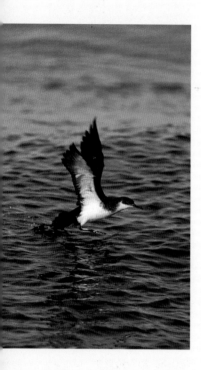

Manx shearwater
Calm sea conditions and a small yacht allowed a reasonably close approach to this Manx shearwater southwest of Ireland.
Camera: *Nikon F4S*
Lens: *300mm f2.8 manual focus plus 1.4x teleconverter*
Film: *Kodachrome 200*

Photographing seabirds at their breeding colonies on land is certainly the easiest way, but doesn't seem to fairly represent their typical habitat and behaviour – they're only ashore for a few weeks each year, and they still feed at sea even then. The alternatives are not straightforward or simple, however. Where do you start to look when you have a whole ocean to search? Suggestions follow based on a few of the sea trips I have made. If you are susceptible to seasickness you may as well forget it!

Some seabirds like kittiwakes and gannets are in the habit of following ships, so there can be opportunities to photograph them in flight from scheduled ferries. The Bay of Biscay ferry routes from Portsmouth to Bilbao and Plymouth to Santander in northern Spain have recently become very popular among birders and cetacean watchers in the late summer, offering good views of great and Cory's shearwaters and even a few little shearwaters, though you are a long way above the sea surface so photography conditions are far from ideal. The Irish Sea and Hebridean island passages can also afford reasonably close views of rafts of manx shearwaters, and these ferries tend to be smaller. The English Channel and North Sea are pretty barren in my experience, but no doubt there are many other profitable routes around the world. To be realistic, most of the time it's difficult to get a decent image size even using 500mm or 600mm lenses with teleconverters.

We have talked about the possibilities of baiting some kinds of seabirds, such as petrels and shearwaters, with 'chum'. There are organized pelagic trips for the benefit of birdwatchers, which reliably turn up great numbers and varieties of seabirds, and those off South Africa in particular are known to be excellent. But you will probably struggle to

move about the boat and get to a good position for photography on such trips, as they tend to pack in as many fare-paying passengers as possible. It is better by far to charter a yacht or game-fishing boat for the specific purpose of photography, and keep the numbers of passengers down to a minimum. This won't be cheap, and you might struggle to find a captain with the necessary experience and the flexibility to put to sea at a time that suits you and the weather.

Once I was lucky enough to be able to join a yacht sailing out of Baltimore in County Cork, Ireland, past Cape Clear and out to the edge of the Continental Shelf. Here we looked for commercial fishing vessels, which generally attract good numbers of birds when they are hauling nets, and tried to get close to them. Standing more or less at sea level meant that it was difficult to see anything too far away, but the fishing boats were detectable on the yacht's radar, and sometimes we were aware of the presence of fish shoals because of large flocks of gannets circling overhead and associated breaching dolphins. Fortunately the sea conditions were very calm, and this meant we could get quite close to manx shearwaters on the sea surface, which were reluctant to take flight. We tried using chum as well, but on this occasion it wasn't particularly effective – a few storm petrels came to investigate, but quite tentatively, and we concluded they must have been finding plenty of food elsewhere. The low position was good for photography, but of course small boats are not very stable so you feel every bit of swell. I was able to use a 300mm lens with 1.4x and 2x teleconverters, sometimes hand-held, sometimes supported on a monopod to relieve my wrists and arms. Obviously, tripods are totally worthless on a small boat.

On another occasion, I joined the Scottish Fisheries Protection Vessel *Sulisker* as she left Leith Docks, Edinburgh, on a ten-day voyage. I was mainly interested in the fishing activities of the Danish sand-eel trawlers operating around the mouth of the Firth of Forth, and wanted to obtain photographs. While the fishery is entirely legal, there are concerns about its effects on the food chain. Sand eels are the staple diet of

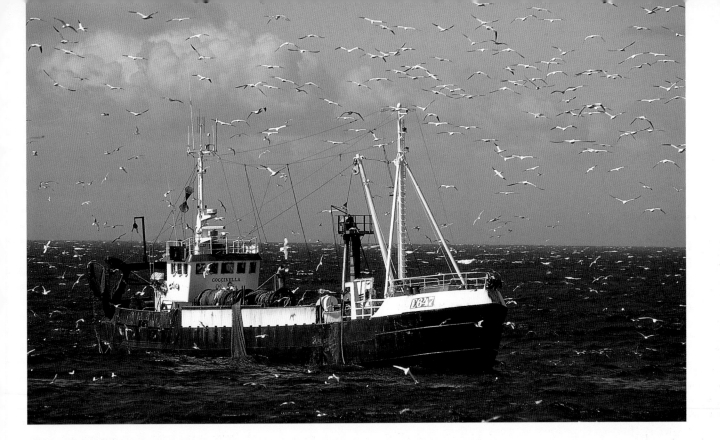

many seabirds, as well as other fish, and their commercial harvesting has been suspected as a possible cause of population crashes of arctic terns in the Orkney and Shetland Islands during the 1980s. Up to 20 trawlers were fishing here in the Firth of Forth this particular June, each capable of removing 800 or 900 tonnes of sand eels every few days. You can't help but wonder if this is really sustainable.

After only two hours' steaming, we reached the fishing fleet just as night fell, so photography was out of the question. Early next morning we could see several trawlers around us towing their nets in different directions, and we would follow them in turn. At intervals during the day, a crew of Fisheries Protection Officers would embark on their launch to board a trawler and investigate its catch. It was always 'clean', meaning that there were no appreciable numbers of any other fish species in the hold. I was able to board only one trawler as most of the time the sea swell was too high to risk passengers, so for the rest of the time I watched and photographed from the *Sulisker*. It would take several hours of towing before a trawler's nets were hauled to the surface, but this was the time to be alongside – as the bulging nets came to the surface, large flocks of plunge-

diving gannets would congregate around the trawler, pouncing on fish that spilled from the net. Scavenging great and arctic skuas joined in, sometimes chasing a gannet to make it regurgitate its meal. The ideal place to be taking photographs would have been from on board the trawler itself, as the gannets continued to feed very close in. As soon as the nets came too close to the ship, flocks of kittiwakes replaced the gannets, swooping on smaller fish and items that fell from the net right alongside the hull. For a few minutes the area was thick with seabirds, but they disappeared as quickly as they came once trawling resumed. I used both 500mm telephoto and 80–200mm zoom lenses on separate camera bodies, with the longer lens suported on a monopod.

I'm still trying to figure out a way to get close to winter-plumaged auks such as puffins and guillemots at sea. It seems as though you could spend the rest of your life afloat and not achieve it.

Plunging for fish

Gannets dive all around this Danish trawler as its nets are hauled to the surface.
Camera: *Nikon F5*
Lens: *80–200mm f2.8*
Film: *Fujichrome Provia 100*

Great shearwater

This was photographed from the Pride of Bilbao *passenger ferry in the Bay of Biscay.*
Camera: *Nikon F5*
Lens: *AF-S 500mm f4 plus 1.4x teleconverter*
Film: *Fujichrome Sensia 100 uprated to EI200*

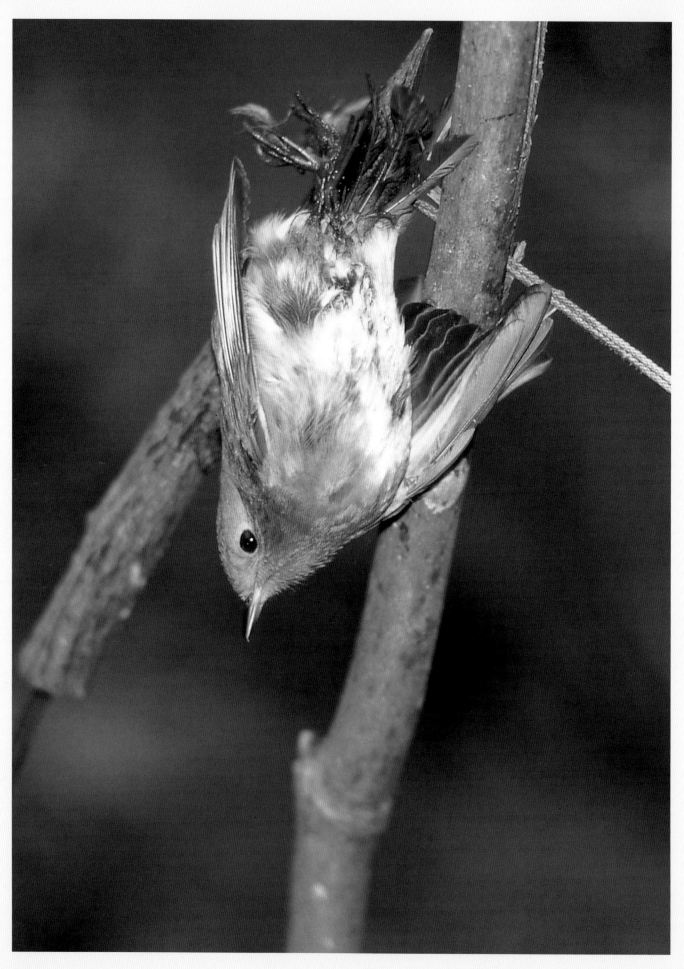

It has occasionally been my sad duty to report on some of the unpleasant things that happen to birds, as victims of natural disaster, environmental accident and, all too often, human persecution. Now it takes no particular skill or technique to photograph a dead or dying bird, or at least it's not usually a problem to get close to them. But it is distressing, and sometimes dangerous, so you have to be able to work without having to think too hard about what to do next. I'm not recommending this as a fun activity or even a rewarding photographic experience, but if you have the stomach for it you might help to publicize some of the atrocities that do occur, and work to bring about change.

Many Mediterranean countries are known to be death traps for migrant birds, which fall victim to guns, nets and various trapping devices in vast numbers. The illegal spring shooting of honey buzzards in Calabria is well documented, as is bird 'liming' in Cyprus, and the shooting and netting of so many birds that happen to pass over Malta. There are many other examples. Some of these places I have visited in an attempt to make a photographic record, but with mixed results. To paraphrase a well-known saying: 'if you've seen one dead bird, you've seen them all'. To get close to some of the hunters would be to risk physical harm – there is a serious level of hostility to 'conservationists' in many of these places. Going equipped with professional camera equipment in the company of known environmentalists would perhaps be asking for trouble. However, as a casual holidaymaker with no obvious political agenda who happens to be carrying a compact camera, you might more easily gain people's confidence.

The other way is to go by appointment, with armed police. One autumn I made a 24-hour visit to Brescia in the north of Italy and kept a rendezvous with a volunteer from the Lega Italiana Protezione Uccelli (LIPU), the Italian BirdLife partner, and some officers of the Corpo Forestale dello Stato (Forest Guard). Over a single morning we scoured a wooded hillside and recovered over 200 illegal *archetto* traps, which are set and baited with ripe berries for the specific purpose of trapping

The victims
Robins are a delicacy in Brescia

robins. The *archetto* (or bow) serves as a spring device, which tightens a snare around the bird's legs when it lands on, and displaces, a loosely fitted perch. Six of these traps contained captured robins, some still just about alive, all with their legs broken. They were later put down in a humane way.

The robins are normally sold to local restaurants where they are served as a traditional delicacy. It has to be said that the trappers are mostly quite poor hill farmers who probably struggle to make a living. And it should also be pointed out that there is no evidence whatsoever that such trapping has any effect on the population or conservation status of the robin. Nevertheless, it seems desperately cruel and is definitely unlawful.

Obviously, there was no time to waste. It was important to take my shots quickly and let the LIPU and Corpo Forestale personnel get on with their job. Working with a 35–70mm zoom lens on a Nikon F4S and using a Speedlight SB-24 for fill flash, I simply did what was necessary. It wasn't too difficult to make a subject like this appear shocking. The photographs have not been widely published before, so I thought it was about time they were.

Confiscating traps
A Corpo Forestale officer gathers a number of illegal archetto *traps (top). Rows and rows of* archetti *were found baited with ripe berries (below), some containing recently captured robins.*

(opposite) **A snared robin**
This robin was close to death when it was found.
Camera: *Nikon F4S*
Lens: *35–70mm f2.8*
Film: *Kodachrome 64*
Lighting: *SB-24 Speedlight*

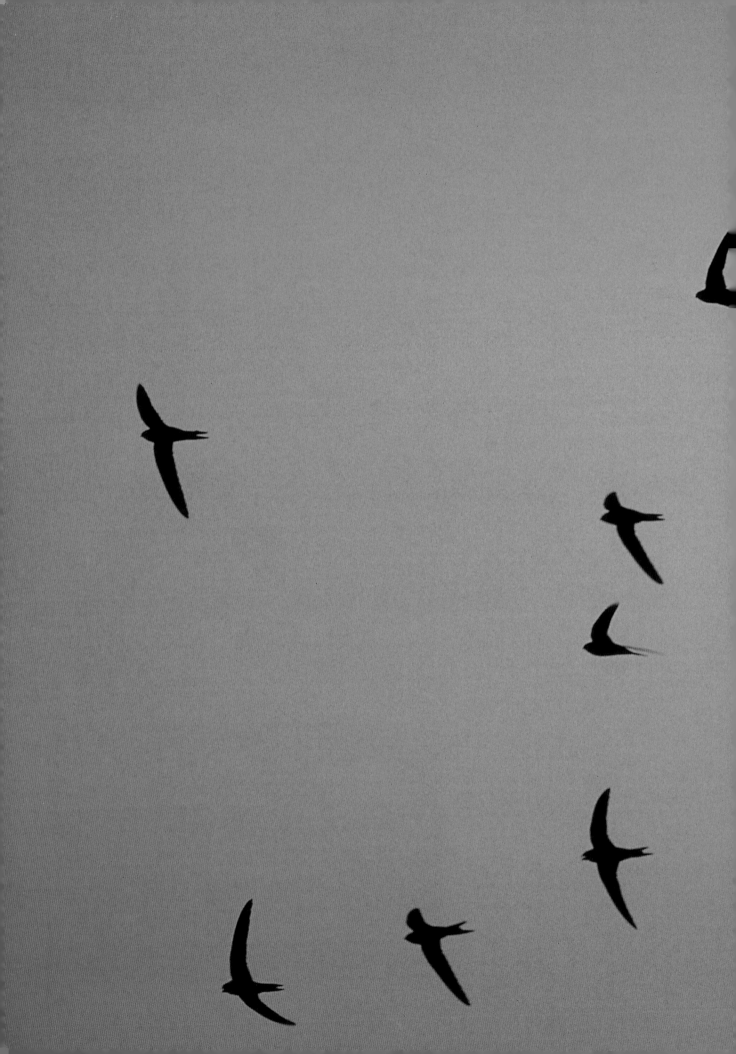

Chapter 5
POST-
PRODUCTION

The creative process does not end with the pressing of the camera shutter. Much work remains to be done in the areas of quality control and administration, sorting the good images from the bad, and then setting about organizing and caring for them. This is before we can even begin to think of presenting our work to a wider audience.

(previous pages)
Screaming flock of swifts
*This was photographed into the
light with a hand-held 500mm
telephoto, to evoke the mood of a
summer evening.*

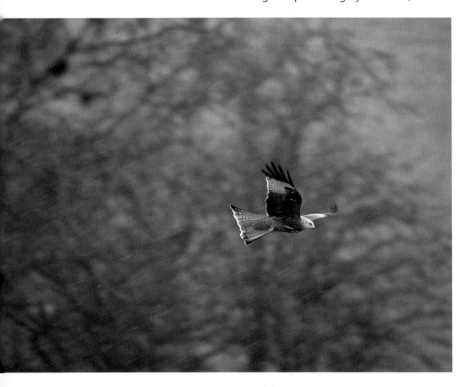

Red kite in sleet shower
*It's always worth taking a chance
in interesting conditions like this,
even if the light might seem
inadequate. I got away with this
shot, taken at the Gigrin Farm
feeding station in mid-Wales, at a
shutter speed of about $^1/_{160}$ sec.,
but several other frames taken at
the same time were blurred and
consequently rejected in editing.*
Camera: *Nikon F5*
Lens: *AF-S 500mm f4*
Film: *Fujichrome Sensia 100
uprated to EI200*

PROCESSING AND
EDITING

There is nothing that quite matches the bitter-sweet feelings of excitement and anxiety as you anticipate the return of your processed films from the lab. By now it's too late to rectify any (well, most) mistakes you may have made, but not too late to learn from them. And the wastebasket is still a powerful tool; you can be judged only by what you choose to show people.

I usually opt for non process-paid films, and arrange for processing by a trusted,

professional lab. I also prefer to collect and deliver films by hand rather than risk them in the post, but much will depend on where you happen to live. As I don't expect to keep more than half of what I've shot, on average (though the shooting ratio varies enormously depending on the nature of the subject and how ambitious my treatment is), I ask the lab to return films cut and sleeved, but not mounted. There's less risk of damage to film this way, I can choose the kind of mounts I prefer and I don't have to pay for mounts I'm only going to throw away.

Transparency films are best viewed on a daylight-balanced light box, equipped with Philips colour 950 fluorescent tubes (formerly

GraphicA 47) or their equivalent. For critical assessment of sharpness, you should use a 'loupe' (or 'lupe'), which is a kind of hand lens specially designed for the purpose. Even the best of these is somewhat cheaper than most standard camera lenses, so go for top quality. My own favourite is the Schneider Kreuznach 4x Lupe, and this does seem to be the choice of most photographic editors, allowing you to view the full 24 x 36mm image area at the best possible resolution. Higher magnifications certainly show up any defects, but they are more difficult and less comfortable to use, especially over long editing sessions. Although you may wish to enjoy the impact of your slides projected large on to a screen, don't rely on this as a method of assessing sharpness, as projectors tend to flatter.

Be ruthless in the editing process, and reject any images that are poorly exposed, not sharp, or otherwise flawed. This is a difficult task when you have just made a large emotional and financial investment in the image-making process, but try not to kid yourself – if you can detect even the tiniest defect or hint of softness, imagine how it will be magnified in an enlarged print or reproduction. Imagine, too, how somebody more objective than you might view it – not kindly, probably. Sometimes the distance of time helps you to be less subjective and more dispassionate. I find that if I review work at a later date I am more inclined to be strict with it, although there is the danger of building up a backlog of editing work this way. It's a process that never ends – you need to go on editing and consigning yet more rejects to the bin every few months. Films get better, standards get higher (your own and others'), and you will be amazed and embarrassed at what you once thought was acceptable, five or ten years on.

Working with cut film strips inserted in clear-view sleeves, it is a simple matter to view all the images on one film side by side on the light box and mark up the sheets with a chinagraph pencil. I find this the quickest way to deal with a number of raw, unedited films at one time. View with frame numbers and manufacturers' film codes the right way round

so that the film emulsion is facing downwards and images are in the correct orientation, and examine closely any potential 'keepers' through the loupe. On the outer protective sleeve score through the rejects or tick those you wish to keep with the chinagraph pencil. Cut the film strips carefully with sharp scissors, ideally while wearing cotton film-handling gloves, and finally separate out those frames that are destined for mounting.

There are various mounting presses on the market for different types of slide mount, with varying degrees of automation. I generally use Gepe metal mask, 2mm plastic mounts, which hold the film securely, pick up easily off the light box and don't jam in projectors. The grey surface should be on the bottom with the white surface uppermost. Gepe provides special plastic tweezers for picking up the film by the rebate sprocket holes and flexing to slot under lugs in the metal mask. The two halves of the mount simply lock together in the press through a system of interlocking ridges and furrows. Other designs of plastic mount are hinged or pre-glued, or designed for roller transport machines. Card mounts are cheaper and easier to write on, but give fuzzy edges to your pictures and tend to fray and come apart.

With machine-mounted slides from the lab, you don't have the hassle of cutting and mounting film yourself, but beware the modern, ultra-thin mounts, which snarl up in many projectors. Frame-edge sensors in the mounting machine can be fooled sometimes if you have reloaded a partially exposed film, resulting in cuts occurring out of sequence (through the image instead of between frames).

Don't use glass slide mounts for your originals. They are prone to condensation spots, film sticking to glass or scorching, optical aberrations such as Newton's rings, and glass shattering in transit causing irreparable damage. The only thing they are good for is preventing slides from 'popping' out of focus as they heat up when projected. So, fine for duplicates and computer-generated text slides (in which case use anti-Newton, or AN, glass mounts), but not for everyday use.

STORAGE AND CONSERVATION

Once mounted, your transparencies need to be filed and protected. There are various ring binders, box files and cabinets designed for the purpose, but the hanging files that store in standard office filing drawers are the most compact, universal system. These hanging files generally hold twenty-four 35mm mounted transparencies in pockets, and suspend from metal bars.

Ideal storage and archival conditions would be dry, dark and cool. A normal filing cabinet in a modern house or office would most likely qualify on the first two counts, but since 'cool' is quite impractical for comfortable living, most of us compromise on that one. If you do live in a part of the world with very high humidity, you might be well advised to install a dehumidifier in the room to avoid the risk of fungus attacking your film. Otherwise there's no need to make any major modifications to your home. One thing to avoid is the vapour from volatile plastics and resins near your transparencies, so it's best to use storage files made of an inert material like polypropylene or polyester, rather than PVC, and store them in metal cabinets. Keep the drawers closed when not in use, and don't leave transparencies out in the light more than you need, to prevent colours from fading. Repeated projection will also lead to rapid deterioration of colour pigments, so keep your best originals pristine, and project duplicates whenever possible.

I like to have the additional protection of 50mm square clear polyester slips (such as Secol 'Tecs'), which help to keep out dust and guard against fingerprints when handling the transparencies. These slip over the mounted transparency before it is inserted in the hanging file – keep the open edges perpendicular to the file pocket opening for best protection and ease of insertion.

It shouldn't be necessary to clean your transparencies if you've been handling and storing them carefully until now, but if they have been in projector magazines or left out unprotected, they may require occasional dusting. Don't blow on transparencies to remove dust, as droplets of saliva will stain the

Sanderlings roosting
You might expect a better keep rate for shots of stationary subjects.
Camera: *Nikon F4S*
Lens: *500mm f4*
Film: *Kodachrome 64*

film. A clean blower brush (kept specially for slides) or anti-static brush will normally do the trick. Clean air duster in aerosol cans is a more powerful way to remove stubborn dust particles, but be careful always to use these in the upright position otherwise the propellant may be dispensed in liquid form, and this too causes stains on film. For more serious stains, surface marks or fingerprints, there are proprietary solvent cleaners on the market such as Aspec film cleaner from Pro-Co. Apply gently with a lint-free cotton cloth, or a cotton bud, and then polish clean. These solvents generally work on the residues of lacquer you sometimes find on transparencies returned by publishers after drum scanning. Of course they should clean them first, but they don't always oblige. On a few rare occasions, I have found residues that don't respond to the organic solvents available to me, but have been able to remove them by rewashing the film in water with a drop of Kodak Photo-Flo solution. Be very, very careful if you do this, as the film emulsion becomes soft and incredibly fragile, and the most innocuous contact can leave a nasty gash – definitely a last resort.

I've talked about the desirability of having duplicates in a number of circumstances. Duplicating transparencies inevitably leads to some loss of quality, but this may be hardly noticeable when the better copies are projected. Unfortunately the quality of duplicates is enormously variable, so what should you look out for? To begin with, I would strongly advise against the home copying outfits, which comprise little more than a bellows and daylight diffuser, intended for use with regular daylight-balanced transparency film. Results from such set-ups are always disappointing, exhibiting unacceptably high contrast and unwelcome colour shifts. For a reasonable quality duplicate you should be using a tungsten light source with appropriate colour filtration, batch-tested duplicating film stock such as Fujichrome CDUII, and a specialist 1:1 copying lens on a copystand or rostrum camera. With luck, this is what you will get from a lab advertising 'reproduction-quality' duplicates, but even that isn't guaranteed, so check the results carefully,

comparing against the original for sharpness and a good colour match. The best examples should make fine projection duplicates. For genuine reproduction-quality copies, you need high-resolution (A.C.T.) duplicates where the film to be copied is immersed in oil (minimizing light refraction) and then lit by collimated, stroboscopic illumination (separate red, green and blue light exposures) for maximum sharpness. This is the duplicating system preferred by most wildlife photo agencies, and it delivers copies almost indistinguishable from the original. It can even eradicate finer surface scratches and adjust for minor underexposure.

Some photographers (mainly professionals) like to have enlarged duplicates made of their prized shots, usually on 70mm film. While these can look impressive on the light box, they don't usually stand scrutiny under a loupe, because of the enlargement that has already taken place. Some editors and picture researchers understand this and allow for the fact, but all too often they don't, and reject the shot without asking further questions. Besides, a 70mm transparency is an unambiguous signal to the editor that they are looking at a duplicate, whereas a high-resolution 35mm duplicate could be taken for an original, so they might well be inclined to go with the latter. For this reason I tend to think of the 70mm duplicates as a waste of money, and prefer to supply 35mm high-resolution duplicates to clients where necessary.

ORGANIZING A PHOTOGRAPHIC COLLECTION

Sooner or later you will have to bring some sort of order and system to your collection of transparencies, or else you'll never find anything. There is no right or wrong way to do this, but you would be wise to establish some sort of filing discipline early on. If we're just talking about photographs of bird subjects for the moment, it would make sense to categorize them in the same order as the systematic list you would find in a field guide – it might take some getting used to if you're new to birding and bird photography, but at

least all of the related species can then be found close together. Picture request lists often follow this taxonomic convention, too. Alphabetical order might seem logical but leads to all sorts of complications; you could use the convention of 'warbler, willow' and 'warbler, wood' in an attempt to keep related species close together, but then what would you do with 'blackcap' and 'chiffchaff' (also warblers)? On the other hand, you might prefer to file subjects geographically, in line with your various photographic expeditions. It's a matter of individual choice how you do it, but try to think through how your system will work when you have amassed thousands of transparencies. One hanging file might do for one species, or even one family at an early stage in your collection. As the file for each species grows, it's a good idea to sub-divide, perhaps by sex, plumage, or behaviour, so that each subject never has more than a few hanging files devoted to it. With hanging files in drawers, it is relatively easy to in-fill. Other filing systems might require major upheavals as the subject files multiply, so consider this at the outset.

Once you have a filing system up and running, it doesn't matter too much if you don't label all the individual transparencies straight away, but do file them in the appropriate subject areas so that at least you will know where to look. If you are well organized and tidy minded, you might well want to caption and label all your new work at the time of editing. You will have more chance of remembering all the relevant details at this stage, and it's easier to run off many similar labels with slide-labelling software applications such as Cradoc Caption Writer. These computer labelling systems are great for printing out professional-looking slide labels, and make most efficient use of the small area of mount available to describe the image. Alternatively, use fine-tipped permanent markers (such as OHP pens) for writing on plastic slide mounts. Caption with both the colloquial and scientific name if you are likely to submit the slides to publishers or other users (the scientific name will be understood anywhere in the world and avoids conflicts between American-English and British-English bird names). Furthermore, if you

Brent geese at Leigh-on-Sea
Would you file this photograph under 'brent goose', 'brent geese', or possibly even 'goose, brent'? On the other hand, might it be categorized by habitat or location? In which case, is it E for estuary, M for mudflats, S for saltmarsh, L for Leigh or T for Thames? If this bothers you, you might wish to consider keywording your collection.
Camera: *Nikon F5*
Lens: *AF-S 500mm f4*
Film: *Fujichrome Sensia 100*

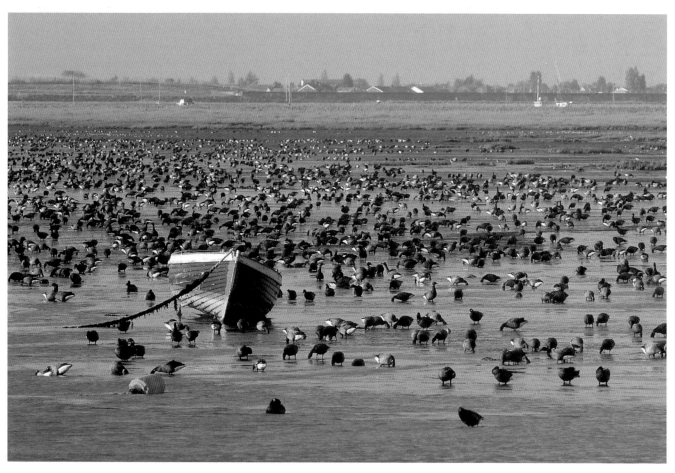

are sending out your slides it would also be a good idea to give each image a unique serial number to enable you to identify it in any communication. Don't forget to add a name and address label to identify yourself as the photographer – some people have these commercially printed in bulk.

Much as I aspire to be this well organized, I usually end up numbering and captioning transparencies only at the point when I send them out on loan. This does have the advantage that I don't waste time on labeling images that nobody ever asks to see. (They might even succumb to the next edit, making sure I never have to label them!) Then I just allocate a sequential number in the computer labeling program as each image comes to the top of the pile, regardless of subject category. At the end of each session, I save each update to my text database, and export the update to a report template, ready to print out as a delivery note. If I need to inquire about a specific transparency at a later date, I can easily search by number, subject name or any other criterion.

Remember that these search engines are entirely rational, so it pays to be consistent with your nomenclature if you expect to search your files this way. For example, you could resolve always to use the singular description "brent goose" in your naming system, since the search engine wouldn't understand that "brent geese" is actually the same thing. It's tempting to believe that a text database can provide you with the perfect cross-referencing system, allowing you to trawl across the species boundaries for attributes such as habitat, season, color, or even abstract concepts like "beauty" or "aggression." Such systems are incredibly time-consuming to set up and maintain, requiring you to establish lists of approved keywords and synonyms for efficient operation, as well as spending an age thinking about the caption for each new image. If you're only filing your own work, then I would suggest that your own memory is likely to be quicker, more reliable, and certainly more flexible.

As well as having duplicates made, you might also want to archive your best images as digital files. In this case, original transparencies and negatives will need to be scanned and the resulting files saved to a data disk such as CD or DVD-RAM (probably the two most stable storage media) because your computer hard disk will soon run out of storage space. The typical desktop flatbed scanner is not good enough for this task, even if it boasts a special "film adapter." You really need a dedicated film scanner such as the Nikon Coolscan, Polaroid Sprintscan, Minolta Dimage or similar if you want to scan transparencies to a reasonable quality. With a scanning resolution of 2,700 ppi (pixels per inch), my Nikon LS-2000 scanner delivers a maximum file size of about 25MB from a 35mm transparency, which is good enough for most printing and publishing purposes. The dynamic range of the scanner is also an important consideration, determining how well it renders tonal detail. A dynamic range of 3.5 or above and 36-bit sampling would indicate a good-quality film scanner, capable of recording subtle tonal differences, especially in the shadows. Investigate the scanner software before you buy – some applications are most unfriendly, and don't seem to be written with photographers in mind. Some offer automatic dust and scratch filtration, which spares you from long and arduous retouching sessions later. There are also bureaus that offer scanning services. Order drum scans for the very best results, or Imacon Flextight machines are generally regarded as supreme among the CCD-type scanners.

In theory, once you have a digital file you should be able to derive perfect, lossless copies ever after. However, sometimes files do become corrupted during transfer and the long-term stability of CDs has come into question, so it would be a sensible precaution to make back-up disks, and to keep backing up on a regular basis. Even if the medium remains perfectly stable, there may not be machines available to read CDs and DVD-RAMs in future, so you could find that you will have to copy all of these files on to some new medium eventually.

So now you have an archive of digital image files to worry about, too. As with slides

in filing cabinets, a few CDs on the shelf holding perhaps 20 or 30 high-resolution images on each isn't too difficult to deal with. But as this collection grows you will need more than just a few scribbled titles on the cover sheet. An image database is the answer. To do this with high-resolution images would take too much space and be too slow, so an image database works with small, low-resolution image files or 'thumbnails' instead. These can be stored right on your computer hard drive. There are a number of image database applications on the market, some of the better known ones being Extensis Portfolio, iView Media Pro, and Canto Cumulus. Use a **relational** database package so that when records require updating – say when a bird's scientific name is revised – you only have to do this once, not for each individual record. The image database should contain captions, unique image reference numbers and all other relevant text data, linked to the image, and include a reference to the location of the high-resolution file. It should be easily searchable, and allow you to sort the images by different criteria with the facility to display the thumbnail shortlist on a "light box." If you are already shooting on digital, you will need to establish a system like this pretty quickly. If not, then you had best start preparing for it.

PRESENTING AND PROMOTING YOUR WORK

You would be a rare photographer if you didn't want to show off your work a bit. Whether it's passing around a few prints to friends or mounting an exhibition at a prestigious gallery, we all like to share our photographs with others, and hope to receive some positive feedback. For many, the ultimate goal is to see their work published in print. Fortunately, there are more ways than ever before to disseminate photographic images.

The slide show is the traditional way to display transparencies to an audience, projecting the images on to a large screen in a darkened room. This format comes in for a lot of criticism and disparaging remarks these days, and indeed we can all think of tedious slide presentations we have had the misfortune to

attend. Still, it remains the best way to show a fine transparency in all its glory. Those shooting digitally will probably want to use a presentation application such as Powerpoint. For a small number of viewers a computer monitor will suffice, but a digital projector will be required for larger audiences. These now work well with relatively high ambient light, but resolution is still lower than a slide projector – for this reason, many photographers choose to have their digital files output to slide through a bureau.

Bird clubs and camera clubs are always on the lookout for new speakers, and are often willing to pay a fee, so if you have the skills, you might find yourself in demand. It gets easier with practice. Maybe you could give free, illustrated lectures to local groups or schools initially, to gain confidence.

The Kodak Carousel (now Ektapro) is the workhorse of slide projectors, with its solid construction and universal, rotary slide tray. Leitz, Zeiss and Rollei also make good projectors with excellent lenses, but perhaps these are not quite so robust and dependable. Autofocus is a great asset on a projector so that you don't have to keep adjusting the focus control, especially when projecting slides in glassless mounts. An extended remote-control cord, or infrared handset will allow you to advance the slides without turning your back

Brown pelicans diving for fish
No post-production trick, digital composite or slide "sandwich" here – these pelicans really do synchronize their dives in this way. Since the left-hand bird is a bit tight to the edge of the frame, I might consider cropping a little from the right to balance it up in a presentation print.
Camera: *Nikon F5*
Lens: *AF-S 300mm f2.8*
Film: *Fujichrome Sensia 100*

on the audience. Normally a projector lens of about 150mm is appropriate for an average-sized hall, with a screen 2 to 3m (7 to 10ft) wide. Remember to take along spare projector bulbs, spare fuses and a power extension lead on all your lecture engagements.

When preparing slides for projection it is customary to 'spot' the slide mounts, to aid loading in magazines. View the slide from the

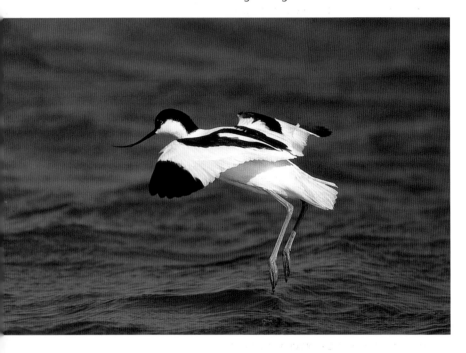

Avocet in flight
Action shots are more likely to be in demand with magazine and picture library editors.
Camera: *Nikon F5*
Lens: *AF-S 500mm f4*
Film: *Fujichrome Sensia 100*

front with the image the right way round, and place the spot at the bottom left corner of the slide mount. This way, you know that if you hold the slide with the spot under your right thumb as you drop it into the slide tray, it will be loaded correctly. If you have a regular slide set for a particular talk, which doesn't vary, it's not a bad idea to have the whole lot duplicated and glass-mounted. The glass mounts will help to keep the slides in focus from edge to edge, but you must remember to dry out the slides before each presentation, or else distracting water marks appear as condensation between the glass warms up in front of the projector bulb. There are purpose-built drying cabinets for this, or you can just leave the slide tray on top of a low radiator for a couple of hours (remember we are talking about duplicates). On no account leave slide trays loaded with glass-mounted slides in a car on a cold night – it's asking for trouble with condensation. One other advantage of glass

mounts is that you can get various metal mask inserts of different aperture proportions (other than the standard 24 x 36mm), for critical reframing of images. These are useful for cropping out any distracting elements you wish you'd seen or been able to exclude when you took the photograph. Don't use these too often, or it will look as though you can't frame a photograph in camera.

Prints are a more convenient way of showing photographs, since you don't need any special equipment and can view them in normal light. To obtain the best conventional photographic prints from transparencies, order 'reversal' prints, where the print is made directly from the slide without the use of an internegative. The best known of these is the Ilfochrome (formerly Cibachrome), and this is generally reckoned to be the most archivally safe form of colour print, but there are other brands that are a good match, and often cheaper.

Fewer and fewer photographers have their own darkroom these days, and indeed it's probably not the time to be starting one up, unless you are passionate about silver halide prints and chemical toning. The digital print has come of age. There are various ways of printing out digital image files, commonly through laser, wax thermal and inkjet printers. The latter is the most widespread printing method in the home environment, and the modern inksets and premium papers can produce quite stunning quality prints from high-resolution scans, to rival the best Ilfochromes. Image-processing software such as Adobe Photoshop enbles you to make fine adjustments, so that in some ways you have more control over the finished print than you ever could over a conventional lab print. It is also more convenient, more economical, and involves much less risk to your original transparency. On the downside, inkjet prints are slow to output, and there is still a lot of doubt about their long-term stability, with some users experiencing colour shifts and fading after just a few weeks. No doubt great research and development efforts are going into rectifying this, but I'm already sold on the virtues of inkjet prints. For the best of both

worlds, send your own digital file to a bureau for them to output as a Kodak CRT or Kodak LED print, Cymbolic Science Lightjet, or Durst Lambda (for larger sizes) print, all of which utilize traditional photochemistry and should therefore last as long as conventional prints. Fuji Pictrographs are also very interesting, high-quality digital prints available through some bureaux, but they employ a unique type of chemistry that may not have the same archival stability.

For portfolios, the presentation of prints of any description can be much improved by dry-mounting them on card. Window mounts with mat cut-outs also do much to enhance a fine print. Framing under glass will further prolong print life, and it's always worth having this done professionally, especially if you plan to exhibit or sell. Galleries might be disinclined to take the risk with an 'unknown' photographer, and in any case they would take a hefty commission on print sales, but there are countless restaurants, hotels, pubs, banks, libraries, visitor centres and so forth that might be pleased to host a display of your work for nothing, and allow you the opportunity to sell off the wall. If your photography and pricing structure do find a ready market, the craft fairs beckon!

There are other ways of achieving wider recognition for your work, not least through participating in photographic competitions. These might be organized by a local camera club or village show, promoted by a magazine (not only photographic magazines), or be internationally recognized events like the BG Wildlife Photographer of the Year. The BG competition is well established and influential, attracting thousands of amateur and professional photographers from all over the world, so it might not be the easiest place to make an impact. However, its touring exhibition and the published portfolio reach huge audiences, so it's got to be worth having a go. Many camera clubs are also active on the international competition scene. Don't overlook the smaller and more obscure competitions where you might have a more realistic hope of being a big fish in a small pond.

Commissioned assignments for wildlife photographers are a very rare phenomenon.

Nobody wants to pay by the day, as the risk of failure is simply too great. Instead, the publishing industry is served by specialist photo agencies (and increasingly by 'clip-art' or 'royalty-free' providers), who keep a wide range of stock photographs. The agents represent the work of a number of photographers, retaining a proportion of their best originals and selling reproduction rights for specified uses, for an agreed licence fee. For this service the agent takes a commission, usually about 50 per cent, and the photographer receives a sales statement at regular intervals. Most importantly, the photographer retains copyright and ownership in his or her work, and can recover it at any time, subject to the terms of the contract. It is the agents who have the established client base and network of contacts, a knowledge of market prices, and are generally in the best position to give a quick, professional service. Whether photographs are used in a book, on a T-shirt, or as part of a global advertising campaign, the agent will know how to supply and how much to ask. Therefore, bird photographers who aspire to selling their work to publishers generally look for an agency to take them on.

Agents' names can be found in books and magazines in the credits accompanying photographs; they usually follow the photographer's name but sometimes replace it altogether. Alternatively, ask their representative organizations BAPLA (British Association of Picture Libraries and Agencies), CEPIC (Co-ordination of European Picture Agencies Press and Stock) or PACA (Picture Agency Council of America) to supply you with a list of members. You may have to pay for a printed directory, so don't overlook the internet as a source of this information. It is a very competitive field and a bit of a buyer's market, so breaking into it is not a straightforward proposition. By and large, agencies will want photographers who can consistently supply good work in volume. As a guideline, the first submission is usually expected to be some hundreds of transparencies, which will be edited rigorously if accepted for consideration. Don't be surprised if you are told they don't have any openings for more bird photographers –

photographs of mammals are more often requested than those of birds, and pets are the most saleable subjects in the animal world. If you do get past this first hurdle and are invited to submit a portfolio, do ensure that the transparencies are neatly and accurately labelled, and well presented in see-through wallets. Nothing is more guaranteed to irritate a picture researcher or editor than a mass of loose slides in boxes. You will further enhance your chances if you show you can edit properly – don't be tempted to make up the numbers with a few 'very nearly sharp' photographs as these will fool nobody and suggest that you can't tell the difference. Above all, keep trying. If you are convinced that your own photographs are at least as good as many you see in print, then somebody somewhere must want them, and be prepared to pay. Recently established agencies will be more inclined to take on new photographers. The 'royalty-free' collections tend to be less selective, and usually offer only a one-off payment, which might make for poorer returns over the long term.

Although competition is increasing all the time, so are the number of outlets for published photography. In recent times the desktop publishing revolution has resulted in a proliferation of new magazines, club newsletters and company reports, all of which demand good-quality photographs even though they don't all expect to pay for them. There are also many new 'pursuit' magazines targeted at particular hobbies, and these often welcome photographic contributions, with some making special provision for readers' portfolios and paying modest fees. If you can write well, you might try to present a complete package of article and pictures to maximize your chances of success. Again, good presentation is crucial to getting noticed. If you are sending original transparencies, check first that the intended client is happy to receive them (especially if you are dealing with a busy weekly publication or daily newspaper), as you might not get them back otherwise. You could of course submit good-quality duplicates. Sending a selection of scanned images with captions and any other

accompanying text on CD is a good idea, but if you do this supply a hard copy of one or two photographs to tempt the editor to look a little deeper. Inkjet prints are good for this purpose. If they reject your proposal or don't even get around to looking at it, at least you haven't lost much in the process. Expect rejection and even lack of acknowledgement from time to time, but don't let this deter you – persistence pays off in the end, assuming your work is of a sufficiently high standard.

Once you are known to a particular publisher or editor, you might supply scanned photographs as email attachments, but don't send these unsolicited as the large files can jam up some networks, and this is not likely to endear you to the company. Low-resolution previews can be saved to 72ppi (monitor resolution) and transmitted in the j-peg file format (minimum compression) to keep the file size down but maintain reasonable image quality. You can even supply high-resolution image files in this way if asked, but let your client stipulate just how files should be supplied to suit their requirements. Some are happy to work with straightforward RGB files, but high-quality publications are more likely to demand press-ready CMYK separations, and this demands some in-depth knowledge of colour management, so don't bluff.

Electronic, online publishing is also an obvious growth area. Copyright does extend to photographs published on the World Wide Web, but can be more difficult to enforce. If somebody wants to use one of your photographs in their own web site or online publication, you are entitled to ask for a fee. And of course, you can create your own web site to display and promote your photography. This a great way of exhibiting a 'virtual portfolio' of images to which you can refer interested parties and potential clients – but don't expect the world to beat a path to your door. While it is the perfect opportunity to self-publish, remember that there are an awful lot of people doing something similar. Web-authoring packages are readily available from a number of software houses, some of which include design templates for standard sites. Engaging a professional web designer is certain

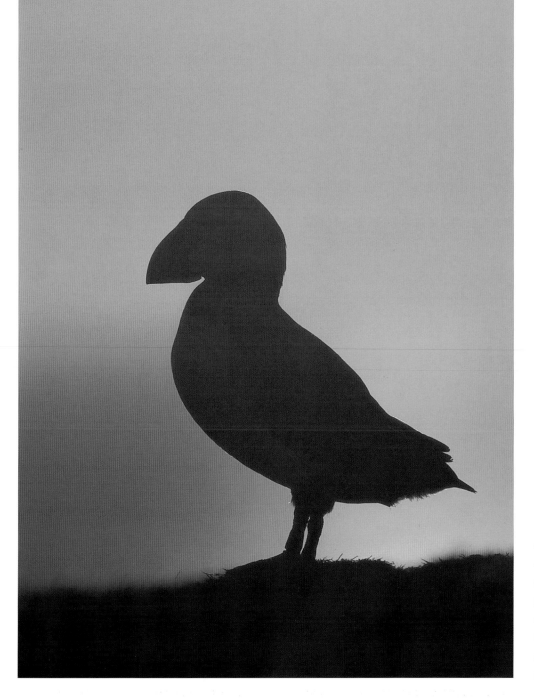

Atlantic puffin
*Birds with strong, easily
recognizable shapes like this
puffin tend to work quite well
in silhouette.*
Camera: *Nikon F4S*
Lens: *500mm f4*
Film: *Fujichrome Sensia 100*

to result in a more distinguished-looking site, for a price. Photographs need to open quickly, so file sizes are normally kept quite small – again, working to the monitor resolution of 72ppi, save as j-peg or gif file formats, and aim for final file sizes under about 50KB. This also makes your photographs more secure against copyright theft. Although they can easily be lifted and used on another web site, at this size they won't really be good enough to reproduce in print. For additional security, you can add visible and invisible watermarks to your photographs – the latter require that you subscribe to a 'policing' service, so that for an annual fee the service provider will search for and notify you of any unauthorized uses of your photographs. Some invisible watermarks purport to be detectable even after they have been copied or printed. All of these systems can be overcome with sufficient determination – you can just hope to make an adequate deterrent.

In conclusion, just make sure that you don't let the 'office' interfere too much with your fieldwork, and remember what motivated you in the first place.

I wish you success, and hope that you will derive as much pleasure from photographing wild birds as I have.

Appendix I

The Nature Photographer's Code of Practice

These excellent guidelines were first drafted in the 1960s by the British nature photographer Derek Turner-Ettlinger, and were later adopted and revised by the Nature Group of the Royal Photographic Society, and endorsed by the Royal Society for the Protection of Birds and the British government's statutory conservation agencies. The principles apply anywhere in the world, and it is my pleasure (duty, no less) to reproduce the sections pertaining to bird photography in the hope of promoting their wider observance.

Introduction

There is one hard and fast rule, whose spirit must be observed at all times. The welfare of the subject is more important than the photograph.

This is not to say that photography should not be undertaken because of a slight risk to a common species. The amount of risk acceptable decreases with the scarceness of the species, and the photographer should do his utmost to minimize it.

Risk to the subject, in this context, means risk of physical damage, causing anxiety, consequential predation, or lessened reproductive success.

The Law as it affects nature photography must be observed. One should find out in advance any restrictions that apply. Apparently lax (or absence of) local legislation should not lead photographers to relax their own high standard.

General

The photographer should be familiar with the natural history of the subject; the more complex the life form and the rarer the species, the greater his knowledge must be. He should also be sufficiently familiar with other natural history subjects to be able to avoid damaging their interests accidentally. Photography of uncommon animals and plants by people who know nothing of the hazards to species and site is to be deplored.

For many subjects some 'gardening' (i.e. interference with the surrounding vegetation) may be necessary to tidy the habitat, or move obscuring vegetation. This should be kept to a minimum to avoid exposing the subject to predators, people, or weather. Plants or branches should be tied back rather than cut off, and the site should be restored to as natural a condition as possible after each photographic session. The photographer should always aim to leave no obvious sign of his visit. If the photograph of a rarity is to be published or exhibited, care should be taken that the site location is not accidentally given away. Sites of rarities should never deliberately be disclosed except for conservation purposes.

It is important for the good name of nature photography that its practitioners observe normal social courtesies. Permission should be obtained before working on private land and other naturalists should not be incommoded. Work at sites and colonies that are subjects of special study should be co-ordinated with the people concerned.

Photographs of dead, stuffed, homebred, captive, cultivated, or otherwise controlled specimens may be of genuine value but should never be passed off as wild and free. Users of such photographs (irrespective of the purpose it is thought that they will be used for) should always be informed, however unlikely it may seem that they care.

Birds at the nest

The terms of the Wildlife and Countryside Act must be observed and licences obtained to photograph Schedule 1 species from the appropriate Statutory Nature Conservation Agency.

It is particularly important that photography of birds at the nest should be undertaken only by those with a good knowledge of bird breeding behaviour. There are many otherwise competent photographers (and birdwatchers) who lack this qualification.

It is highly desirable that a scarce species should be photographed only in an area where it is relatively frequent. Many British rarities should, for preference, be photographed in countries overseas where they are commoner. Photographers working abroad should of course act with the same care as they would at home.

A hide should always be used when there is a reasonable doubt that birds would continue normal breeding behaviour otherwise. No part of the occupant (e.g. hands adjusting lens-settings, or a silhouette through inadequate material) should be visible from the outside of the hide.

Hides should not be erected at a nest site

where the attention of the public or any predator is likely to be attracted. If there is any risk of this an assistant should be in the vicinity to shepherd away potential intruders. No hide should be left unattended in daylight in a place with common public access.

Tracks to and from any nest should be devious and inconspicuous. As far as possible they (like the 'gardening') should be restored to naturalness between sessions.

Though reported nest failures attributable to nest photography are few, a high proportion of those that occur are due to undue haste. The maximum possible time should elapse between consecutive stages of hide movement (or erection), introduction of lens or flash-gear, gardening and occupation. There are many species that need at least a week's preparation; this should be seen as the norm.

Each stage of preparation should be fully accepted by the bird (or both birds, where feeding or incubation is shared) before the next is initiated. If a stage is refused by the birds (which should be evident from their behaviour to a competent bird photographer) the procedure should be reversed at least one stage; if refusal is repeated the attempt at photography should be abandoned.

In some conditions it may be necessary to use a marker in the locality of the nest hole to indicate its occupancy. This type of disturbance should be kept to a minimum.

The period of disturbance caused by each stage should be kept to a minimum. It is undesirable to initiate a stage in late evening, when the birds' activities are becoming less frequent.

Remote-control work where acceptance cannot be checked is rarely satisfactory. Where it involves resetting a shutter, or moving film on manually between exposures it is even less likely to be acceptable because of the frequency of disturbance.

While the best photographs are often obtained about the time of hatch, this is not the time to start erecting a hide – nor when eggs are fresh. It is better to wait till parents' reactions to the situation are firmly established.

There are few species for which a 'putter-in' and 'getter-out' are not necessary. Two or more may be needed for some species.

The birds' first visits to the nest after the hide is occupied are best used for checking routes and behaviour rather than for exposures. The quieter the shutter the less the chance of birds objecting to it. The longer the focal length of the lens used the more distant the hide can be and the less risk of the birds not accepting it.

Changes of photographer in the hide (or any other disturbance) should be kept to a minimum, and should not take place during bad weather (rain or exceptionally hot sun).

Nestlings should never be removed from the nest for posed photography; when they are photographed in situ care should be taken not to cause an 'explosion' of young from the nest. It is never permissible to artificially restrict the free movement of the young.

The trapping of breeding birds for studio-type photography is totally unacceptable in any circumstances.

The use of playback tape (to stimulate territorial reactions) and the use of stuffed predators (to stimulate alarm reactions) may need caution in the breeding season, and should not be undertaken near the nest. Additionally the use of bait or song tapes to attract birds to the camera, even though this is away from the nest, should not be undertaken in an occupied breeding territory.

Birds away from the nest

Predators should not be baited from a hide in an area where hides may later be used for photography of birds at the nest. Wait and see photography should not be undertaken in an area where a hide may show irresponsible shooters and trappers that targets exist; this is particularly important overseas. The capture of even non-breeding birds for photography under controlled conditions is not an acceptable or legal practice. Incidental photography of birds taken under licence for some valid scientific purpose is acceptable provided it causes minimal delay in the bird's release. If any extra delay is involved it would need to be covered by the terms of the licence.

Published by The Nature Group of The Royal Photographic Society, The Octagon, Milsom Street, Bath BA1 1DN. Tel: 01225 462841.

Appendix II

The RSPB Guide to Bird Photography and the Law

Photography of wild birds in Britain is limited by law where it involves the disturbance of rare breeding species, as explained in paragraph 9 below. Other legal and moral restrictions, such as those affecting access to nesting colonies, or feeding and roosting sites, may also be relevant to photographers seeking close views.

The birds' welfare must always come first – photography should not disturb their normal activity. At times this will mean not taking photographs. Some extra considerations apply to photography at the nest:

1 Ensure you have the landowner's permission.
2 Keep the nest site secret. Choose a site away from public view, and if a hide is used, camouflage it well. Leave no tracks or signs that may lead predators to the brood.
3 Keep visits to the nest as few and as short as possible. Changes of photographer should be kept to a minimum and should not take place in bad weather.
4 Leave the nest as you find it. Any "gardening" of a nest should be kept to a minimum to avoid exposing the nest to predators or adverse weather. Tie back vegetation rather than cutting it so it can be restored to its original position.
5 When using a hide, erect it some way off, moving it closer over a period of days so the birds grow used to it. Ensure at each stage that the hide has been accepted. If there is any doubt, move it back. Many species will need at least a week's preparation.
6 The use of a friend is recommended as a "walk-away," accompanying the photographer to and from the hide. Certain species may require two people for this purpose. This is often the only responsible method to minimize disturbance.
7 Fingers and lenses suddenly poked out of a hide, flapping cloth and loud noises scare birds. Get them used to small sounds, talk to them perhaps, before taking pictures.
8 Remember that public opinion generalizes actions, and that the thoughtlessness of one bird photographer may damage the reputation of others.
9 To protect rare breeding birds, the law prohibits intentional disturbance of any species included in Schedule 1 of the Wildlife and Countryside Act 1981. This applies while such a bird is building a nest, or is in, on or near a nest containing eggs or young. It is also illegal to intentionally disturb dependent young of Schedule 1 birds.

The Royal Society for the Protection of Birds

The Lodge, Sandy, Bedfordshire SG19 2DL.
Tel: 01767 680551

Photographers cannot visit such nests unless they obtain the appropriate license from the relevant authority. These are as follows:

English Nature

Northminster House, Peterborough PE1 1UA.
Tel: 01733 455000.

Countryside Council for Wales

Plas Penrhos, Fford Penrhos, Bangor, Gwynedd LL57 2LQ. Tel: 01248 370444.

Scottish Natural Heritage

Research and Advisory Service, Bonnington Bond, 2/5 Anderson Place, Edinburgh EH6 5NP.
Tel: 0131 554 9797.

Schedule 1

Birds that are protected by special penalties and that may not be photographed at or near a nest without a license:

Avocet
Bee-eater
Bittern
Bittern, little
Bluethroat
Brambling
Bunting, cirl
Bunting, Lapland
Bunting, snow
Buzzard, honey
Capercaillie (Scotland)
Chough
Corncrake
Crake, spotted
Crossbills (all species)
Divers (all species)
Dotterel
Duck, long-tailed
Eagle, golden
Eagle, white-tailed
Falcon, gyr
Fieldfare
Firecrest
Garganey
Godwit, black-tailed

Goldeneye
Goose, graylag (Outer Hebrides, Caithness, Sutherland and Wester Ross only)
Goshawk
Grebe, black-necked
Grebe, Slavonian
Greenshank
Gull, little
Gull, Mediterranean
Harriers (all species)
Heron, purple
Hobby
Hoopoe
Kingfisher
Kite, red
Merlin
Oriole, golden
Osprey
Owl, barn
Owl, snowy
Peregrine
Petrel, Leach's
Phalarope, red-necked
Pintail
Plover, Kentish
Plover, little ringed
Quail, common
Redstart, black
Redwing

Rosefinch, scarlet
Ruff
Sandpiper, green
Sandpiper, purple
Sandpiper, wood
Scaup
Scoter, common
Scoter, velvet
Serin
Shorelark
Shrike, red-backed
Spoonbill
Stilt, black-winged
Stint, Temminck's
Stone-curlew
Swan, Bewick's
Swan, whooper
Tern, black
Tern, little
Tern, roseate
Tit, bearded
Tit, crested
Treecreeper, short-toed
Warbler, Cetti's
Warbler, Dartford
Warbler, marsh
Warbler, Savi's
Whimbrel
Woodlark
Wryneck

Bibliography

Benvie, N. *The Art of Nature Photography*, David
& Charles, 2000

Campbell, L. *The RSPB Guide to Bird and Nature
Photography*, David & Charles, 1990

Cramp, S. et al (eds.) *The Birds of the Western
Palearctic*, vols I–IX, Oxford University Press,
1977–1994

Hill, M. and Langsbury, G. *A Field Guide to
Photographing Birds in Britain and Western Europe*,
Collins, 1987

Langford, M.J. *Basic Photography*, Focal Press,
1965; 5th edition, 1986

Langford, M.J. *Advanced Photography*, Focal Press,
1969; 4th edition, 1980

McDonald, J. *The New Complete Guide to Wildlife
Photography*, Amphoto Books, 1992; revised
1998

Morris, A. *The Art of Bird Photography*, Amphoto
Books, 1998

Pölking, F. *The Art of Wildlife Photography*,
Fountain Press, 1995

Scott, S. (ed.) *Field Guide to the Birds of North
America*, National Geographic Society, 1983; 2nd
edition, 1987

Shaw, J. *The Nature Photographer's Complete
Guide to Professional Field Techniques*, Amphoto
Books, 1984

Stroebel, L. *View Camera Technique*, Focal Press,
1967; 4th edition, 1980

Acknowledgements

First and foremost, thanks to my parents for their
patience and understanding, and the gift of
opportunity.

Per Axel Åkerlund, naturalist, photographer
and family friend, inspired me in my youth.

John Horsfall kept me going on those long
bike rides to the coast, when all was fresh and
there to be learned. We're still learning.

The late Bobby Tulloch was a great
companion during my time in Shetland, and I
recall our shared photographic excursions with
fondness and gratitude.

Sincere thanks to the Royal Society for the
Protection of Birds, not just for the hugely
important work they do for birds and
biodiversity, but also for appointing me to the
best 'job' in Britain. Nicholas Hammond had faith
in me when it counted. I am especially indebted
to the many RSPB reserves and conservation staff
and their families, too numerous to name, who
gave their hospitality, time, knowledge and
enthusiasm so willingly over the years. Paul Fisher
and Colin Crooke deserve a special mention for
their friendship and support, which has always
extended well beyond the call of duty. Andy
Simpson helped me at a difficult time.

Many, many people have assisted on my
various photographic assignments, notably:
Gabriel Sierra and Carlos Sanchez, and the
Sociedad Española de Ornitología in Spain; Chris
Bowden and Mohammed Ribi in Morocco; Steve
and Paula Parr in the Seychelles; Signor Perluigi
Candela and the Lega Italiana Protezione Uccelli
in Italy; Chris Skinner in Norfolk; Tony Cross,
Eithel Powell, and Chris Powell in Wales; and
Peter Urquhart, Justin Grant, and the Scottish
Fisheries Protection Association in Scotland.
Thank you all, and to those I have undoubtedly
overlooked.

Ian McCarthy and Kirk Mottishead made
absolutely brilliant photographic models, and Phil
Cottier obliged by taking my portrait for the
dustjacket.

Freya Dangerfield, Diana Dummett, Sarah
Hoggett and Anna Watson at David & Charles
managed to keep me on track, and transformed
my efforts into this beautiful book.

I should also like to acknowledge the
invaluable contributions of the guest
photographers, and express my gratitude for
their confidence in this project. Apologies to the
many other excellent photographers it wasn't
possible to include on this occasion.

John Horsfall, Mike Lane, Bill Thompson III,
Roger Tidman and Robin Wynde kindly made
helpful comments on the manuscript, and
probably saved me some embarrassment. But
perhaps not all Of course, I accept full
responsibility for any factual errors and all
opinions expressed.

Finally, none of this would have been possible
without the love and support of my wife Pat, and
daughters Hannah and Alice. I took an
outrageous risk with their futures by leaving a
perfectly good job and regular salary to pursue a
dream. To them, I shall be forever grateful.

Index